SPECTACLE AND DISPLAY

SPECTACLE AND DISPLAY

EDITED BY

DEBORAH CHERRY
AND
FINTAN CULLEN

Blackwell Publishing

AAH
ASSOCIATION OF ART HISTORIANS

This edition first published 2008
Originally published as Volume 30, issue 4 of *Art History*
© 2008 Association of Art Historians

Blackwell Publishing was acquired by John Wiley & Sons in February 2007. Blackwell's publishing program has been merged with Wiley's global Scientific, Technical, and Medical business to form Wiley-Blackwell.

Registered Office
John Wiley & Sons Ltd, The Atrium, Southern Gate, Chichester, West Sussex, PO19 8SQ, United Kingdom

Editorial Offices
350 Main Street, Malden, MA 02148-5020, USA
9600 Garsington Road, Oxford, OX4 2DQ, UK
The Atrium, Southern Gate, Chichester, West Sussex, PO19 8SQ, UK

For details of our global editorial offices, for customer services, and for information about how to apply for permission to reuse the copyright material in this book please see our website at www.wiley.com/wiley-blackwell.

Library of Congress Cataloging-in-Publication Data

Spectacle and display/edited by Deborah Cherry and Fintan Cullen.
 p. cm.
Includes bibliographical references and index.
ISBN 978-1-4051-7524-1 (pbk. : alk. paper)
1. Art museums—Social aspects. 2. Art museum attendance. 3. Art and society. I. Cherry, Deborah. II. Cullen, Fintan.

N430.S64 2008
069—dc22

069CHE 2008010837
A catalogue record for this book is available from the British Library.

Set in 10/12pt SwiftEF-Regular by Macmillan India Ltd., Bangalore, India
Printed in the United Kingdom by TJ International, Padstow, Cornwall

01 2008

CONTENTS

1.1 Lubaina Himid, *My name is Aniweta/ They call me Sally*, 2004. Exhibited in *Uncomfortable Truths*, London, 2007 with the text: My name is Aniweta/ They call me Sally/ My cups were used in rituals/ Now the ceremonies are lost/ But I can remember the order'. Reproduced with kind permission of the artist.

1

SPECTACLE AND DISPLAY: SETTING THE TERMS

DEBORAH CHERRY and FINTAN CULLEN

Alan Bennett's laconic and witty description of attending the exhibition of drawings by Michelangelo at the British Museum in 2006 aptly summarizes a not unfamiliar experience of many in metropolitan museums and blockbuster exhibitions: crowds, queues, anticipated visual pleasure and a certain discomfort:

> Today is the last day of the British Museum Michelangelo exhibition, which because of demand, is open until midnight. For all we go quite late, it's still crowded out, paintings hard enough to look at under such circumstances and drawings well-nigh impossible. One straightaway abandons any attempt to look at them in sequence (not that sequence helps) and makes for any drawing that is not being looked at, the people with earphones the real menace as they all move at the same speed and cause jams.[1]

Bennett's comments are temporally specific, detailing the conditions of art viewing in the early twenty-first century. And they are also prompted by place. Bennett is in London, yet his remarks would not be inappropriate for many cities in western Europe or North America, where museums, through an alliance with outstanding architecture – new buildings and redesigned existing structures – by celebrated architects, have become not so much the place to view art as the venue for a day out (or an evening in Bennett's case) and many kinds of social conviviality: meeting, eating, conversing, shopping. Added over the winter and spring of 2006–2007 by Tate Modern, one of several museums of modern and/or contemporary art to be opened in the past decade or so, and now reportedly the second most popular tourist venue in the UK, were the thrills of hurtling down Carsten Höller's slides. *Test Site* was one of a number of art works to embrace the gigantic as spectacular, encouraged by the spatial potential of Tate Modern's Turbine Hall.[2]

If museums have long been locations for spectacle and social conviviality, what seems novel now is the sheer scale of the enterprise, and the accompanying shifts in the 'rituals' of the museum. Carol Duncan's much-quoted study of 1995, *Civilising Rituals: Inside Public Art Museums*, analysed the enlightenment mission that has shaped collections of art and design since the eighteenth century, considering how the private moved into the public domain, describing the civilizing rituals of secular museums, and demonstrating the significance of these public institutions in shaping behaviours and class identities. Duncan's analysis of museums, like Tony Bennett's equally influential investigation of the public exhibition, built on the theories of Michel Foucault and Pierre Bourdieu in which the museum is envisaged as an all-seeing power house or panopticon, a repository

of class-based attitudes to culture.[3] By 2000 these approaches to visual spectacle and display were being overtaken, it could be argued, by changes to museum and exhibitionary cultures worldwide, the rapid expansion of 'museum studies', and the multiplicity of approaches becoming current in academic discourse. Display and spectacle are now not one story but many stories.

In reflecting on the terms spectacle and display, the essays in this collection emphasize how objects appear when put on show, and on the many and varied kinds of visual spectacle and visual responses. Display can be part of a performance, or a secular or religious ritual. It can be educational, yet contributing to state or other ideologies. It may be judged a success, and also a failure. In their separate ways, the contributors deal with display in a range of stories stretching from the consideration of the uses of a manuscript in eleventh-century Byzantium by Robert Nelson to the discussion of private palaces in eighteenth-century Rome by Sabrina Norlander Eliasson or the myriad exhibitions of London in the 1780s by John Bonehill. The practices of curating in museums in Britain and the United States in the later twentieth century is variously considered by Peter Funnell, Charles Saumarez Smith and Tapati Guha-Thakurta. As all these essays demonstrate, display has many manifestations and meanings. Selection, presentation, an over-arching rationale may play a part, as may the decisions of curators, collectors and interpreters. In addition, a raft of recent studies have focused on the 'social lives of things', the transformations and re-significations that take place when an object enters a collection.[4] According to the *Oxford English Dictionary*, display means a setting out for view, an unfolding. Display may thus imply a gaze that can be intimate, close-up and engaged, as well as a more distant regard, which is often associated with spectacle, although, as several contributors point out in these pages, spectacle can also depend on participation and engagement.

Art History as a discipline has been much concerned with variations on the definitions of display: collectors and art institutions have played a part in these ruminations. By contrast, spectacle has more often preoccupied sociologists and philosophers. Over forty years ago, Guy Debord asked us to recognize the importance of signs emanating from 'dominant organisation[s] of production', and he then proceeded to analyse modern alienation, revolutionary organizations and consumption, emphasizing how modern social relations are mediated through images.[5] Understandably, his book was made famous by the events of 1968. Debord understood that spectacle is by no means confined to museums and exhibitions, but spills out into a wide range of popular cultural forms such as shopping, media, entertainment, street events, secular and religious festivals. This theme is intriguingly elucidated by Neil Cummings and Marysia Lewandowska in the artists' pages commissioned for this volume. The other side of display, as is evident in their contribution, is that which is hidden or removed from view, items which are de-acquisitioned, objects deposited in stores, outposts, reserves, or the warehouses of shipping firms. Spectacle has long been associated with the vast exhibitions of the nineteenth century, such as the Manchester Art-Treasures Exhibition of 1857, examined here by Helen Rees Leahy, or the world expositions interrogated in Angus Lockyer's study of Osaka in 1970. But, as our collection emphasizes, display and spectacle are often intertwined. Peter Funnell draws attention to the arresting drama of the new displays at the National Portrait Gallery in London in the 1960s, while Tapati Guha-Thakurta considers the

'clashing custodial claims' of the trans-national curating of Indian sculpture in the 1980s.

Carol Duncan traced the movement of the rituals of display from the elite home to the public or state museum; more recent scholarship, as well as exhibitions, has increasingly drawn attention to viewing rituals within private spaces.[6] Robert Nelson elucidates the privileged use of manuscripts by priests in eleventh-century Constantinople: close readings and in religious activities which involved physically holding and kissing sacred texts and icons suggest an intimacy that was only seen and enjoyed by a few. The same can be said for the viewing of family portraits in Palazzo Barberini in eighteenth-century Rome, where such works were displayed in a purpose-built portrait gallery inserted into the fabric of the building. The Roman elite relied on visual aids, such as the biblical iconography of a series of grisaille panels placed between the portraits. Byzantine culture represented that intimate form of display in visual form on the page of the lectionary under discussion. Furthermore, the Byzantine manuscript moved between exclusive and public viewing. Nelson explains: 'Opening and displaying the Florence lectionary on September 1 in the Forum of Constantine was part of a great public spectacle in medieval Constantinople, but it also constituted a private encounter between the Patriarch and his manuscript.'

Recent studies of art in eighteenth-century Rome have focused on the development of the neo-classically inspired statuary that culminated in the work of Antonio Canova and the large-scale, but somewhat *retardataire*, Counter-Reformation altarpieces that poured from the palette of artists such as Corrado Giaquinto.[7] Eliasson's essay here moves away from these worlds to investigate the (to many) inaccessible and closed world of family squabbles and dynastic contention. Portraiture, she suggests, was deployed by the Barberini and Colonna clans to smooth over the frictions of familial relations, dynastic tensions and potential splits. In this way, Roman art production in the mid-eighteenth century is comparable to the better-known world of British portraiture in a domestic setting, recently discussed by Marcia Pointon and Kate Retford.[8]

John Bonehill's interests in eighteenth-century display centres around exhibition culture in London. *Art on the Line* (curated by David Solkin in 2001) showed the importance of reconstructing past exhibitions and the historical viewing experience, whether physically or in words.[9] Bonehill focuses on Joseph Wright of Derby and his personal feud with the Royal Academy in the 1780s and he tracks the genesis of the artist-led one-man show that would quickly become distinctive in nineteenth-century display. To Wright, the solo show provided not just the opportunity to sell his work, as seems to have been the motive behind so much of the activity of the Royal Academy. Rather, with the help of the poet William Hayley, Wright seized the opportunity to exhibit patriotism, sensibility and all the traits of a man of feeling.

The Manchester Art-Treasures Exhibition of 1857 was one of the great spectacles of the mid-nineteenth century. Unlike the Great Exhibition of the Works of Industry of all Nations held in London in 1851, the focus in Manchester was on art: sculpture, old-master paintings, recent pictures, portraiture, drawings and prints, alongside armoury and plate. Helen Rees Leahy asks us to think anew about such extravagant events, not only in terms of the celebrity of some exhibits

– Annibale Carracci's *Three Maries* (c.1604, London: National Gallery) was a surprise hit – but also in terms of exhibitionary experience. As she suggests, the Manchester occasion articulated novel codes of etiquette and forms of behaviour as visitors reacted to the unknown or the unforeseen, and the outcome was often unexpected and surprising. With its displays and contingent pleasures, the Manchester exhibition was 'a temporary event that could be comprehended, enjoyed or resisted ... neither the coded messages of the display schema nor the example set by prestigious visitors were able to direct the behaviour and aesthetic responses of many spectators.' Some twenty years later Émile Zola described in loving detail in *L'Assommoir* (1876) a visit to the Louvre by a group of working-class wedding guests. Giggling at a figure of a woman urinating in the corner of Peter Paul Rubens's *The Kermis* (*Peasant Festival*, c. 1631, Paris: Musée du Louvre), and thrilled by 'Antiope's thighs' in what is now known as Antonio Allegri da Correggio's *Venus, Satyr and Cupid* (c.1525, Paris: Musée du Louvre), the visitors became intimidated by the architecture and by the guards who watched them wandering around the museum. In the end, these inexperienced gallery-goers panicked and fled.[10] Rees Leahy suggests that the ways in which nineteenth-century visitors learned to hold their bodies at exhibitions and museums – learning, she suggests, how to comport themselves in the new public institutions of modern society – prompted a stream of commentary and debate, much of which foreshadows twenty-first century discussions on display and spectacle.

For Angus Lockyer, the great exhibitions of the nineteenth century embody spectacle in a multiple form: in terms of what he calls 'the monopolization of a space of representation so as to effect the work of ideology or its critique' and in terms of the sheer diversity of what was on display, the 'multiple interests and investments' in which popular entertainment and distractions figured large. The Great Exhibition of 1851 certainly seems to conform to the work of spectacle as ideology in its promotion of British trade and imperial concerns. Here as in later exhibitions, the inclusion of Indian art, and the presence of Indian artisans, assisted in the creation of India as an imperial spectacle central to the making of British identities.[11] The Art-Treasures Exhibition undoubtedly depended on an international cotton trade, on Manchester's success built upon its interests in and dependence on the Indian sub-continent and the resources and contacts of empire. World fairs and expositions offered mappings of the world and of national identities. The Osaka Expo of 1970, one of several organized worldwide post 1945, reconfigured the world map from the perspective of Japan. But, as Angus Lockyer indicates, at Osaka there were conflicts between the government's promotion of Japan's industrial progress, the creative input of the architects, artists and designers, and the subversive seizure by a protester, Satō Hideo, of the one of the most arresting displays, which in Osaka were designed to prompt active participation not just passive spectatorship. This 'cacophany' of display and spectacle leads Lockyer to the provocative conclusion that at 'this most visited and therefore most successful expo in history', the 'logic of spectacle' was one of indifference, of accommodation rather than regulation. This capaciousness and capriciousness, he suggests, offered forms of spectacle at odds with more controlled displays: Osaka and other world fairs were thus ahead of the game, anticipating the recent moves by museums to popular entertainment, to a logic of spectacle which measures success in visitor numbers.

These more controlled displays are evoked in the galleries of contemporaneous museums. Peter Funnell traces the major transformations which took place at the National Portrait Gallery in London in the 1960s and 1970s, in which the regulated arrangement of serried rows of portraits was replaced by eye-catching multi-media arrangements which included giant maps, sculpture and weaponry, with objects on loan from other collections to heighten the impact. Funnell demonstrates how the single and singular portrait as indicative of the individual was replaced by dramatic displays in which objects and portraits were grouped according to the historical contexts of the sitters. The galleries were dedicated to re-telling England's history. The big successes of the Napoleonic wars, for example, were introduced by a screen emphasizing intimate biography with portrayals of Lord Horatio Nelson and Emma Hamilton. The inspiration lay not only in the Labour government's attempts to widen the audience for the arts, but in 'new manifestations of an enthusiasm for history', indicated by a huge rise in visitors to historic properties owned by the National Trust and the emergence of innovative popular histories on television and in illustrated publications, many with a distinctly nationalist flavour. For Funnell, as for Charles Saumarez Smith, styles of museum display are historically informed, intimately connected to the values and ideas of the periods in which they are created. The new displays at the National Portrait Gallery were introduced during the directorship of Roy Strong. Funnell, himself an innovative curator who has imaginatively transformed the hanging of nineteenth-century portraits, examines the role of the curator and the director in implementing change.

Writing when Director of London's National Gallery, Charles Saumarez Smith provides the first published account of different display styles at the Gallery during the twentieth century, each one reflecting the interests of the curators and/or the director, and shaped by what he calls 'period orthoxodies'. Starting with Sir Kenneth Clark's 'hanging by eye', he traces the moves from isolated masterpieces to the 'universal survey', from minimalist trends to the 'heritage hang' and 'ecclesiastical hang'. London's National Gallery, its foundation, history and the formation of its canonical collection have been the subject of considerable scholarly attention, yet it was only in 2006 that a full-scale history of the institution was published.[12] Saumarez Smith's focus is recent, the past seventy years or so, but what he calls 'the power relations within the institution' have doubtless been there since its foundation in the early nineteenth century. He discusses the tensions between those who are 'permitted to undertake the display', the public and perceived needs for 'additional contextual information'. It may come as a surprise that, in this era of relatively free access to information, museum display is still one of those undiscussed topics that 'touches on sensitivities about how organisations are managed', although this may well be to do with scholars not knowing what questions to ask as opposed to some hidden secret.

Spectacle and display come together in Tapati Guha-Thakurta's consideration of the vast Festivals of India in which sculpture was promoted as the premier art form of the sub-continent. These 'mega-events' participated in the globalized culture of spectacle that produced the Osaka Expo. Attentive to the particularities of how the selected sculptures were arranged, Guha-Thakurta considers the 'transformative impact' of museum display on objects garnered from temple and

museum collections. Countering the more familiar story of aestheticization and decontextualization, she considers how Western museums today 'function as a complex site for the production of new orders of "religious" value around Indian sculpted objects', and the tensions which have emerged between sacred and aesthetic tropes. Following the religious value (re-)attached in museums to Byzantine icons and to a Tibetan altarpiece, though not (yet?) to Christian altar-pieces at the National Gallery, Guha-Thakurta demonstrates that the 'religious reinscription' of Indian sculptures not only created a certain Orientalism, but threatened, then as now, to 'dislodge their parallel lives as "works of art"'. Charting the twists and turns of clashing custodial claims by Indian and Western institutions, she concludes that many items are now consigned to limbo, neither worshipped as religious icons nor valued as works of art.

How museums and galleries function is the topic of Andrew McClellan's essay. He assesses the state of Museum Studies on both sides of the Atlantic and speculates on what exactly museums are for. For McClellan, too much of the discussion on museums and too many of the contributors to this ever-growing literature are from the university sector. He asks that more comment and analysis emanate from curators and museum professionals. By bringing together contributors from the museum world and the academic sector, we hope that we are participating in the renewed discussions on spectacle and display.

Notes

The editors warmly thank our contributors who originally presented versions of these chapters at a two-day conference at the University of Nottingham in January 2007. We are also extremely grateful to our anonymous readers, the audience at the Nottingham conference and to the sponsors of the conference: the Association of Art Historians, the British Academy, Blackwell Publishing and the University of Nottingham. We are indebted to Sam Bibby for carefully preparing several texts, Jody Patterson for coordinating the volume, Sarah Sears for her meticulous copy-editing and imaginative layout, and the production team at Wiley-Blackwell.

1 Alan Bennett, 'My 2006', *London Review of Books*, 4 January 2007, 6.

2 On the spectacular displays of contemporary art, see Julian Stallabrass, *Contemporary Art: A Very Short Introduction*, Oxford, 2006.

3 Carol Duncan, *Civilizing Rituals: Inside Public Art Museums*, London and New York, 1995; Tony Bennett, 'The Exhibitionary Complex', in *The Birth of the Museum: History, Theory, Politics*, London and New York, 1995, 59–88; Michel Foucault, *Discipline and Punish: The Birth of the Prison*, trans. A. Sheridan, London, 1977; Pierre Bourdieu, *Distinction: A Social Critique of the Judgement of Taste*, trans. R. Nice, London, 1984.

4 Arjun Appadurai, ed., *The Social Life of Things, Commodities in Cultural Perspective*, Cambridge, 1986.

5 Guy Debord, *The Society of the Spectacle*, trans. D. Nicholson-Smith, New York, 1994 (originally published in French as *La société du spectacle*, Paris, 1967), 13.

6 *At Home in Renaissance Italy*, exhibition at the Victoria and Albert Museum, London, October 2006 to January 2007.

7 Edgar Peters Bowron and Joseph J. Rishel, eds, *Art in Rome in the Eighteenth Century*, Philadelphia, 2000.

8 Marcia Pointon, *Hanging the Head*: Portraiture and Social Formation in Eighteenth-century England, New Haven and London, 1993, and Kate Retford, *The Art of Domestic Life: Family Portraiture in Eighteenth-Century England*, New Haven and London, 2006.

9 *Art on the Line. The Royal Academy Exhibitions at Somerset House 1780–1836*, ed. David H. Solkin, New Haven and London, 2001.

10 Émile Zola, *L'Assommoir* (1876), trans. L. Tancock, Harmondsworth, 1970, 88–91.

11 Saloni Mathur, *India by Design: Colonial History and Cultural Display*, Berkeley and London, 2007.

12 Jonathan Conlin, *The Nation's Mantlepiece: A History of the National Gallery*, London, 2006.

2
ARTISTS' PAGES

NEIL CUMMINGS and MARYSIA LEWANDOWSKA

PICTURE CREDITS

2.1 *Empty Shop*, Laskowa Poland 2005

2.2 *Covered*, British Museum London 1996
2.3 *David*, Academy Florence 1981

2.4 *Native American*, Selfridges London 1994
2.5 *Catalogue of the Great Exhibition*, London 1851
2.6 *Barbies*, Selfridges, London 1994

2.7 *London*, London 1999
2.8 *'Ginger'*, The British Museum London 1996

All photographs courtesy of the artists and chanceprojects.com

3

EMPATHETIC VISION: LOOKING AT AND WITH A PERFORMATIVE BYZANTINE MINIATURE

ROBERT S. NELSON

At the moment a work of art is made, it is known just to its maker. Only after it is shown to others does it accrue social and aesthetic value. Quieter, less studied, but not less important are the ways in which the art object becomes entwined in the lives of those who see, use, or possess it, and thereby alters how they see themselves and are seen by others. Various social practices enable such trans-formations, but for medieval objects valued today as art, ecclesiastical rites are among the most important and, not irrelevantly, the best documented.

The present study relies upon church ritual and devotional vision to explore the performative meanings that arise from the display of a particular miniature in an eleventh-century Byzantine manuscript in Florence, Bibl. Laur. Med. Palat 244.[1] The inquiry works with distinctions expressed in the first section of the title and what anthropologists have termed etic and emic culture.[2] The etic are those aspects that can be described or enumerated from the outside by means of categories that the investigator brings to the topic. The emic approximates the insights of the local or past world and expresses an internal perspective. For objects, the emic can be observed in moments of use and performance and requires the commentator to study and apply the local social codes, thereby assuming temporarily and vicariously a role within that society. Thus the emic demands an element of projection to recover or imagine the past.

Some approaches of art history – formal analysis, for example – are normally etic; others, like iconographical interpretations, might be either, but tend towards the etic. Erwin Panofsky in his classic essay,[3] for example, looked at a man lifting his hat and described three ways of understanding the gesture. Neither he nor anyone else has looked *with* this fictive gentleman and contem-plated what it felt like to be observed by an art historian, converted into method, and discussed by countless art history classes over the years. By its nature, much iconographic analysis, and including 'readings', the latest manifestation of the approach,[4] transforms the work discussed into an object of art history.

As an art-historical datum and as the sum of other art-historical data – date, provenance, condition, dimensions, etc. – the art work obscures its past ontolo-gies as gift or commodity and as hybrid object/subject ensconced within a dense social nexus. Lost also is the notion that art objects, like certain other types of things, 'both are and affect social relations ... are a partner in them, and ... mix

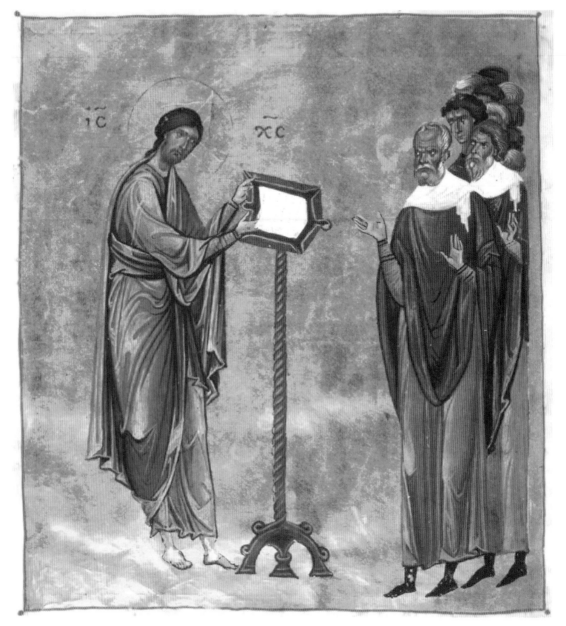

3.1 *Christ Reading*, eleventh century. 338 × 270 mm. Florence: Bibl. Laur. Med. Palat. 244, f. 30v, Photo: Florence: Biblioteca Medicea Laurenziana.

together chains of humans and nonhumans.'[5] Because art works were often cultural symbols in past societies, they once functioned as models *of* and models *for*, giving 'meaning, that is, objective conceptual form to social and psychological reality both by shaping themselves to it and by shaping it to themselves'.[6] Reading a work of art as a model of a past event, custom, or belief is a standard process of history and art history. Understanding that object as a model for requires exploring its active agency and ventures in the direction of anthropology or sociology.[7]

16

The distinctions between etic and emic are encoded in the etymologies of the governing words of this volume, display and spectacle. The former carries the sense of unfolding, as 'unfolding to view', that is exhibiting and presenting, and it has a particular ornithological meaning.[8] Like a bird spreading its feathers in a mating dance, the display of a work of art is an unfolding, a setting out for viewing, for attracting interest. In the case of an illuminated manuscript, its museum exhibition involves opening the book and pinning back its pages, thus immobilizing a portable object that had a more dynamic life in the past that this study seeks to recover.[9] The modern display of a work of medieval art transforms from the outside, and in this sense is etic. But a manuscript may also be opened by someone for whom it was made and seen in the conditions proper to what J.L. Austin called a performative. In this case, the viewer can be changed by the active action of viewing, just as a participant in a performative ritual, for example a wedding, is changed by the pronouncement of certain words.[10]

Spectacle has similar general meanings as display, but a different etymology, deriving from Latin and Romance words for 'to look'.[11] In English, 'to look' is normally followed by the preposition 'at', but also 'on' or 'upon', each implying the etic. The 'looking with' in my title is not standard English, but its awkwardness serves to call attention to a type of vision that will be introduced below. Although spectacle in broader parlance can have negative associations, its senses of theatricality are relevant, because the Florence manuscript was made for public performance. What happens to viewers in display, spectacle and performance is the concern of this essay.

The concept of 'looking with' is similar to but different from the ultimately Romantic notion of empathy that animated German psychology and art history in the late nineteenth and early twentieth centuries. That discourse led to the first uses of empathy in English.[12] While Juliet Koss has shown the later demise of this initial concept of empathy, she also notes its persistence in different guises, for example, studies of spectatorship in film that are relevant for the present project.[13] Less useful is the empathy mixed with sympathy or compassion of popular discourse, for it implies a modern subjectivity and sentimentality; hence the utility of the more neutral 'looking with'. The latter depends more generally on the hermeneutics of interpretation applied to seeing and identifying with the performative display of a single image in a medieval Greek manuscript presently in Florence (plate 3.1).

ICON

Entirely written in gold ink, the manuscript has lections for twenty-two major feast days of the year.[14] Normal lectionaries have readings either for every day or for the Saturdays and Sundays of the year.[15] The abridgment of the Florence manuscript means that it was used only on the most august occasions. Its golden writing indicates significant expense, hence an elite clerical readership in a prestigious and well-endowed church. That institution was most likely the cathedral of Constantinople, Hagia Sophia. A note in the manuscript, to be discussed below, details rituals for that church. Moreover, a nearly identical manuscript in Moscow, State Historical Museum, Syn. gr. 511, once belonged to Hagia Sophia and in 1588 was given by the Patriarch of Constantinople to the Patriarch of Moscow.[16]

Both lectionaries have evangelist portraits and large ornamental headpieces, but only the Florence manuscript also includes a full-page miniature of Christ reading (plate 3.1). It introduces the lection for 1 September, the beginning of the Byzantine secular year. There Jesus turns towards the book on the stand and his audience, who are led by two men wearing white scarves, similar to a bishop's omophorion but without the latter's ubiquitous dark crosses.[17] Jesus is taller and more active than the two men and the crowd behind, if their ascending group of heads are understood as a convention for representing spatial recession. His hands touch the lectern and at the same time address the group. Raising his hands, the first of the bishop-like figures acknowledges the reader and the reading.

The lectern's vertical support bisects the miniature, reinforces the verticality of the composition, and draws the eye to the open book. The visually striking white book contrasts with the surrounding gold ground and connects the hands of Jesus to the two men with the white collars and the crowd beyond. The miniature's gold ground, axial design, spare composition and general solemnity are the hallmarks not of a narrative illustration in a manuscript but of an icon.

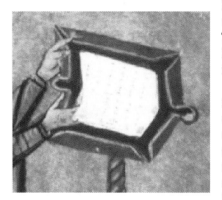

3.2 Detail of *Christ Reading*. Florence: Bibl. Laur. Med. Palat. 244, f. 30v.

For the Byzantines, an icon was a matter of subject matter and devotion, not medium. The single miniature in the Florence lectionary, as the following will argue, functions as an icon.

The ostensibly simple visual design of the miniature supports a subtle and sophisticated iconography that may be seen in something as conventional as the traditional sacred names, *IC* and *XC*, inscribed on either side of the head of Jesus. The letters *XC*, signifying Christ, the anointed one, the Messiah, are placed directly above the book and on the critical central axis of the miniature. The text on the book, shown here rotated and enlarged (plate 3.2), records the words from Isaiah read by Jesus and affirms the general Messianic message of the scene: 'The spirit of the Lord is upon me because he has anointed me to preach good news to the poor.' Originally the text continued past this point, as indicated by the two erased lines at the end. They would have accommodated the next two Greek words, which in English are 'he has sent me.'[18] Not inscribed are their continuation and the further details of the mission: 'to proclaim release to the captives and recovering of sight to the blind, to set at liberty those who are oppressed, to proclaim the acceptable year of the Lord.'

The manuscript's scribe and/or illuminator carefully arranged the chosen words across the verso and recto sides of the depicted book (plate 3.2), as translated literally:

> Verso: 'The spirit of the Lord is upon me because he has anointed me.'
> Recto: 'To preach good news to the poor he has sent me.'

The arrangement differs from the word division of English translations and the Greek edition upon which they are based.[19] In the latter, the clause 'to preach the

good news' is grouped with the preceding words and ends one sentence. 'He has sent me' begins the next sentence, thus 'The spirit of the Lord' ... to the poor. He has sent me to proclaim' The division on the depicted book follows the actual punctuation of the lection a few pages later (f. 32r). Throughout the manuscript, crosses separate units of thought. In this section, a cross precedes the words 'spirit' and 'to preach' and follows the last 'me' of 'he has sent me.' The recto of the lectern book thus begins at the second cross. The break at this place stresses the anointing and works with the letters *XC*, the anointed one, that are placed above the book.

Also emphasized by the symmetrical format of these six-line texts is the 'me' at the end of both pages. Although the last word on the recto is mostly erased, the bottom of the letter and the uniformity of the script suggests that the missing word mirrored the facing page. The erasure also effaced the ends of Christ's fingers which once extended on to the page. In that position, they would have pointed to the 'me'. Seen in the full, unrotated miniature (plate 3.1), this hand also gestures to the right, an action that connotes speech in Byzantine art (see plate 3.4). Thus, the pointing, speaking gesture represents Jesus addressing these words, and especially the pronoun, to the audience before him. Visually and orally, he assumes the subject position of the first-person pronoun, just as the lector would in the oral recitation of this text.

The miniature thus distils the basic message of the lection (Luke 4:16–22a) that follows (ff. 31r-33v). On the Sabbath Jesus went to the synagogue at Nazareth and stood up to read. He was handed the book of Isaiah, opened it, and recited the text for the day. Closing the book, he sat down, and 'the eyes of all in the synagogue were fixed on him.' (Luke 4:20) Jesus said to the congregation, 'Today this scripture has been fulfilled in your hearing.' (Luke 4: 21) The people were amazed and wondered 'at the gracious words which proceeded out of his mouth' (Luke 4:22). As a result of his transformative, transcending performance, Jesus became for those present the anointed one whom Isaiah had foretold (61: 1–2).

Some sense of the miniature's significance and even originality, to evoke an anachronistic concept, may be gained through comparison with other contemporary lectionaries. The day that the lection was read, 1 September, received special attention in the Byzantine lectionary because it was the beginning of the Byzantine administrative year and the start of the immovable feasts, the second part of the lectionary. The saint commemorated that day is Symeon Stylites, and he is the focus of the illustration for this lection in an eleventh-century manuscript in the Dionysiou Monastery at Mt Athos.[20] Perched atop a dark-veined marble column with a delicate lattice, Symeon faces outwards. The same column appears after Symeon's death in another eleventh-century lectionary in the Pierpont Morgan Library (plate 3.3).[21] There monks gather around the saint's body on the funeral bier. The standing figure at the right looks and gestures to the beholder. Inclining his head to his right and towards the deceased saint, this monk connects the beholder to the image. The other monks provide subject positions for potential viewers and suggest ways in which they can visualize themselves grieving over the body of Symeon, someone who is meant to be as well known to them as he was to his colleagues at his death.

The left side of the Pierpont Morgan miniature illustrates Christ in the synagogue. He hands a book to an attendant in the synagogue in slight

contradiction of Luke's Gospel, which states that after Jesus had completed his reading, he gave the text back to the attendant and then sat down. The artist has emphasized instead the subsequent events at the moment when Jesus said that the prophecy had been fulfilled in the space of their hearing. In the miniature Jesus sits among four other men but occupies a more elevated, throne-like seat and rests his feet on a footstool, a sign of high status. To indicate further that he is the Messiah, Jesus is significantly larger than the other men, and his haloed head extends above the top of the seating and thus calls attention to itself.

At this version of the Nazareth synagogue, the congregants either look at Christ or discuss his teachings in amazement or consternation. Centrally positioned on his throne, Jesus presides as if he were a bishop in the taller, central seat of the synthronon, the semi-circular structure along the curved wall of the apse of a church. On Easter at Hagia Sophia, the patriarch would read the Gospel

3.3 *Christ Reading; Death of Symeon Stylites*, eleventh century. New York: Pierpont Morgan Library, ms. 639, f. 294.

lection from this throne, and the deacon would repeat his words from the ambo.[22] The wooden structure that the congregants share also resembles post-medieval choir stalls in the monastic churches of Mt Athos and Mt Sinai and may refer to medieval structures. Such allusions to the everyday situate the teaching of Jesus inside a church and ground his lesson in the space of hearing and seeing of those present at the medieval retelling of the story.

The two possible themes for 1 September are combined in a twelfth-century lectionary in Paris (Bibl. Nat. suppl. gr. 27).[23] St Symeon and his column stand atop a framed miniature depicting an enthroned Jesus addressing not seated but standing elders, as in the Florence miniature. This variant follows the tradition of the extensive narrative illustration of the Gospels that is preserved in the eleventh-century Paris, Bibl. Nat. gr. 74.[24] There the account of Jesus in the Nazareth synagogue extends over two scenes. In the first, Jesus, seated on a throne and holding a book, speaks to a group of standing men; in the second, he stands and reads from a large book on a lectern. The miniature in the Florence lectionary merges the two events.

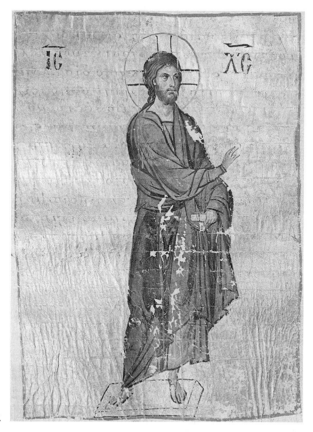

3.4 *Christ Speaking*, late eleventh–
early twelfth century. Athens:
National Library cod. 2645, f. 166v.

Also relevant to its iconography is a lectionary in Athens dating from the late eleventh or early twelfth century. Both lectionaries are decorated with evangelist portraits and only one additional illustration, a full-page miniature for 1 September.[25] Set on a gold field, the Athens Christ (plate 3.4) stands on a gilded footstool, twists his upper body to the right, and gestures towards the beginning of the lection on the facing recto. Formally, the figure is an odd pastiche. The upper half of the lecturing Christ, especially the right arm, resembles the lector in the Florence lectionary, but the lower body follows another tradition, seen, for example, in the early eleventh-century lectionary at the monastery of St Catherine at Mt Sinai, cod. 204.[26] The latter illumination is part of a suite of preliminary iconic images which, like the Athens miniature, depict a single figure on a gold ground.

Although the Florence illumination tells a story and thus differs from the preceding images, its design is similar. From the narrative tradition, the illuminator has taken the crowd and the standing, reading Jesus and rearranged these elements into a balanced, hieratic, iconic composition on a gold ground. At the visual and iconographic centre of the miniature is the tall, slender lectern and the open book with the Messianic message and the abbreviation *XC*. Narrative thereby becomes icon. As a result, medieval sources about visual piety can be profitably introduced, and the inquiry moved from the etic to the emic.

Like icons, the lectionary miniature has prominent *nomina sacra*, the abbreviated names of Jesus Christ, inscribed on either side of his head. Sacred names

become obligatory in iconic images from the ninth and the tenth centuries and have been credited to the debates over the legitimacy of religious images during the Iconoclastic controversy that ended in the mid-ninth century.[27] A label on someone who needs no identification does not have the same referential value as a caption beneath a photograph. Literate and illiterate alike would have recognized the meaning of letters *IC XC*, because they are inseparable from an image of Jesus Christ. Both signify visually.

Nomina sacra legitimated and sanctified the image. As the Acts of the Seventh Ecumenical Council (787) declared,

> many of the sacred things which we have at our disposal do not need a prayer of sanctification, since their name itself says that they are all-sacred and full of grace In the same way, when we signify an icon with a name, we transfer the honor to the prototype; and by embracing it and offering to it the veneration of honor, we share in the sanctification.[28]

Performative and referential, sacred names act, as well as represent, an inheritance of the magical force of prior sacred languages.[29] For this reason, the inscription *XC* positioned above the book on the lectern describes and sanctifies, as much as the Gospel passage inscribed on the book.

The icon offered immediate reference to the divine, as expressed most succinctly by St Basil: 'the honour shown to the image is transmitted to its model.'[30] That veneration extended beyond looking at the icon and included kissing and touching, or, if the panel was small, holding it in one's hands. This beholding created a spiritual relationship, a bond facilitated by dialogic texts that accompany icons[31] and by the widespread acceptance of the extramission theory of vision: that to see something was to touch it by means of optical rays emitted by the eye.[32] Seeing, especially devotionally, was another form of touching, an engaged, empathetic seeing, a looking with.

The meanings of all icons are completed in the space and the person of the pious beholder; hence the importance of what Otto Demus called 'the icon in space', images that envelope the beholder in the visual dramaturgy on the walls of the church and enfold all into the sacred drama and dogma.[33] In an illuminated manuscript, those spatial effects are more intimate. Every illuminated opening in the manuscript is potentially a devotional diptych. In the case of the lection for 1 September the verso miniature of Christ reading in the Florence lectionary communicates with and defines the text that Christ read and the lector reads on the facing recto. As Christ touches the text in the miniature and points to the word 'me', the lector touched the book with his hands and with his eyes and voiced that 'me'. The spatial icon merges text, image and reading and thereby creates a powerful mandate and obligation for the lector on 1 September.[34]

RITUAL

The ritual programme for this day, the *taxis*, is known from two sources: the tenth-century Typikon of the Great Church, that is, Hagia Sophia, and an entry at the end of the Florence lectionary that was probably added later in the twelfth century.[35] The two texts agree in most but not all details. Chronologically, they bracket the creation of the late eleventh-century miniature and define a context of use. The Typikon, the simpler and shorter of the two texts, establishes the basic

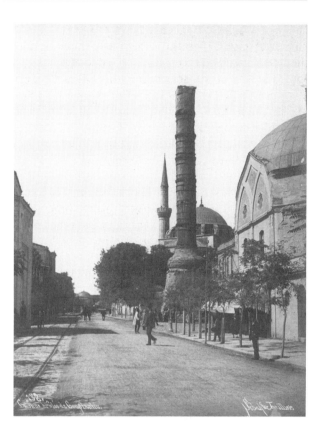

3.5 Sébah & Joaillier, *Divan Yolu and the Column of Constantine*, late-nineteenth century. Private Collection.

sequence of rites.[36] During the evening service before the first day of the year, the liturgy began in Hagia Sophia with the patriarch present, then moved to the nearby church of St Mary Chalkoprateia, and, as the sun was setting, concluded back at the Great Church with the reading of the life of St Symeon Stylites. After matins the next morning, the patriarch descended to Hagia Sophia from his nearby apartments, entered by a lateral door, and performed various liturgical rites. The choir sang from the ambo and continued to chant as they joined the patriarch, other clergy and the congregation in processing from Hagia Sophia to the Forum of Constantine, a distance of about a half a kilometre.

The assembled would process through the colonnaded Mese, the principal ceremonial avenue of Constantinople, to the circular Forum, a public space bounded by porticoes and decorated with an array of ancient sculpture. At its centre stood a porphyry column, surmounted until the early twelfth century by a statue of Constantine the Great (plate 3.5). The relics from the life of Christ, placed at or beneath the column, further enhanced its prestige.[37] The column still stands, though damaged by fire. Because a trolley line presently runs down the middle of the Ottoman equivalent of the Mese, the column is better viewed from a late nineteenth-century photograph that gives some sense of how the column would have appeared – less the mosque and minaret – to a procession approaching from Hagia Sophia. The column's pedestal has been altered, and its lower parts obscured by the rise of approximately 2.5 m in the level of the city.

23

Originally its seven porphyry drums and the marble pedestal rested on a stepped base that opened to a plinth at the top broad enough for a small chapel on one side dedicated to St Constantine (plate 3.6).[38]

In medieval Constantinople, religious processions were frequently seen on the streets of the city, and many passed through the Forum of Constantine.[39] When those walking from Hagia Sophia on 1 September reached the Forum, they heard psalms 1, 2, and 64 intoned. After the third psalm, the Patriarch pronounced 'the usual prayers' that are unspecified in the Typikon. Then followed the Epistle lection, Colossians 3:12–16, that urged the faithful to lead a pious life:

> Brothers, Put on then, as God's chosen ones, holy and beloved, compassion, kindness, lowliness, meekness, and patience, for bearing one another and, if one has a complaint against another, forgiving each other; as the Lord has forgiven you, so you also must forgive. And above all these put on love, which binds everything together in perfect harmony. And let the peace of Christ rule in your hearts, to which indeed you were called in the one body. And be thankful. Let the world of Christ dwell in you richly, as you teach and admonish one another in all wisdom, and as you sing psalms and hymns and spiritual songs with thankfulness in your hearts to God.

The Gospel lection from Luke (4:16–22a) followed. Afterwards the procession moved to the church of St Mary Chalkoprateia for more readings and returned to Hagia Sophia for the liturgy and the recitation of the same Gospel lection once again.

The *taxis* in the Florence lectionary matches one found in a manuscript in Kiev that was first published by Dimitrievskii and again by Mateos.[40] Neither knew of its existence in the Florence lectionary. The Kiev manuscript has a longer, more descriptive title; the Florence version is simpler: 'the order (*taxis*) that takes place on September 1 in the Forum'. It adds that a similar procession occurs on the birthday of the city, 1 May. That date is an error. The scribe probably dropped a digit, as Constantinople celebrated its founding on 11 May. The Kiev manuscript describes only the rites at Hagia Sophia and the Forum; the Florence lectionary follows the procession to the Chalkoprateia and Hagia Sophia, as described in the tenth-century Typikon.

3.6 Reconstruction of base of Column of Constantine (after Cyril Mango).

The basic outline of the rites in the two manuscripts follows the practices already established in the tenth century. After matins, the Patriarch, choir and congregation process to the Forum of Constantine. There the same three psalms are chanted, but not in their entirety. More details are supplied in the manuscripts. The order highlights certain verses and intersperses refrains. For Psalm 1, the refrain is 'Save me, Lord.' It follows the first verse, 'Blessed is the man who has not walked in the counsel of the ungodly.' (Psalm 1:1a) For those walking to the Forum, the passage would have constituted a gloss on the procession they had just undertaken. The second verse recited is usually translated 'and in the way of sinners' (Psalm 1:1b). However, the Greek word for 'way' (ὁδῷ) has both a metaphorical and a literal meaning, thus way and road, so that this verse can also be read phenomenologically. The next two verses express the same duality: 'For the Lord knows the way of the righteous' (Psalm 1:6a) and 'But the way of the ungodly shall perish.' (Psalm 1:6b)

The verses selected from Psalm 2 would have resonated with the political context of their performance, a site where military triumphs were staged before the emperor and court[41] and a public space dominated by the Column and Chapel of Constantine the Great. The refrain of Alleluia separated the following verses:

> 'Wherefore did the heathen rage, and the nations imagine vain things?' (Ps 2:1); 'The kings of the earth stood up, and the rulers gathered themselves together' (Psalm 2:2); 'Serve the Lord with fear' (Ps 2:11); and 'Blessed are all who trust in him' (Psalm 2:12b).

Of the verses from the concluding Psalm 64, the one most relevant for the occasion is the last: 'You will bless the crown of the year' (Psalm 64:5a). Read on 1 September, it offers the promise or the hope that God will bless the year to come.

After the conclusion of the three psalms, the Patriarch came forward. He likely spoke from the top of the steps of the platform surrounding the porphyry column, for it afforded a view over the Forum. The emperor stood there on other occasions.[42] Pronouncing those 'usual prayers', now identified in the Florence and Kiev manuscripts, the patriarch prayed for the Church, the 'very pious emperors, for their court and their army, and for the people who love Christ', and for 'our city', Constantinople, and all cities and the country. Once more the words would have had special significance for the elite of Constantinople gathered in this space. After the patriarch blessed the people three times, someone, presumably the deacon, read the epistle lection from another manuscript brought to the Forum.

In the Kiev-Florence *taxis*, the Epistle changes to I Timothy (2:1–7), which has a different character to that of the passage from Colossians quoted above. I Timothy acknowledges those 'in high positions', validates the author/reader, and introduces the theme of mission that will be continued in the Gospel lection that is emphasized in the Florence manuscript:

> First of all, then, I urge that supplications, prayers, intercessions, and thanksgiving be made for all men, for kings and all who are in high positions, that we may lead a quiet and peaceable life, godly and respectful in every way. This is good, and it is acceptable in the sight of God our Saviour, who desires all men to be saved and to come to the knowledge of the truth. For there is one God, and there is one mediator between God and men, the man Christ Jesus, who gave himself as a ransom for all, the testimony to which was borne at the proper time. For this I was appointed a preacher and apostle (I am telling the truth, I am not lying), a teacher of the Gentiles in faith and truth.

After a few more verses from psalms the deacon said, 'Wisdom' and the archdeacon commanded, 'Listen standing to the holy Gospel according to Luke.' Once the people had become calm, the patriarch blessed them three times, intoned 'Peace to you', and began the lection (Luke 4:16–22a). As the Patriarch read, a deacon repeated after him in a loud voice, suggesting the presence of a large assembly crowded into the Forum. As noted above, the same procedure of the Patriarch reading and the deacon repeating was followed on Easter Sunday at Hagia Sophia.

At the moment of its performance, the reading of the lection by the Patriarch was both public and private, or at least more intimate. The Patriarch assumed the voice of Jesus upon whom the Spirit of the Lord had fallen, and like Jesus in the synagogue, he addressed the assembly. There the correspondence ends, however, because the Patriarch was not Jesus, and his audience was not as attentive as that described in the Gospel of Luke. If they had been, it would not have been necessary a few minutes earlier to quiet the crowd before the Patriarch began to read. Most people gathered in the Forum followed the reading indirectly, as amplified by the deacon. Only the higher clergy gathered around the Patriarch heard him directly. That group presumably included bishops wearing omophoria, similar to the leaders of the congregation in the Florence miniature. Some clerics would have stood on the lower steps of the column base, as did the lesser-ranking members of the imperial court when the emperor occupied the upper platform.[43]

Rituals such as these are a special form of communication, and as Edmund Leach has noted,[44] their senders and receivers are often the same people, who say things to and for themselves. At the top of the ecclesiastical hierarchy, symbolically and physically, and the centre of the ceremony at the Forum on 1 September was only one person, the Patriarch of Constantinople, and as he began to read, he looked at the miniature in this manuscript most likely made for his cathedral. The icon he saw identified the original speaker of these words as Jesus, the anointed one, the Messiah, and at the same time recast the event as a medieval liturgy for the benefit of the patriarch and clergy. Powerfully legitimating at the moment of performance, the miniature would have continued to bear these meanings for those who saw the miniature during the late eleventh century. Those privileged enough to have access to the manuscript in the Patriarchal library or the treasury of Hagia Sophia would also have likely been present at the ceremonies for 1 September and have remembered the Patriarch's role. Someone from that community in the next century added the *taxis* for this day to the end of the Florence lectionary, thus recording a ritual use that had existed since at least the tenth century.

This and other miniatures of the period served as models of and models for performance and subjectivity. At the Forum, the Patriarch read from the manuscript now in Florence and looked at an image whose iconic simplicity made it an object of veneration and a means for projection and identification. Opening and displaying the Florence lectionary on 1 September in the Forum of Constantine was part of a great public spectacle in medieval Constantinople, but it also constituted a private encounter between the Patriarch and his manuscript. At that moment, looking with was a performative act.

Notes

I am grateful for the editorial suggestions of the editors and for the careful reading of the liturgical and religious aspects of this chapter by Fr Robert Taft and and my colleague Christopher Beeley.

1 On the concept of the performative and further literature, see Robert S. Nelson, *Hagia Sophia, 1850–1950: Holy Wisdom Modern Monument*, Chicago, 2004, 5, n. 17. In the present essay, the word performative refers to the linguistical and philosophical concept, developed by J. L. Austin, *How to do things with words*, Cambridge, MA, 1975, and extended to ritual studies, especially by Stanley Jeyaraja Tambiah, 'A performative approach to ritual', in his *Culture, Thought, and Social Action: An Anthropological Perspective*, Cambridge, MA, 1985, 123–66. As such, performative in the present essay differs from the more informal sense as an adjective from performance that is used in Bissera V. Pentcheva, 'The Performative Icon', *Art Bulletin*, 88 2006, 631–55.

2 E.M. Melas, 'Etics, Emics, and Empathy in Archaeological Theory', Ian Hodder, ed., *The Meanings of Things: Material Culture and Symbolic Expression*, London, 1989, 137–55. I thank my colleague Milette Gaifman for this reference.

3 Erwin Panofsky, 'Iconography and Iconology: An Introduction to the Study of Renaissance Art', in *Meaning in the Visual Arts*, Garden City, NY, 1955, 26–8.

4 Elizabeth Sears and Thelma K. Thomas, *Reading Medieval Images: The Art Historian and the Object*, Ann Arbor, 2002.

5 John Frow, 'A pebble, a camera, a man who turns into a telegraph pole', *Critical Inquiry*, 28, 2001, 279.

6 Clifford Geertz, 'Religion as a Cultural System', in *The Interpretation of Cultures: Selected Essays*, New York, 1973, 93.

7 Hence, the book of Alfred Gell, *Art and Agency: An Anthropological Theory*, New York, 1998.

8 'Display, v.', *Oxford English Dictionary*, http://www.oxfordreference.com/views/BOOK_SEARCH.html?book=t140&authstatuscode=202, accessed 11 December 2006.

9 As I have discussed once before: Robert S. Nelson, 'The Discourse of Icons, Then and Now', *Art History*, 12:2, 1989, 145.

10 Austin, *How to do things with words*, 5–7. I am not considering here the many ways in which museum displays can be performative, a theme that is at the heart of Carol Duncan, *Civilizing Rituals: Inside Public Art Museums*, New York, 1995.

11 Less useful for the medieval contexts of this essay is the work of Guy Debord, who has used display and spectacle to refer to production and consumption in capitalist and post-capitalistic systems: Guy Debord, *The Society of the Spectacle*, New York, 1995. See also the introduction by Peter Wollen to Lynne Cooke and Peter Wollen, *Visual Display: Culture Beyond Appearances*, Seattle, 1995, 9–13.

12 According to the *Oxford English Dictionary*, 'empathy' is the translation of the German 'Einfühlung' and is first attested at the beginning of the twentieth century. *Oxford English Dictionary*, on-line edition. On the German context and the formative role of Robert Vischer, see the introduction by Harry Francis Mallgrave and Eleftherios Ilonomou to *Empathy, Form, and Space: Problems in German Aesthetics, 1873–1893*, Santa Monica, 1994, 17–29.

13 Juliet Koss, 'On the Limits of Empathy', *Art Bulletin*, 88, 2006, 139–57.

14 Most recently on the manuscript, see Robert S. Nelson, in Helen C. Evans, ed., *Byzantium: Faith and Power (1261–1557)*, New Haven and London, 2004, 542–3.

15 On illustrated Byzantine lectionaries in general, see Jeffrey C. Anderson, *The New York Cruciform Lectionary*, University Park, 1992, 1–12; Mary-Lyon Dolezal, 'Illuminating the liturgical word: Text and image in a decorated lectionary (Mt. Athos, Dionysiou Monastery, cod. 587)', *Word & Image*, 12, 1996, 23–60. Dr Dolezal's dissertation ('The Middle Byzantine lectionary: Textual and Pictorial Expression of Liturgical Ritual', University of Chicago, 1991) is particularly informative about lectionaries of the later eleventh century and is available on-line at http://proquest.umi.com/pqdweb?index=0&did=743820041&SrchMode=1&sid=2&Fmt=1&VInst=PROD&VType=PQD&RQT=309&VName=PQD&TS=1176247955&clientId=13766, accessed 5 December 2006. More generally on the Greek lectionary, see the bibliography cited in Robert F. Taft, *The Byzantine rite: A short history*, Collegeville, Minn., 1992, 49–51, n. 17.

16 A. V. Zacharova, 'Греческое Евангелие-апракос из Государственного исторического музея. История, кодиколгия, текст и декоративное оформление', *Художественное наследие*, 20 (50), 2003, 7–19. I thank Dr Zacharova for kindly bringing her study to my attention.

17 *The Oxford Dictionary of Byzantium*, New York, 1991, 1526.

18 Ἀπέσταλκέ με.

19 Kurt Aland et al., *The Greek New Testament*, Stuttgart, 1975, 217, with references to the punctuation in other editions.

20 Dolezal, 'Illuminating the liturgical word', fig. 14.

21 Kurt Weitzmann, 'The Constantinopolitan lectionary, Morgan 639', in Dorothy E. Miner, ed., *Studies in Art and Literature for Belle Da Costa Greene*, Princeton, 1954, 368–9. See also the catalogue

entries in Gary Vikan, ed., *Illuminated Greek Manuscripts from American Collections: An Exhibition in Honor of Kurt Weitzmann*, Princeton, 1973, 118–20; and Helen C. Evans and William D. Wixom, eds, *The Glory of Byzantium: Art and Culture of the Middle Byzantine Era, A.D. 843–1261*, New York, 1997, 105–107.

22 Juan Mateos, *La célébration de la parole dans la liturgie byzantine: étude historique*, 143; Mateos, *Le Typicon de la Grande Église. Ms. Sainte-Croix no. 40, Xe siècle*, vol. 2, 94–7.

23 Henri Omont, *Miniatures des plus anciens manuscrits grecs de la Bibliothèque nationale du VIe au XIVe siècle*, Paris, 1929, pl. XCVIII,3.

24 Henri Omont, *Évangiles avec peintures byzantines du XIe siècle*, Paris, 1908, pl. 101.

25 Anna Marava-Chatzinicolaou and Christina Toufexi-Paschou, *Catalogue of the Illuminated Byzantine Manuscripts of the National Library of Greece*, vol. 1, Athens, 1978, 139–49.

26 Robert S. Nelson and Kristen M. Collins, eds, *Icons from Sinai: Holy Image, Hallowed Ground*, Los Angeles, 2006, 136.

27 Karen Boston, 'The Power of inscriptions and the trouble with texts', in Antony Eastmond and Liz James, eds, *Icon and Word: The Power of Images in Byzantium. Studies presented to Robin Cormack*, Burlington, VT, 2003, 35–57; Robert S. Nelson, 'Image and Inscription: Pleas for Salvation in Spaces of Devotion', in Elizabeth James, ed., *Art and Text in Byzantine Culture*, Cambridge, forthcoming.

28 Joannes Dominicus Mansi, *Sacrorum conciliorum nova et amplissima collectio*, 15, Graz, 1960, col. 269; *Icon and logos: Sources in eighth-century iconoclasm*, trans. Daniel J. Sahas, Toronto, 1986, 99; Boston, 'Power of inscriptions', 43–4.

29 Naomi Janowitz, *Icons of Power: Ritual Practices in Late Antiquity*, University Park, 2002, xx, 23–4; David Frankfurter, 'The Magic of Writing and the Writing of Magic', *Helios*, 21 1994, 211.

30 Cyril Mango, *The Art of the Byzantine Empire, 312–1453: Sources and Documents*, Englewood Cliffs, NJ, 1972, 47, 169.

31 Nelson, 'Discourse of icons', 147–8.

32 Robert S. Nelson, 'To Say and to See: Ekphrasis and Vision in Byzantium', *Visuality Before and Beyond the Renaissance: Seeing as Others Saw*, New York, 2000, 143–68.

33 Otto Demus, *Byzantine Mosaic Decoration: Aspects of Monumental Art in Byzantium*, Boston, 1955, 13–14.

34 The Lukan passage remains important. As this essay was being written Katherine Jefferts Schori was invested as the presiding bishop of the Episcopal Church in America, the first woman to lead an Anglican province as chief bishop. The text from Luke and its quotation from Isaiah were the basis of her homily that day.

35 The black ink of the note contrasts with the gold of the main text. The note is written in a less exalted style than the formalized, ceremonial hand of the lectionary proper. Scribes did employ different writing styles and might use a more ordinary script for commentaries and liturgical tables, so that that the entry could be contemporary with the main text. Yet, on balance, it is more likely written somewhat later.

36 Mateos, *Typicon de la grande église*, vol. 1, 2–11.

37 On the Forum of Constantine, see Wolfgang Müller-Wiener, *Bildlexikon zur Topographie Istanbuls: Byzantion, Konstantinupolis, Istanbul bis zum Beginn des 17. Jahrhunderts*, Tübingen, 1977, 255–7. On its sculpture and relics, see Sarah Bassett, *The Urban Image of Late Antique Constantinople*, New York, 2004, 188–208.

38 Cyril Mango, 'Constantine's Porphyry Column and the Chapel of St. Constantine', *Deltion tes Christianikes Archaiologike Hetaireias*, ser. 4, vol. 10, 1980–81, 107–108.

39 The Forum of Constantine, according to the Typikon of the Great Church, figured in liturgical processions on fifty days of the year: Mateos, *Typicon de la grande église*, vol. 2, 273. On religious holidays and processions generally, see James C. Skedros, 'Shrines, Festivals, and the "undistinguished mob"', in Derek Krueger, *Byzantine Christianity*, Minneapolis, 2006, 81–3.

40 Aleksej Dimitrievskij, *Opisanie liturgitseskich rukopisej*, 1, reprinted Hildesheim, 1965, 152–4; Mateos, *Typicon de la grande église*, vol. 2, 200–203. The fundamental study of stational liturgy in Constantinople is John F. Baldovin, *The Urban Character of Christian Worship: The Origins, Development, and Meaning of Stational Liturgy*, Rome, 1987, 205–226. See now also Robert F. Taft, *Through their Own Eyes: Liturgy as the Byzantines saw it*, Berkeley, 2006, 30–60.

41 See especially the description of the ritual subjugation of an Arab emir, as described in Michael McCormick, *Eternal Victory: Triumphal Rulership in Late Antiquity, Byzantium, and the Early Medieval West*, New York, 1986, 161–5.

42 Mango, 'Constantine's Porphyry Column', 105.

43 Mango, 'Constantine's Porphyry Column', 105.

44 Edmund Leach, *Culture and Communication: The Logic by which Symbols are Connected*, Cambridge, 1976, 43. The bibliography on ritual is vast, and most work, like this essay, consists of case studies, as, for example, the informative, recent volume edited by Nicolas Howe, *Ceremonial Culture in Pre-modern Europe*, Notre Dame, Ind., 2007.

4

A FACELESS SOCIETY? PORTRAITURE
AND THE POLITICS OF DISPLAY
IN EIGHTEENTH-CENTURY ROME

SABRINA NORLANDER ELIASSON

In 1781 John Moore (plate 4.1) wrote in his influential travel book *A View of Society and Manners in Italy:*

> With countenances so favourable for the pencil, you will naturally imagine that portrait painting is in the highest perfection here. The reverse, however, of this is true; that branch of the arts is in the lowest estimation all over Italy [...] the Italians very seldom take the trouble of sitting for their pictures. They consider a portrait as a piece of painting which engages the admiration of nobody but the person it represents or the painter who drew it. Those who are in the circumstances to pay the best artists, generally employ them in some subject more universally interesting, than the representation of human countenances staring out of a piece of canvas.[1]

In a period in which the portrait market expanded heavily in most parts of Europe, Moore's observation is worthy of further discussion. Specifically, there is a need to acknowledge a discrepancy between the scholarly field of eighteenth-century portraiture and its social function. For instance, the expanding field of study on eighteenth-century Rome still lacks extensive contributions on portraiture and its various functions.[2] By contrast, portrait production in Britain presents a strong and multifaceted tradition and has been well documented by such texts as Marcia Pointon's *Hanging the Head. Portraiture and Social Formation in Eighteenth-Century England* and recently Kate Retford's *The Art of Domestic Life.* Both books have demonstrated the fruitful results which can arise from an interdisciplinary approach.[3] For scholars of portraiture operating in other European areas, such an approach remains of utmost importance. Yet it is necessary to stress that in terms of social display the role of portraiture varied across Europe according to the specific characteristics of the elite groups who chose visually to manifest their status and position. John Moore's astonished reaction to an Italian disinterest in the genre of portraiture must therefore be seen in the light of his own national identity and his position as a tourist. He experienced Italy and eventually Rome in relation to a specific travellers' discourse in which the dichotomy of foreign/familiar was crucial to his impressions.[4] His remarks on the lack of portraiture in the homes of the Roman elite is

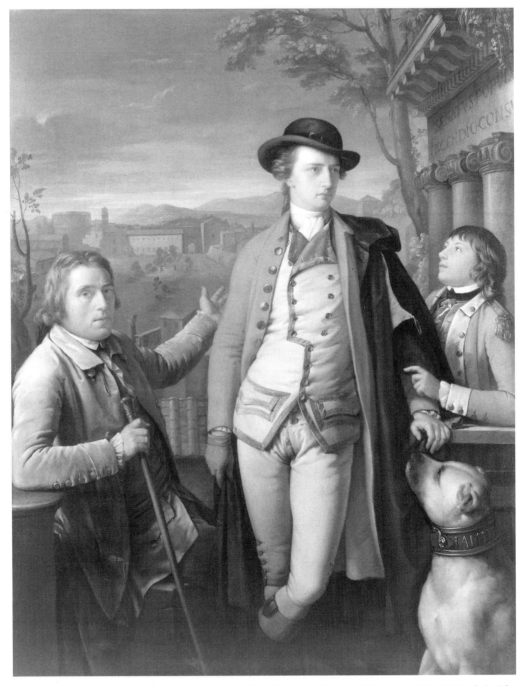

4.1 Gavin Hamilton, *Douglas Hamilton, 8th Duke of Hamilton and 5th Duke of Brandon, 1756–1799 (with Dr John Moore, 1730–1802, and Sir John Moore, 1761–1809, as a young boy)*, 1775–77. Oil on canvas, 178 × 101.5 cm. Edinburgh: Scottish National Portrait Gallery.

coloured by the British vogue for the genre and its importance within the process of social legitimacy for the British elite.[5] As Moore also reflected, 'in palaces, the best furnished with pictures, you seldom see a portrait of the proprietor, or any of his family. A one-quarter length of the reigning Pope is sometimes the only portrait of a living person to be seen in a whole palace.'[6]

This comment not only suggests that Moore was apt to find similarities between the socio-cultural practices of the elite of his own country and that of Rome. His observations also indicate a specific approach to the genre, namely its function as a social tool with the aim of presenting a family's history, its connections and status within a specific context of importance to the family in question. In this particular case, Moore leaves out the aesthetic potentials of the genre. As will be shown here, this was clearly not because he found those aspects of portraiture unimportant. On the contrary, he most probably conceived the genre's duplicate roles and possibilities as both aesthetic and social objects.[7]

THE POLITICS OF SOCIAL DISPLAY IN EARLY MODERN ROME

Before examining the reliability of Moore's observations, it is necessary to look more closely at the precise characteristics of social display in eighteenth-century Rome. But first, it is important to acknowledge those characteristics that separate this particular elite from others, both within and outside Italy. The political division of Italy had created different conditions that made a homogeneous elite culture impossible.[8] The papal state was modelled as a monarchy, but without the necessary element of continuity and succession.[9] This paradox was reinforced by a court culture dominated by males and structured on the concept of celibacy, which resulted in a precarious arena where political and social power was inevitably transitory.[10] This lack of a prime succession meant that portraiture could not be used to display the continuity of one single dynasty. As John Moore observed:

> Several of the Roman princes affect to have a room of state, or audience chamber, in which is raised a seat like a throne, with a canopy over it. In those rooms the effigies of the Pontiffs are hung: they are the work of very inferior artists, and seldom cost above three or four sequins: as soon as his Holiness departs this life, the portrait disappears, and the face of his successor is in due time hung up in its stead. This, you will say, is treating their old sovereign a little unkindly, and paying no very expensive compliment to the new [...].[11]

From the sixteenth century onwards, a career in the Church had been the way to secure social status for ambitious families of non-Roman origin. Through the Church they could compete with the feudal nobility, established in the city during the high Middle Ages and the owners of extensive land.[12] Families who could claim a social rank through the ecclesiastical careers of one or more male members felt secure within the hierarchy, since changing power would only partly shift their position. As part of the papal elite, they would obtain social respect from their ecclesiastical past.[13]

The tight and precarious relationship between the Church and the elite resulted in a specific and ongoing process of displaying social status. From the sixteenth through to the eighteenth centuries, the Roman elite used architectural enterprises both within the city and in the immediate countryside in order to

establish social control. Extensive art collections contributed to the display of wealth, culture and good taste.[14] Collections of antiquities were of particular importance here since the ownership of such an ancient material culture linked the grandeur of Rome's past with the contemporary elite. More specifically, the use of ancient culture and most especially the spectacle of the triumph established a connection between the ceremonials of the papal court and those of the Roman Republic.[15] The notion of a dominant Christian Rome built on pagan grounds was an important part of this discourse. The Roman elite manifested themselves as integrated parts of this process by means of a range of ceremonies and literary exultations.[16] Poems and prose in honour of Roman family members were skilfully balanced between the necessary element of individual biography and a more general elite mythology that involved fictive ancient genealogies that suggested the families' right to occupy the highest positions in Rome.[17]

How did portraiture feature within this socio-cultural practice? Firstly, we need to look at the frequency of the genre within Roman art collections, and secondly, we need to examine how portraiture was displayed within the urban palaces. As Patricia Waddy has shown, these complex buildings had strict rules regarding space status and accessibility, which affected the viewing of art.[18] Equally, these buildings were only partly regarded as family homes since they were regularly open to art students and tourists equipped with suitable letters of recommendation.[19] John Moore's observations on the faceless palaces should therefore be considered in relation to the actual access that he, being a British tourist, was allowed. According to his accounts, he evidently gained access to the more official parts of the palaces, such as the apartment on the *piano nobile* of the palace, a space used for art installation as well as for social gatherings.[20]

Examinations of palace inventories have shown that a portrait would generally gain a prominent display place if it were considered good art, regardless of the sitter's identity. According to the inventories of the *appartamento nobile* in Palazzo Doria Pamphilj in 1747–50, there were, with only two exceptions, no portrait displays in the apartment. The first room where portraits appeared was the throne room, where the portrait of the reigning pope was hung.[21] In the prince's audience chamber, separate from the throne room, portraits by canonical masters such as Titian and Anthony Van Dyck appeared with no reference to the sitters' identities.[22] This lack of information is important, since it shows that this particular hanging aimed at a display which represented portraiture as an art genre in a categorical sense rather than a rhetorical tool of dynastic continuity and prestige. This suggestion is reinforced when one compares this document to a later inventory dating from 1762–64.[23] Here it is stressed that the name of the former audience chamber was changed to *stanza de ritratti* or 'the portrait room', thus differentiating it from those other interiors where the family art collection was displayed according to genre. Portraits by Pietro Perugino, Angelo Bronzino, Titian and Peter Paul Rubens are highlighted in this document without any references to family sitters. The present keeper of the Doria Pamphilj collection, Andrea De Marchi, has rightly suggested that these portraits should be seen more as acquisitions in order to complete the collection as a whole rather than possible family portraits.[24] This suggestion reinforces the documentary evidence that excluded the social function of family portraiture from the rooms of the *piano nobile*.

The absence of family portraits in the most official part of the palace is crucial, but it does not exclude the possibility that portraits were present in less official parts. Inventories taken from the apartment of Teresa del Grillo Pamphilj (1676–?) during her widowhood show a high frequency of portraits of female sitters as well as portraits of popes and cardinals.[25] The apartment of the illustrious cardinal Benedetto Pamphilj (1653–1739) appears, on the contrary, sparser in its portrait collection, and the criteria were decisively to display paintings that connected to the inhabitant's own position as a high prelate.[26] The cardinal, who was an important patron of art and music, kept four portraits of popes in the first *anticamera* of his apartment, which probably demonstrated an important connection between him and the sitters.[27] The male theme continued in the sixth room of the suite, with more papal portraits and paintings of unidentified male sitters regarded by the notary as 'antichi', which presumably meant that the paintings were old and did not show contemporary sitters.[28] In a small studio next to the library, the cardinal had a rich and varied hanging of art works, among which portraits were present.[29] This display repeated the pattern chosen for the grand interiors of the *piano nobile*, with still-life paintings, landscapes, portraits and drawings hung according to category.[30]

The Doria Pamphilj inventories show a separation between the palace's prominent space and family portraiture. Nevertheless, these documents also show that the presence of portraiture was neither obvious nor neglected. Yet it seems clear that there was a strong disregard for the genre's social potential in favour of a desired artistic quality. Quality thus decided whether the painting was to be publicly displayed or kept isolated in less visited parts of the palace.

AN EIGHTEENTH-CENTURY PORTRAIT GALLERY IN PALAZZO BARBERINI

In the 1770s a small portrait gallery was commissioned in Palazzo Barberini. Considering the role of the portrait in the Roman palazzo as so far described, this particular interior occupies a somewhat paradoxical position in eighteenth-century Roman art history. The carefully set portrait display shows a social use of the genre more common to the British eighteenth-century context than to that of the papal city. There were several processes which led to the interior's completion, but as shall be shown below, they all related to the complex culture of social display adhered to by the Roman elite.

At the time of the room's conception, the Barberini family was experiencing a long-term internal conflict in which inheritance and prestige were crucial components. The Barberini family had acquired its social status in Rome in the early seventeenth century. The social rise of this Tuscan family was due to one of its members' serious engagement in political and humanistic matters. The ecclesiastical fortune of the cardinal Maffeo Barberini led to his election as Pope on 6 August 1623. The nepotistic culture of Urban VIII would eventually lead to the elevation as cardinals of two of his nephews, Antonio (1608–1671) and Francesco (1597–1679), sons of the Pope's brother Carlo (1562–1630), duke of Monterotondo, and his Florentine consort Costanza Magalotti (1575–1644). Taddeo (1603–1647), remaining son of Carlo and Costanza, was destined to be the head of the secular branch of the family and, due to his strategic marriage in 1627 to a daughter of the feudal nobility,

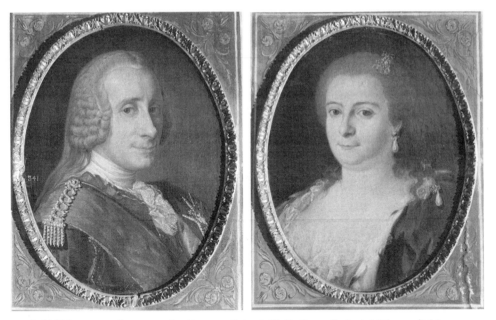

4.2 (left) Unknown artist, copy after Pompeo Batoni, *Giulio Cesare Barberini Colonna di Sciarra*, 1760s. Oil on canvas, 51.5 × 40 cm. Rome: Galleria nazionale d'arte antica, Palazzo Barberini. Photo: Archivio fotografico soprintendenza speciale per il Polo museale romano.

4.3 (right) Unknown artist, *Cornelia Costanza Barberini Colonna di Sciarra*, 1760s. Oil on canvas, 51.5 × 40 cm. Rome: Galleria nazionale d'arte antica, Palazzo Barberini. Photo: Archivio fotografico soprintendenza speciale per il Polo museale Romano.

Anna Colonna (1658-?), the Barberini's position in Rome was well secured.[31]

At the beginning of the eighteenth century, the prominent position of the family was threatened. In 1722 Urbano Barberini, fifth prince of Palestrina, died. The legitimate heir to the family name and patrimony was his six-year-old daughter Cornelia Costanza (1716–1797), born from his third marriage to Maria Teresa Boncompagni (1692–1744).[32] The low birth rate that had afflicted many aristocratic groups in eighteenth-century Europe led to the endings of several family lines. In order to save the dynasties, an intricate system of adoptions and strategic marriages was introduced.[33] This system not only helped in preserving a name, it equally helped in preserving those patrimonies involving collected art works that were so important to the visual manifestation of social status.[34] For the Barberini family the situation was precarious. The heiress's uncle, Cardinal Francesco (1662–1738), headed the long and complex process that would eventually lead to Cornelia Costanza's marriage.[35] The final candidate, Giulio Cesare Colonna di Sciarra, prince of Carbognano (1705–1787), had to accept the firm conditions, sanctioned by Benedict XIII and based on the prime inheritance of the family established by Urban VIII (Plates 4. 2 and 4.3).[36] Giulio Cesare would add the name Barberini to his own and accept that only the second-born son would inherit the name and patrimony of the Colonna di Sciarra family. As compensation he would benefit, as would his consort, from the Barberini prime inheritance. The marriage was eventually celebrated in 1728.

A NEW APARTMENT

One significant way to establish social status in Rome was through the commissioning of a family palace. Palazzo Barberini had been constructed in the years 1625–33 according to the plans of Carlo Maderno and Gian Lorenzo Bernini.[37] Its elegant villa-like front had two adjacent wings, one planned for the secular branch of the family, the other housing the ecclesiastical members. This organization of the family household remained intact during the course of the seventeenth century. Yet the marriage in 1728 of Cornelia Costanza Barberini and Giulio Cesare Colonna di Sciarra resulted in an alteration of the distribution of domestic space, and the second floor of the south wing was subjected to a complete refurnishing for the young couple.

Today's museum visitor to the Galleria nazionale d'arte antica situated in Palazzo Barberini may explore sections of the apartment that Cardinal Francesco Barberini commissioned for his young *nipoti*. The history of this suite of rooms is complex and can only partially be reconstructed because of a gap in the Barberini accounts regarding the middle part of the eighteenth century.[38] It is clear, however, that the building works were lengthy and did not end until the 1770s.[39] The sequence of interiors (plate 4.4) is composed of a dining room (A), a cabinet with marine motifs (B), a small gallery (C), a drawing room (D), a bedchamber (E), a combined drawing room and chapel (F) and finally a large salon (G). The portrait gallery (H) was not a part of this particular sequence of rooms nor is it today accessible to the public. The interior faces the western façade of the palace, and it

4.4 Plan of second floor, South wing of Palazzo Barberini. Photo/drawing: Arch. Magnus Stenmark.

4.5 Bedchamber in the eighteenth-century apartment, Palazzo Barberini. Rome: Galleria nazionale d'arte antica, Palazzo Barberini (see 'E' in plate 4.4). Photo: Istituto centrale per il catalogo e la documentazione.

is comprised of a small section of a corridor already present in the seventeenth-century plan. During the eighteenth century, this area contained a number of bedrooms and remained less decorated in comparison to the other rooms. The elegant portrait gallery, with its neoclassical decoration and furnishing, stands out within the preserved documentation.[40]

The complex dynastic situation within the Barberini family, as well as the status assigned to different spaces within the apartment belonging to Cornelia Costanza and Giulio Cesare suggest that the setting of such a portrait gallery be closely examined. But first it is necessary to consider the actual use of the apartment during the decades following the 1728 marriage. Household organization was fluid, and comfort and particular needs determined the distribution of rooms. When the couple had small children and the building works on the second floor were ongoing, it is probable that the family lived elsewhere in the palace. Nevertheless, inventories taken after the death of Giulio Cesare in 1787 and Cornelia Costanza in 1797 clearly show that both husband and wife had come to use the apartment, on the second floor for lengthy periods. All the same, the documents indicate that the couple never lived together in the apartment, yet Donna Cornelia chose to move in after her husband's death.[41] A glimpse into the life of the Barberini household is offered by a letter of 1782 from Donna Cornelia to her eldest son Urbano describing a dramatic scene of lightning striking the

Palazzo. From this account it appears that Cornelia and her husband lived in different apartments and on different floors in the south wing of the palace but as a consequence of the lightning, 'the Prince Your Father', as she writes to Urbano, 'who was in his own apartment', was 'brought down' to his wife's apartment.[42] A somewhat unexpected commentator on this event is Lady Philippina Knight (1726–99) who, in her letters from Italy, described her friendship with the Barberini family and in particular with Giulio Cesare. Her account gives further evidence of the actual inhabitants of the second-floor apartment:

> [...] I believe I have often named to you our good old Prince of Palestrina; he is aged eighty-two and is one of the most worthy men existing. Four months since he received a paralytic stroke which was accompanied by a fever; for three or four days his voice and one leg remained much affected. About three weeks since he felt his stomach somewhat disordered, which was owing to the weather being singularly bad. He is very happy in all his illness to sleep well. He was in a most profound sleep; while his daughter and master of the household were sitting by the bed on which he was laid down they were exceedingly terrified by a violent tempest and went on their knees to prayers, when they saw him entirely covered by fire. A picture which hung at the bed's head and a column of the alcove in which he slept was much damaged. The daughter exclaimed aloud that her father was dead; it waked him. Some time after, attempting to rise, he found his legs and arms very painful and useless to him; the room stank horribly of sulphur and they removed in other apartments [...].[43]

With a natural talent for drama, Lady Knight indicates that Giulio Cesare was the prime inhabitant of the second-floor apartment by mentioning the alcove and columns in the bedchamber where he slept. The room is still open to the public today (plate 4.5; 'E' in plate 4.4).

A FAMILY CONFLICT

Of the six surviving children born to Cornelia Costanza and Giulio Cesare, two were boys (plates 4.6 and 4.7), Urbano (1733–1796) and Carlo (1735–1819). According to the marriage contract, Cornelia Costanza could choose the heir to the Barberini patrimony, which occurred in 1767. Remarkably, the Roman princess chose her second-born son Carlo as principal heir, while Urbano was given the much smaller Colonna di Sciarra inheritance instead.[44] This inverted decision caused a long and difficult quarrel which was to affect family relations for more than a decade. The reason for Cornelia Costanza's choice is somewhat unclear. Initially, she apparently promised the prime inheritance to her first-born, but an unofficial understanding with Carlo evidently led to the opposite result. Officially she would state that Urbano had expressed a wish to pursue an ecclesiastical career, which would have made difficult his candidacy for the entailed estate. These assumptions were in any case unfounded, as Urbano actually married into the Neapolitan nobility and settled far from his parents. The probable reason for the mother's decision was because of her own misgivings. According to the regulations of the prime inheritance, the heir was not allowed to disperse any part of the patrimony. It is true that Cornelia Costanza was not the only member of a Roman elite family guilty of this charge, but it seems probable that she feared that Urbano would reveal her crime.[45] And indeed a year later, in 1768, Urbano

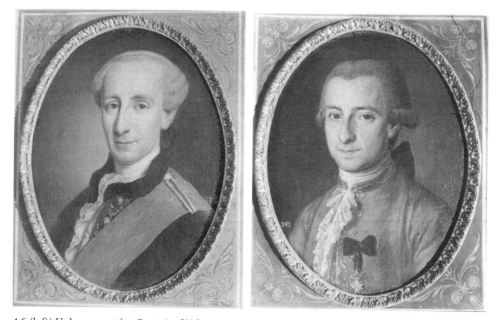

4.6 (left) Unknown artist, *Portrait of Urbano Maria Barberini Colonna di Sciarra*, 1760s. Oil on canvas, 51.5 × 40 cm. Rome: Galleria nazionale d'arte antica, Palazzo Barberini. Photo: Archivio fotografico soprintendenza speciale per il Polo Museale Romano.

4.7 (right) Unknown artist, *Portrait of Carlo Maria Barberini Colonna di Sciarra*, 1760s. Oil on canvas, 51.5 × 40 cm. Rome: Galleria nazionale d'arte antica, Palazzo Barberini. Photo: Archivio fotografico soprintendenza speciale per il Polo museale romano.

pressed charges against his mother at the *Tribunale del Sacro Collegio* in Naples, claiming his rights to the Barberini succession.[46] The complicated process regarding the Barberini patrimony was to continue for years, long after the death of both Cornelia Costanza and Urbano. At first the *Sacra Rota* consented to the reasons claimed by Cornelia Costanza but subsequently the verdict changed in favour of Urbano's heirs. Eventually the patrimony was divided between the two branches of the family.[47]

SOCIAL DISPLAY AND THE STATUS OF SPACE: DIFFERENT APPROACHES WITHIN THE APARTMENT

The marriage between the Barberini and the Colonna families in 1728 had aimed at a preservation of two important names and patrimonies through intricate legislation. The conflict was troublesome and clearly inconvenient. The new apartment on the second floor of Palazzo Barberini constituted a new space in the palace where the union of the two families could display its lineage and consequent legitimacy. How was this done? The question can be answered by comparing the rooms which held specific dynastic programmes, namely the portrait gallery and the *Sala dei Fasti Colonnesi* (the annals or deeds of the Colonna), the most prominent room in the apartment (see plate 4.11). The use of different art genres in these two spaces is important because they exemplify the connection

4.8 (left) Unknown artist, copy after Pompeo Batoni, *Portrait of the Cardinal Prospero Colonna di Sciarra*, 1760s. Oil on canvas, 51.5 × 40 cm. Rome: Galleria nazionale d'arte antica, Palazzo Barberini. Photo: Archivio fotografico soprintendenza speciale per il Polo museale Romano.
4.9 (right) Unknown artist, *Portrait of Maria Artemisia Barberini Colonna di Sciarra*, 1760s. Oil on canvas, 51.5 × 40 cm. Rome: Galleria nazionale d'arte antica, Palazzo Barberini. Photo: Archivio fotografico soprintendenza speciale per il Polo museale Romano.

between portraiture and history painting and the status attributed to each of these genres by the Roman elite.

Although it is impossible to prove through documentary evidence, it is evident from stylistic analysis that the small portrait gallery was decorated during the course of the family conflict from the 1760s onwards. The interior, which shows some influence from the architect Robert Adam, was decorated with carved wooden walls and painted fields framed by grotesque-painted pilaster strips. The colours were light green, pink and blue. Twenty-three similar-sized oval portraits of family members were organized in sections and set into the wall with carved, gilded frames.[48] Several of the paintings are copies of well-known portraits, such as those of the brothers Giulio Cesare (plate 4.2) and the Cardinal Prospero Colonna di Sciarra (plate 4.8), painted by Pompeo Batoni in 1750 and 1768 respectively, and possibly commissioned on the occasion of the room's furnishing.[49] The portraits show members of both the Barberini and the Colonna di Sciarra families yet there is no apparent display criterion that suggests a particular connection between individual sitters. The exception was a bas-relief of Urban VIII which was located above one of the doors, clearly singling out the family's connection with a famous pope.[50] Among the sitters of the new family creation, the children of Cornelia Costanza and Giulio Cesare were all represented, including the portrait of Maria Artemisia (1736-?), who entered the Convent of Santa Caterina of Siena a Magnanapoli (Quirinale, Rome) at the age of

fifteen (plate 4.9). With an image of a seventeenth-century pope together with a college of cardinals, this later eighteenth-century inclusion of the portrait of a young nun indicates the importance placed by each generation of the now-combined families on the existence of an ecclesiastical member.[51]

The gallery also contains an important iconographic source which links the room even further to the family conflict. Twelve grisaille paintings placed in between the upper and lower sections of the walls show detailed scenes of Old Testament themes. These grisaille decorations may have been an attempt to stress continuity with an existing decorative scheme dealing with themes of dynastic prosperity which existed in the north wing of the palace, where ceiling paintings showed Genesis motifs dating from the period when the Sforza family owned part of Palazzo Barberini.[52] In the portrait gallery in the south wing, the prevalent figure of the series is Abraham, a choice of narrative that focused on

4.10 Unknown artist, *The Sacrifice of Isaac*. Oil on panel. Rome: Galleria nazionale d'arte antica, Palazzo Barberini. Photo: Archivio fotografico soprintendenza speciale per il Polo museale Romano.

concepts such as faith, devotion, loss, treason and sacrifice. One of the dramatic scenes depicts the sacrifice of Isaac where Abraham's devotion is tested (plate 4.10). The grisaille shows the decisive moment when the angel prevents the absolute proof of devotion. The motifs together with the portrait series, constitute a narrative of family prosperity, one which would have reinforced the ideal image of the union between the Barberini and Colonna families. At the same time, the family conflict is reflected through the sacrifice theme, which alludes to the family policy of personal feelings being secondary in relation to future benefits for the entire family.

In contrast to the portrait gallery, which was an entirely private room the *Sala dei Fasti Colonnesi* (plate 4.11) constituted the apartment's grandest interior – the one which the eighteenth-century visitor would enter first and where they would most likely be entertained by the family. The room was decorated in the 1760s by Niccolò Ricciolini (1687–1772) and Domenico Corvi (1721–1803) and might have preceded the decoration of the portrait gallery. The main narrative of the salon focused on important deeds enacted by, as well as personalities of, the Barberini and Colonna families.[53] In its emphasis on precise actions and specific events the decoration privileges history painting over portraiture, thus

4.11 Niccolò Ricciolini and Domenico Corvi, *Sala dei Fasti Colonnesi*, 1760s. Rome: Galleria nazionale d'arte antica, Palazzo Barberini. Photo: Istituto centrale per il catalogo e la documentazione.

underlining the minority status given to portraiture within the eighteenth-century Roman elite.

The power and capabilities of the two families is reflected in the motifs chosen for the thirteen canvases in the salon: war is contrasted with peace, teaching with religious exorcism. Equally, the prestigious roles held by various family members range from saints and popes, generals and cardinals, to monks and nuns. There was evidently a clear ambition in the organization of the decoration to point at well-documented interactions between members of each family in order to stress the continuity of connections long before the 1728 marriage: one scene, for example, painted by Domenico Corvi, represents the Barberini pope, Urban VIII, granting Francesco Colonna the title of Prince of Carbognano (plate 4.12). The roles played by members of the two families offer an intriguing insight into the early modern Roman conception of elite formation and success. At the same time these pictorial virtues suggest that dynastic display could be of decidedly didactic proportions. Another painting by Corvi perfectly exemplifies this educational motif. In his representation of the *Blessed Margherita Colonna* (c. 1254–80; plate 4.13), this revered member of the family is shown instructing two young girls and pointing to a distant Palestrina where she had been born. In time she founded a community of Poor Clares which settled in the Convent of San Silvestro in

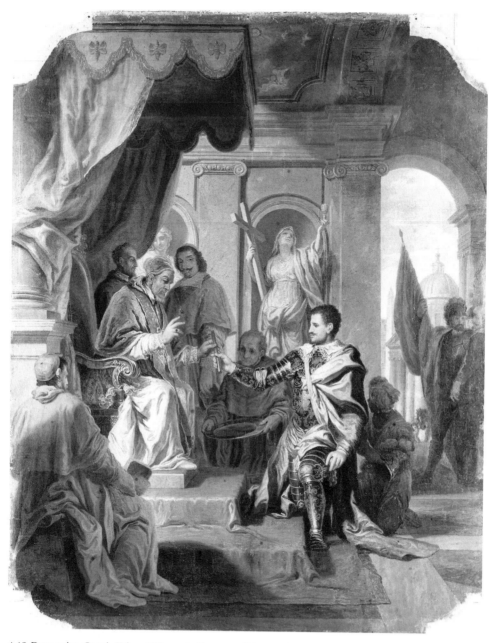

4.12 Domenico Corvi, *Urban VIII grants Francesco Colonna the title of Prince of Carbognano in 1630,*
c. 1764. Oil on canvas, 167 × 132 cm. Rome: Galleria nazionale d'arte antica, Palazzo Barberini.
Photo: Istituto centrale per il catalogo e la documentazione.

Rome.[54] As with the portrait of Maria Artemisia in the private gallery (plate 4.9),
this history painting by Corvi stresses the importance of ecclesiastical female
virtue in an elite family context, a context in which a traditional portrait
such as that of Maria Artemisia was clearly not enough. By contrast, in the

painting of the *Blessed Margherita*, the general idea of the educative role of aristocratic nuns is combined with a topographical statement that allows the beholder to capture Margherita's exact identity. Among other things, Corvi's painting highlights honourable action, personal identity and social status; conventional portraiture on a smaller scale could not match this ambition.

The existence of a family conflict not surprisingly required the representation of happy union between the two families. Although the traditional exaltation of family history is fully represented in the *Sala dei Fasti Colonnesi*, it is clear that history painting per se was not enough. The portrait gallery's narrative supports that of the salon, the difference being that the Genesis themes suggest a meditation on the consequences of choices and the dependence on Divine intervention that indicate the private pains of dynastic troubles. Family conflict raised a private desire for displaying family unity in a period when those material reasons that had originally brought about the marriage of Cornelia Costanza and Giulio Cesare had now led to severe familial rupture. The display in the portrait gallery was not aimed at the general social eye but at the select family circle. Portraiture helped to point directly at those individuals who were involved in the conflict. Rupture of family order and its visual restoration thus remained a private affair effectively displayed through the genre of portraiture far away from the public eye.

By contrast, the official space of the *Sala dei Fasti Colonnesi* displayed an untroubled union between the families. The importance given to the Colonna members, in turn, permitted the other branch of the

4.13 Domenico Corvi, *Margherita Colonna educating two young girls*, c. 1764. Oil on canvas. Rome: Galleria nazionale d'arte antica, Palazzo Barberini. Photo: Istituto centrale per il catalogo e la documentazione.

new family to display its lineage within a purpose-built space. The status balance between Giulio Cesare and Cornelia Costanza was fragile, and despite the creation of a new family name, the 1728 marriage had essentially aimed at the preservation of the Barberini patrimony. After their marriage, the couple lived in the bride's family home and Cornelia Costanza was, according to contemporary sources, an independent woman who was well aware of her status as the last heir to a powerful Roman family.[55] It is probably not by chance that a small, amateur painting showing Giulio Cesare on horseback appears among the grand pictures in the salon: 'Near the window next to the described room there is a small canvas in the form of a picture which represents the Prince happily alive on a white horse.'[56] (plate 4.14) The presence of this small portrait gives a clear indication of a desire, over time, to insert the contemporary head of the new family into a general narrative of social grandeur and continuity.

With reference to the status of domestic space in Palazzo Barberini, it becomes clear that the decorations in the second-floor apartment of the south wing were not merely conceived as new stylistic additions to a well-known baroque palace. The Palazzo's private portrait gallery and the history paintings in the *Sala dei Fasti Colonnesi* aimed at placing the new dynastic order fully on display. The Colonna family thus gained status, dignity and importance in a space where the Barberini name had always held natural precedence on display.

4.14 Unknown artist, *Portrait of Giulio Cesare Barberini Colonna di Sciarra on horseback*, 1760s. Oil on canvas. Rome: Galleria nazionale d'arte antica, Palazzo Barberini. Photo: Istituto centrale per il catalogo e la documentazione.

Notes

Some of the points made in this chapter were originally developed for the doctoral thesis 'Claiming Rome. Portraiture and Social Identity in Eighteenth-Century Rome', forthcoming in an adapted version with Manchester University Press. I wish to thank dott.ssa Maria Giulia Barberini at the Museo Nazionale di Palazzo Venezia for generous and kind advice on the topics of this chapter and Prof. Enzo Borsellino at the Università degli Studi di Roma Tre for inviting me to lecture on them.

1 John Moore, *A View of Society and Manners in Italy with Anecdotes relating to some eminent characters,* London, 1781, II, 71.

2 Francesco Petrucci, 'Traccia per un repertorio della rittrattistica romana tra' 500 e'700', Francesco Petrucci and Marina Natoli, eds, *Donne di Roma dall'Impero Romano al 1860. Rittrattistica romana al femminile,* Rome, 2003, 13.

3 Marcia Pointon, *Hanging the Head. Portraiture and Social Formation in Eighteenth-Century England,* New Haven and London, 1990; Kate Retford, *The Art of Domestic Life. Family Portraiture in Eighteenth-century England,* New Haven and London, 2006.

4 Chloe Chard, *Pleasure and guilt on the Grand Tour. Travel writing and imaginative geography 1600-1830,* Manchester, 1999, 20-2.

5 Shearer West, 'Patronage and power: the role of the portrait in eighteenth-century England', Jeremy Black and J. Gregory, eds, *Culture, politics and society 1660-1800,* Manchester, 1991, 131-53.

6 Moore, *A View of Society and Manners in Italy,* II, 71.

7 Pointon, *Hanging the Head,* 1.

8 Claudio Donati, 'The Italian nobilities in the seventeenth and eighteenth centuries', H.M. Scott, ed., *The European nobilities in the seventeenth and eighteenth centuries,* London, 1995, 237.

9 Dino Carpanetto and Giuseppe Ricuperati, *L'Italia del settecento. Crisi, trasformazioni, lumi,* Rome and Bari, 1998, 22.

10 Judith A. Hook, 'Urban VIII. The paradox of a spiritual monarchy', Arthur Geoffrey Dickens, ed., *The courts of Europe. Politics, patronage and royalty 1400–1800,* London, 1977, 213-31; Maria Antonietta Visceglia, 'Figure e luoghi della corte romana', Giorgio Ciucci, ed., *Roma moderna,* Bari, 2002, 40-78.

11 Moore, *A View of Society and Manners in Italy,* II, 164-5.

12 Tracy L. Ehrlich, *Landscape and identity in early modern Rome: Villa culture at Frascati in the Borghese era,* Cambridge, 2002, 18.

13 Carpanetto and Ricuperati, *L'Italia del settecento,* 241-2.

14 Visceglia in Ciucci, *Roma moderna,* 71-2.

15 Maria Antonietta Visceglia, *La città rituale. Roma e le sue cerimonie in età moderna,* Rome, 2002, 101.

16 Marina Caffiero, 'Istituzioni, forme e usi del sacro', Giorgio Ciucci, ed., *Roma moderna,* Bari, 2002, 151.

17 Sabrina Norlander Eliasson, *Portraiture and social identity in eighteenth-century Rome,* Manchester, 2008, forthcoming.

18 Patricia Waddy, *Seventeenth-century Roman palaces. The Use and the Art of the Plan,* New York, 1990.

19 Anthony Morris Clark, 'The Development of the Collections and Museums in 18th Century Rome', *Art Journal,* 1967, 26, 136-7.

20 Moore, *A View of Society and Manners in Italy,* I, 382-3.

21 Archivio Doria Pamphilj, scaffale 86, n. 36, f. 93.

22 Archivio Doria Pamphilj, scaffale 86, nr. 36, fs. 171-6.

23 Archivio Doria Pamphilj, scaffale 86, nr. 39, f. 96.

24 *Il Palazzo Doria Pamphilj al Corso e le sue collezioni,* ed. Andrea De Marchi, Rome, 1999, 154-72.

25 Archivio Doria Pamphilj, scaffale 86, nr. 36, fs. 264-78.

26 Archivio Doria Pamphilj, scaffale 86, n. 36, fs. 385-420.

27 Archivio Doria Pamphilj, scaffale 86, nr 36, f. 388.

28 Archivio Doria Pamphilj, scaffale 86, nr. 36, fs. 393-4.

29 Archivio Doria Pamphilj, scaffale 86, nr. 36, fs. 403-404.

30 On the artistic interest of cardinal Benedetto Pamphilj, see, for instance, Francesca Cappelletti, 'La galleria Doria Pamphilj', Rome, 1996, 12.

31 For a general history on the Barberini family, see Pio Pecchiai, *I Barberini,* Rome, 1959.

32 Caroline Castiglione, 'Extravagant pretensions: aristocratic family conflicts, emotion, and the "public sphere" in early eighteenth-century Rome', *Journal of Social History,* 2005, 685-703.

33 Gérard Delille, *Les noblesses européennes au XIXe siécle,* Rome, 1988, 3-7.

34 Philippe Boutry, 'Nobiltà romana e curia nell'età della restaurazione. Riflessioni su un processo di arretramento', Maria Antonietta Visceglia, ed., *Signori, patrizi, cavalieri nell'età moderna,* Bari, 1992, 400-401.

35 Carlo Pietrangeli, *Palazzo Sciarra,* Rome, 1987, 94.

36 Nicola La Marca, *La nobiltà romana e i suoi strumenti di perpetuazione del potere,* Rome, 2000, I, appendix, 333-67.

37 Howard Hibbard, *Carlo Maderno and Roman Architecture, 1580-1630,* Pennsylvania, 1971, 222.

38 Giuseppina Magnanimi, *Palazzo Barberini,* Rome, 1983, 185-99; Magnanimi, 'The eighteenth-

century apartment in Palazzo Barberini', *Apollo*, 1984, 120, 252–61.

39 Magnanimi, *Palazzo Barberini*, 185; Magnanimi, 'The eighteenth-century apartment', 255; Lorenza Mochi Onori, *La Galleria Nazionale d'Arte antica. Breve guida al Settecento*, Rome, 1988, 51.

40 Biblioteca Apostolica Vaticana, Archivio Barberini, Indice II, 1130, f. 12.

41 Biblioteca Apostolica Vaticana, Archivio Barberini, Indice II, 1130, f. 12; Archivio Barberini, Indice III, 304, n.p.

42 Biblioteca Apostolica Vaticana, Archivio Barberini Colonna di Sciarra, tomo 137, fascicolo 5, letter from Rome, 8 October 1782. In a further letter of 22 October 1782, Donna Cornelia informs her son of how his father is now ensconced in her own apartment, 'in the room next to mine'. All translations by the author.

43 *Lady Knight's letters from France and Italy 1776-1795*, Lady Eliott-Drake, ed., London, 1905, 20.

44 Pietrangeli, *Palazzo Sciarra*, 98–9.

45 La Marca, *La nobiltà romana*, 1, 352.

46 La Marca, *La nobiltà romana*, 1, 183.

47 Pietrangeli, *Palazzo Sciarra*, 100–101.

48 Biblioteca Apostolica Vaticana, Archivio Barberini, Indice II, 1130, f. 12.

49 Anthony Morris Clark, *Pompeo Batoni. A complete catalogue of his works with an introductory text*, ed. Edgar Peters Bowron, Oxford, 1985, cat. nos. 328 and 140.

50 Biblioteca Apostolica Vaticana, Archivio Barberini Colonna di Sciarra, tomo 174, fascicolo 23, f. 880.

51 Biblioteca Apostolica Vaticana, Archivio Barberini Colonna di Sciarra, tomo 137, fascicolo 6, fs. 353–4; Archivio Barberini, Indice IV, 218.

52 John Beldon Scott, *Images of nepotism. The painted ceilings of Palazzo Barberini*, Princeton, 1991, 19 and 28.

53 Magnanimi, *Palazzo Barberini*, 189.

54 Pietrangeli, *Palazzo Sciarra*, 58.

55 Francesco Valesio, *Diario di Roma*, VI, ed. Gaetana Scano, Milan, 1977-9, V, 1731, 372.

56 Biblioteca Apostolica Vaticana, Archivio Barberini Colonna di Sciarra, tomo 174, fascicolo 23, f. 870.

LAYING SIEGE TO THE ROYAL ACADEMY: WRIGHT OF DERBY'S *VIEW OF GIBRALTAR* AT ROBINS'S ROOMS, COVENT GARDEN, APRIL 1785

JOHN BONEHILL

5.1 Joseph Wright, *The Maid of Corinth*, 1785. Oil on canvas, 106.3 × 130.8 cm. Washington, DC: National Gallery of Art.

On Wednesday 4 May 1785 the diarist Sylas Neville visited two exhibitions of contemporary art lately opened in London: the annual Royal Academy of Arts show, at Somerset House, and a one-off display devoted to the work of a single

artist at Robins's Rooms, Covent Garden. He was to record his very different responses to these rival exhibits in his journal:

> Saw Wright of Derby's Exhibition, who on account of some dispute has this year separated himself from the R. Academy. Here we have some pictures of great merit in the peculiar stile of his pencil – moon lights, storms of thunder & lightning, different effects of fire. The Exhibition of the R. Academy has but few pictures of great merit this year – indeed I did not stay long, the crowd of company & heat of the rooms made it into a Calcutta business.[1]

It is hardly surprising Neville should have understood Joseph Wright's show as resulting from 'some dispute': rumours of the Derby painter's hostility towards the Academy had been circulating in art world circles for some time, and included speculation that he might mount an exhibition of his own. Particulars of the artist's disaffection remained somewhat hazy; however, it was well established that two years earlier Wright had felt himself slighted by the election to full Academician status of the landscape painter Edmund Garvey, having expected to receive the nomination himself. There may also have been a suspicion that he had been unhappy, as other artists were, with the positioning of his works on the crowded walls of the Great Room in Somerset House.[2] Breaking with the Royal Academy, the artist sought an alternative platform for the presentation of his work.

Wright's pictures had been little seen in the capital since the 1782 Royal Academy exhibition, and the Covent Garden display was staged to mark a prominent painter's return.[3] Featuring some twenty-five pictures, chosen to demonstrate the artist's erudition, range and versatility, the show consolidated Wright's reputation as a painter of novel light effects, while extending his subject matter and approach.[4] On payment of an admission fee of one shilling, visitors were presented with a catalogue listing views of the Continental and national landscape, contrasting types of portraiture, alongside subject pictures derived from a variety of literary sources. Many of these works were paired, encouraging visitors to reflect on contrasting approaches to a theme or the mutuality of works distributed across the room. The most ambitious painting, however, and clearly the centrepiece of Wright's show, was a canvas drawing on the country's recent wartime history, entitled *View of Gibraltar during the destruction of the Spanish Floating Batteries, 13 September 1782* (plate 5.2).[5]

This was the only picture named in press announcements for the exhibition, and must surely have dominated the show room.[6] Its subject was dramatic and allowed for a dazzling display of the artist's trademark handling of chiaroscuro, in concerning itself with the spectacular sight of enemy ships aflame at night, off the coast of the British garrison at Gibraltar during the final battle of a long-drawn-out siege. This may appear, at first, to have been a somewhat idiosyncratic choice as a lead picture, Wright not having attempted anything approaching a battle painting prior to this date. With pictures like *The Captive (from Sterne)*, sent to the Royal Academy in 1778, the preceding decade or so had seen the artist's work embrace classical and literary themes, breaking with the remarkable candlelight conversations or contrasting scenes of rustic smithies and hard labour that had established Wright's reputation. Subjects drawn from events in the nation's recent past, popularized in the new kind of history painting pioneered by Benjamin West and John Singleton Copley, had not fallen within the

5.2 Joseph Wright, *View of Gibraltar during the destruction of the Spanish Floating Batteries, 13 September 1782*, 1783–85. Oil on canvas, 152.5 × 259 cm. Kingston, Ontario: Agnes Etherington Art Centre.

artist's compass. *View of Gibraltar* was obviously conceived as a bold, audacious statement on the artist's part, intended to rival the American painters' work and calculated to attract the attention of the city's exhibition-going public.

Recent scholarship has effectively challenged a previously dominant view of Wright the marginal, provincial painter, and demonstrated his keen attentiveness to developments on the metropolitan scene. David Solkin has argued convincingly for the artist's responsiveness to the advent of public exhibitions in the 1760s, for example, as well as for Wright's subsequent 'desire to distance himself from the grand pretensions' of the Royal Academy, as indicated by an initial continued loyalty to the rival Society of Artists.[7] Such research has enabled greater understanding of the arresting, unprecedented iconography of those works that brought the painter to public prominence. This accounts, in turn, however, for the lack of critical scrutiny focused on Wright's later, apparently more conventional, subjects. The complexities of the painter's later dealings with the capital's artistic community, and his attempts to position himself in the greatly expanded exhibition culture of the 1780s are little understood. For by the late 1770s Wright had evidently come to recognize the pre-eminence of the Academy's annual exhibitions, and submitted works every year from 1778 until his secession. Once this became untenable, it became necessary to adopt expedient measures. With the Society of Artists failing, those figures finding themselves disillusioned with the conditions imposed by the Royal Academy conceived

alternative means of placing their work before the public. Indeed, Wright was but one of a number of prominent artistic personalities – including Copley and Thomas Gainsborough – opting to display their pictures separately, often as not highlighting works decidedly patriotic in theme.[8]

This essay examines the events surrounding Wright's decision to undertake the *View of Gibraltar*: a picture he considered crucial to his career and which fetched the highest price of any in his lifetime when going to the Wakefield wool merchant John Milnes for 420 guineas.[9] It is equally concerned, however, with the circumstances of its original exhibition. For the painting cannot be understood outside of the type of display in which it was first introduced. If the timing of the artist's show was, as he informed his close friend and collaborator William Hayley, intended 'to get the start of the Royalists', and therefore invite comparison with works displayed at Somerset House, then it was surely also meant to recall and rival that kind of one-off exhibition focused on the work of a single artist pioneered in recent years by figures like Copley.[10] That artist's contemporary history painting *The Death of the Earl of Chatham* had been displayed to great critical and commercial effect at Spring Gardens in the summer of 1781. This had been followed by the exhibition of the intensely dramatic *The Death of Major Pierson* (plate 5.3) in rented rooms at 28 Haymarket in mid-1784.[11] These innovative shows were geared principally towards the marketing of engravings after the works on display. Wright's exhibition was to differ in format, however, in not being directed towards the promotion of a print and placing a broader range of pictures on

5.3 John Singleton Copley, *The Death of Major Pierson*, 1782–84. Oil on canvas, 246.4 × 365.8 cm. London: Tate.

display. Nevertheless, it may still be aligned with such precedents, not least in the way exhibitions of this kind quite deliberately dramatized the tensions and antagonisms to be found in the contemporary art world. Such exhibitions, as Rosie Dias has pointed out, were understood as open displays of disaffection with the Royal Academy that highlighted the inadequacies of the country's premier artistic body.[12] It is also important to note that this new kind of art display was focused almost exclusively on paintings of a martial and declaratively patriotic theme, so serving to throw the failure of the Academy actually to realize its goal of a properly public-minded art – promoted so eloquently by the President Joshua Reynolds's *Discourses* – into still greater relief.

A wealth of correspondence and other material evidence relating to Wright's show allows unparalleled insight into the planning and level of provision required to stage such an exhibition. What follows details Wright's preparation of his 1785 display, with a particular emphasis on its centrepiece, for what these joint works reveal of one artist's relationship to what was widely perceived to be a moment of crisis for British art, as schisms and disaffection came to dominate aesthetic debate. This account will necessarily consider the social dimensions of Wright's artistic practice, most notably in its focus on the ever-closer alliance the painter was to forge with the Sussex poet William Hayley during this period. Indeed, in many ways Hayley, the self-styled 'Hermit of Eartham', came to shape the artist's exhibition through a variety of promotional activities, and was instrumental in constructing a view of the artist as a literary painter and 'man of feeling'. Wright made his plans to paint the dramatic events of the siege of Gibraltar known to the poet from the beginning, together with the scheme to introduce the picture to the public through a one-off exhibition. For it was clearly an ideal subject to take centre stage in the artist's show. If the choice of subject was unprecedented in Wright's career to date, *View of Gibraltar* was of obvious commercial potential and in accord with a conception of the artist as a painter of sensibility developed in works exhibited alongside.

VIEWS OF GIBRALTAR

Following the loss of the American colonies, the successful defence of the British garrison at Gibraltar, against the superior forces of a combined French and Spanish fleet, was widely seen as restoring honour to the country's military. After more than three years of siege warfare the Bourbon blockade had come to an end following a climactic battle waged over the night of 13 and 14 September 1782.[13] In an attempt to enforce the final submission of the garrison, the allies amassed a line of battering ships intended to breach fortress defences. However, these floating batteries were to succumb to a constant rain of red-hot shot from the defenders. Cannon fire striking the magazines of the ships, they exploded leaving the crews of the allied ships in what contemporary reports described as 'deepest Distress, and all imploring Assistance', forming 'a Spectacle of Horror not easily to be described'.[14] Abandoned by their own command, the garrison commander General George Augustus Elliot ordered his aide-de-camp Captain Roger Curtis to rescue the drowning.

With the eventual relief of the Rock a month later by a fleet under Admiral Lord Howe, reports of the final stages of the battle for the Rock appeared in extraordinary editions of the *London Gazette*. Taking the form of letters from

Curtis, Elliot and Howe, and intensely dramatic in content, they did much to cement these officers' reputations.[15] While Elliot and Howe attracted a good deal of adulation, emphasis was to fall on Curtis's selfless acts, with the officer claiming 'we felt it as much a Duty to make every Effort to relieve our Enemies from so shocking a Situation, as an Hour before we did to assist in conquering them.'[16] Hastily assembled accounts of the siege, alongside a flood of commemorative verse, prints and paintings, many sanctioned by key participants in the fight for the Rock, fleshed out these initial reports further, finding confirmation of national fortitude, fellow feeling and benevolence in the leading figures and events.

Resilience in the face of adversity, coupled with a benign benevolence, was of obvious appeal to those who cultivated a reputation for feeling, such as Wright and Hayley, while still calling to those like the poet who had been hostile to the war with the colonists.[17] Wright was among the first to recognize the potential of the subject, writing of his plans to commemorate the siege as early as mid-January 1783:

> Ever since I read in the Papers the account of the late great Event of Gibrates I have been fired wth a Desire of bringing so great an effect on Canvass. My friends are anxious I should undertake the task, as ye subject for my pencil, but my Situation is very unfavourable for collecting the necessary materials for the composition of such a picture. An historical truth must be observed, and all the material Incidents of the Action ... These must be got from some one who was witness to the Action, & who had the power of commiting his Ideas to paper – Sr. Roger Curtis is the person to be applied to, ... there is no time to be lost, as the subject is by Sr. Roger's assistance already in the hands of several & will soon be a Hackney'd one.[18]

This awareness of the intense rivalry between artists over the subject was to continue to trouble Wright in the coming months as he worked on his version of events. Central to these concerns was an acute sense of a need to access the kinds of information that would guarantee an 'historical truth'. These are both issues considered at length below. Here, it need only be noted that Wright turned to his correspondent for assistance in their management. Indeed, Wright's work towards his epic version of events, together with his plans for its eventual London exhibition, can be traced in some detail through surviving correspondence with Hayley.

'ARTIST AND BARD IN SWEET ALLIANCE': HAYLEY'S *ODE TO MR. WRIGHT OF DERBY*

In a letter to Hayley confiding his still limited progress on the Gibraltar painting, dated 9 March 1783, Wright assured the poet: 'It is thought unnecessary by my friends, that my intention of painting the subject should be immediately known to the publick in a morning paper.'[19] Yet it was soon judged expedient to make the artist's plans public. Copley secured the commission from the City of London to commemorate 'the glorious defence and relief of Gibraltar' within days of Wright's letter, usurping his principal rival Benjamin West.[20] That year's Academy exhibition saw William Hamilton, James Jefferys, Thomas Whitcombe and West's seventeen-year-old son Lamarr West all show works on the subject, causing the critic of the *Morning Chronicle* to complain that his patience had been 'literally worn out with looking at floating batteries and Gibraltar'.[21] Writing to Hayley

again at the end of April, with the show at Somerset House only recently opened, Wright was thanking his friend 'for informing the publick of my intention of painting the Action before Gibraltar, wch I find many little dirty souls are endeavouring to suppress, by saying I came too late to get instruction'.[22] Wright's sense of frustration over the competition for ownership of the subject, then being played out on the walls of the Great Room and in the London press, is palpable. His irritation is also to be found in a postscript lamenting the difficulties in completing his picture, the artist observing: 'Copley you see is a lucky man, the Citizens have given him a commission of 1200 to paint them a picture.'[23] These are surely the set of circumstances that led to the appearance of Hayley's *Ode to Mr. Wright of Derby*, 'distributed, without regular publication' in the summer of 1783.[24]

This extended verse tribute calls on the Derby painter to 'Give to our view our favorite scene of Fame,/Where Britain's Genius blaz'd in glory's brightest flame.'[25] There follows an effusive panegyric to the staunch defenders of the nation's military pride at Gibraltar, as embodied in the figures of Curtis and Elliot. For Hayley, their heroism presented a 'glory', in which both the country's military and artistic communities might share, and ascend to their true, deserved prominence:

> Rival of Greece, in arms, in arts,
> Tho' deem'd in her declining days,
> Britain yet boasts unnumber'd hearts,
> Who keenly paint for public praise:
> Her battles yet are firmly fought
> By Chiefs with Spartan courage fraught:
> Her Painters with Athenian zeal unite
> To trace the glories of the prosperous fight,
> And gild th' embattled scene with art's immortal light.[26]

Connections between British arms and the development of a national art were made frequently by contemporaries to emphasize the patriotic nature of artists' endeavours. Here, Hayley represents victory at Gibraltar as an opportunity for the promotion of an art committed to classical principles. Characterizing Britons as the natural, virtuous heirs to the effusions of classical culture, where the country's unique constitutional freedoms were to be likened to the Athenian democratic ideal, had been a common assertion throughout the eighteenth century. Indeed, it had been an animating principle behind Hayley's first major publication, *An Essay on Painting* of 1778. That work had comprised a comparative history of the art in ancient and modern times across two epistles: the first described its origins and status, together with the accomplishments of the Greeks, its sad decline and eventual revival in Italy; the second examined painting's renewed ascendancy in more recent times, culminating with the achievements of his contemporaries and fellow countrymen. For Hayley, the rise of English painting in the present age, recalling the grandeur of Athenian achievement, could be dated to an earlier moment of military triumph, to the glories of the Seven Years' War, 'When BRITAIN triumph'd, thro' her wide domain,/O'er FRANCE, supported by imperious SPAIN'.[27]

An Essay on Painting exerted no little influence on Wright, inspiring the artist's meditation on the origin of painting, *The Maid of Corinth* (plate 5. 1); a commission for the potter Josiah Wedgwood, destined to be exhibited alongside *View of Gibraltar*

in Covent Garden.[28] Wright may also have found the arguments for a civic-minded painting that run throughout the poem of relevance when he conceived the *View of Gibraltar*. Instructive words could be found for realizing such a picture, along with guidance on the appropriate form of presentation. For the most telling aspect of Hayley's *Essay*, as regards its relevance to an understanding of Wright's intentions at this moment, came by way of a lengthy footnote reflecting on the 'annual entertainments' afforded by the spectacle of the city's art exhibitions:

> Our exhibitions at once afford both the best nursery for the protection of infant genius, and the noblest field for the display of accomplished merit: nor do they only administer to the benefit of the artist, and the pleasure of the public: they have a still more exalted tendency; and when national subjects are painted with dignity and force, our exhibitions may justly be regarded as schools of public virtue. Perhaps the young soldier can never be warmly animated to the service of his country, than by gazing, with the delighted public, on a sublime picture of the expiring hero, who died with glory in her defence.

This imaginary exhibition anticipates the kind of show staged by Copley in the early 1780s. It is notable, however, that while conceiving of the display as a rousing, even jingoistic experience, and advocating the inclusion of suitably stirring scenes, Hayley was still anxious that such 'martial enthusiasm' be balanced. In support of these sentiments, the poet cited the authority of Vicesimus Knox's *Essays, Moral and Literary* on 'how the heart is mollified, the manners polished, and the temper sweetened, by a well-directed study of the arts of imitation'.[29] This description of an exhibition room, animated by 'national subjects' of a resolutely patriotic and martial theme, yet simultaneously tempered by the model, soothing effects of the fine arts, aptly describes the kind of display that – as we shall see – Wright, with Hayley's assistance, was to mount in Covent Garden in early 1785. That show was conceived, of course, as an explicitly anti-Academic statement; an aspect also anticipated in Hayley's earlier verse.

An Essay on Painting had been dedicated to George Romney, and – according to the poet's *Memoir* – intended 'to animate the genius and promote the reputation of that aspiring yet diffident artist'.[30] Hayley's verse to the Derby painter was obviously conceived in a similar manner, calculated to advance, endorse and sponsor. To return to the later *Ode*, Hayley's puff for Wright's still unrealized painting carefully distanced the artist's work from that of his competitors:

> Tho' many a hand may well portray
> The rushing war's infuriate shock,
> Proud Calpe bids thee, WRIGHT! display
> The terrors of her blazing rock.[31]

These lines betray something of the painter's anxiety in having come 'too late to get instruction', especially given the number of artists undertaking or already having exhibited works on the theme. What is equally noteworthy is Hayley's concern, even at this early date, to relate plans to depict events at Gibraltar to the artist's ongoing dispute with the Royal Academy, where 'envious leagues'

And dark cabals, and base intrigues
Exclude meek Merit from his proper home;
Where Art, whom Royalty forbade to roam,
Against thy talents clos'd her self-dishonor'd dome.[32]

Wright had been defeated in the ballot for Academicianship, where Garvey had been preferred, in February 1783, and this is as likely to have prompted Hayley's *Ode* as much as the sudden flood of pictures depicting events on the Rock. Hayley's verse struck an appropriate chord for Wright who, in thanking the poet, mused: 'Some little time ago I rec'd 100 copies of your charming ode would I deserved what your warm friendship has lavished on me some of wch I distributed among my friends, but would it not be more advantagious to me, to spread abroad the rest when my picture is finished, especially if I make an exhibition of it, wth some others.'[33] Evidently, the Covent Garden show that was to eventually open some eighteen months later had already been conceived. Following the suggestion of Hayley's earlier verse, *View of Gibraltar*, a painting celebrating the country's military excellence, would take centre stage.

VIEW OF GIBRALTAR

Progress on the *View of Gibraltar* was slow, with the painter often laid low by those regular bouts of ill health the valetudinarian Wright was widely known to suffer. If that mode of one-off exhibition popularized by Copley provided a significant precedent for artists wishing to control the display and marketing of their work, the American painter's insistence on historical accuracy was equally influential. Copley went to extraordinary lengths to guarantee the apparent authenticity of his Gibraltar painting, for example; courting serving officers like the chronicler of the siege, Colonel John Drinkwater, and making exhaustive preparatory studies.[34] Following Copley's lead, virtually all artists intent on pursuing subjects of this nature sought to assert the accuracy of their designs, whether by reference to appropriate documentary evidence or collusion with an eyewitness. Such was Wright's concern to ensure a degree of fidelity to events on the Rock he made at least two rare excursions to London. Wright visited the Treasury in the company of John Whitehurst, a long-time Derby associate then with an official post at the Mint, who provided an introduction to the Office. According to an unpublished letter of 9 March 1783, Wright was able to copy there two 'Drawings for the sake of the scenery wch is grand indeed, independent of the Action, & if I should paint two pictures it will do admirably for that, in wch the scenery shall be principal, the Action subservient, & make a good Companion to the other, where the action will be principal.'[35]

It appears that at this stage Wright intended to execute two pictures of the siege. This is further demonstrated by the catalogue for the Covent Garden show, which relates:

> In the first (which is now exhibited) he has endeavoured to represent an extensive view of the scenery combined with the action. In the second (which he hopes to finish hereafter) he proposes to make the action his principal object, and delineate the particulars of it more distinctly.[36]

View of Gibraltar, as exhibited in 1785, was not therefore the picture Wright had originally planned. Nor was it the painting Hayley had trumpeted in the *Ode*,

5.4 Joseph Wright, *An Eruption of Mount Vesuvius, with the Procession of St Januarius's Head*, 1778. Oil on canvas, 162 × 213.4 cm. Moscow: Pushkin State Museum of Fine Arts.

which had placed emphasis on the acts of benevolence of Curtis and Elliot. Unable to establish contact with Curtis, as originally planned, and so lacking appropriate forms of information, it is to be assumed the artist fell back on his knowledge of the spectacular, sublime scenes encountered in Italy. Views of an active Vesuvius, often paired with scenes of the spectacular fireworks of the Roman Girandola, had been mainstays of the artist's repertoire since his visit to Italy in the mid-1770s. Works like *An Eruption of Mount Vesuvius, with the Procession of St Januarius's Head*, exhibited at the Royal Academy in 1778, and its companion, *The Girandola, or Grand Fire Work at the Castle of St Angelo in Rome*, shown at the same institution the following year, demonstrate the ambitious nature of many of these pictures (plates 5.4 and 5.5). Large-scale works, with the night sky lit in a dramatic, startling manner, such pictures provided a ready precedent for the 'fine blaze' of a *View of Gibraltar*.[37] They were also instructive models for that work, in locating the evocation of sublime phenomena in a specific topography.

While it might be supposed that the second picture was to conform more readily with the kind of work brought to prominence by Copley or West, Wright appears to have considered the exhibited work to have been most comparable to the work of marine specialists like Dominic Serres or Richard Paton, who were both to essay works on the siege of Gibraltar. Pictures by these artists were largely evaluated in terms of a fidelity to eyewitness authority. Understandably, as the

5.5 Joseph Wright, *The Girandola, or Grand Fire Work at the Castle of St Angelo in Rome*, 1779. Oil on canvas, 162.5 × 213 cm. St Petersburg: Hermitage Museum.

date of exhibition neared, Wright became anxious that his work might be judged according to criteria of this kind; a letter to Hayley expressing concern over his lack of familiarity with 'naval matters'.[38] That the picture's exhibition was therefore to be managed carefully was an issue of some concern.

A letter to the editor of the *General Evening Post*, dated 16 January 1785 and signed 'Fabius Pictor', made the artist's intentions public just three months before the painting went on show:

> It has long been lamented by every lover of the fine arts, that so distinguished a genius as Mr. Wright of Derby, should chuse his place of residence so far remote from the capital, more especially as he, for some reason, does not exhibit with his brethren of the Royal Academy; in Consequence of which the public, in a great degree, are deprived of the pleasure of contemplating his excellent performances ... I have lately seen some landscapes by Mr. Wright, at Mr. Gisborn's, in Derby, and Mr. Boothby's, at Ashburn, which would do honour to the pencil of *Claude Lorraine*; which contain the *breadth* of Wilson, the *masterly touches* of Loutherbourg, and the *freshness* of nature. Indeed, it is generally allowed that no painter ever showed such *various powers* with *equal force* as the artist in question.
>
> The ingenious and liberal Mr. Wedgewood, whose judgment in painting is indisputable, gives a most interesting account of the sublimity of Wright's late representation of the repulse of the Spaniards before Gibraltar, which, by his best judges who have seen it, is said to be his master-piece.

Surely, Mr. Editor, this capital piece with several others upon historical subjects now in his posses-
sion, would be a noble treat to the public. I trust his friends will not suffer his modesty to with-hold
him from an Exhibition in this metropolis. Unless he can be prevailed on to put some such plan in
execution, the *amateurs* and thousands of his admirers will be deprived of viewing these noble
performances, which I may venture to say, without presumption, afford a greater variety of *subject*,
and a more finished style of *execution*, than is to be met with in the works of any painter living.[39]

This notice is worth quoting at some length for its eloquent summary of the
forthcoming exhibition's agenda, not least in that the lament for the artist's
absence from the metropolitan scene establishes the dispute with the Academy as
the context for its staging. This puff was the first of a steady stream of press

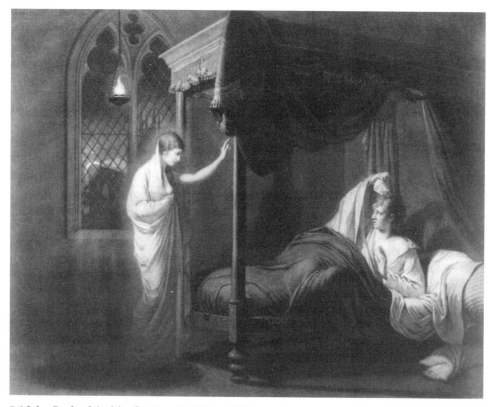

5.6 John Raphael Smith after Joseph Wright, *William and Margaret*, published 12 April 1785.
Mezzotint, 45.5 × 55.5 cm. Derby: Derby Museum and Art Gallery.

notices to appear in the lead-up to the Covent Garden show. Stretching back to the
appearance of Hayley's *Ode* in the summer of 1783, such communiqués are indic-
ative of a concentrated manipulation of the mechanisms of urban publicity, the
strategies of which extended to the publication by John Raphael Smith of a
mezzotint of the show's *William and Margaret*, simultaneous with the opening of
the exhibition (plate 5.6).[40] These publications participated in a concerted
attempt not only to publicize but, in concert with the material organization of
Robins's Rooms, to control the reading of Wright's exhibits.

VIEW OF GIBRALTAR AT MR ROBINS'S ROOMS, COVENT GARDEN

Wright's show opened at the fashionable auction house Robins's Rooms on Monday 11 April 1785, running until mid-June. Critical response was favourable from the beginning, picking up on arguments already forwarded in the press. 'We cannot withhold our admiration', wrote the *Morning Post*'s reviewer, 'when we consider that so many capital pieces came from the pencil of the same artist in the various branches of fancy, historical, landscape, and portrait painting.'[41] This sense of the artist's uniqueness had been commonplace from the beginnings of his exhibiting career.[42] Such views were in accord with those accounts of 'genius' forwarded by contemporaries, which frequently highlighted the ability to 'treat with equal facility the sublime beauties of historic composition, agreeable scenes of landscapes, portraits from life, and many various subjects'.[43] No doubt Wright's selections placed emphasis on the variety of his productions with such conceptions in mind. But reviewers were also keen to highlight the broad appeal of the artist's exhibits, likely to 'please the eye of the rude and of the critical spectator'.[44] This stress on Wright's varied abilities did not mean, however, that the works exhibited were not also intended to conform to an overarching, regulating scheme.

Writing two months earlier, of his plans for the exhibition and supplying a list of the works he intended to show, the artist had asked Hayley to compose descriptions for certain pictures and select appropriate verse for an accompanying catalogue. Flattering the poet for his 'concise elegant language', Wright considered guidance of some kind necessary, in part, for 'the ignorant are by much the greater part of the Spectator.'[45] Mark Hallett has recently demonstrated the ways in which contemporary displays of paintings at the Royal Academy, as exemplified by the hang of 1784, fostered an aesthetic and narrative dialogue across adjacent exhibits; sometimes accidental but often intended (plate 5.7).[46] If we are to accept that Wright's withdrawal from the competition for attention on the laden walls of Somerset House was prompted by the shabby treatment of earlier works, as noted at the beginning of this essay, then it might be supposed that the frequently unfortunate juxtaposition of images in that environment also played its part. To judge from the organization of the artist's own Covent Garden show, there was an evident attempt to direct the audience's experience. Visitors to Robins's Rooms were to be guided around the exhibits, with the catalogue acting in the manner of a vade-mecum, mediating responses.[47] Considered in this light, Hayley's selections for the catalogue are revealing, not least in that the frontispiece carried a quotation from William Mason's 1783 translation of Charles Alphonse Dufresnoy's *De arte graphica*; perhaps the most influential of academic exegeses on the doctrine of *ut pictura poesis* (plate 5.8). This inclusion is indicative of the mutually supportive roles painting and poetry had in the exhibition itself. Verse from Milton's *Comus*, Percy's *Reliques of Ancient English Poetry*, Pope's translation of Homer's *Odyssey*, and Hayley's own *Essay on Painting* were to be found in the catalogue, prompting a particular kind of viewing experience. Read in conjunction with the images, these extracts were no doubt intended to arouse the sensibilities by reference to an audience's familiarity with these texts and so reinforce the emotive force of the picture being considered.

Claims for commonality between painting and poetry rested not only on a shared iconography but on a mutual concern for the imitation and improvement

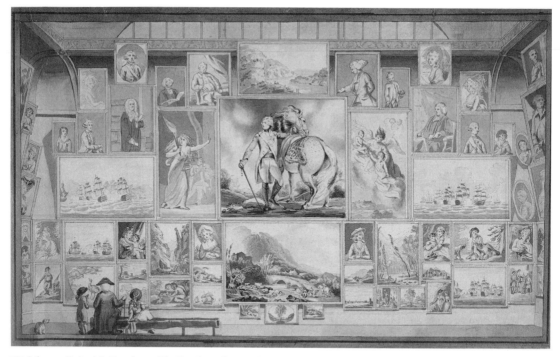

5.7 Johann Heinrich Ramberg, *The Royal Academy Exhibition of 1784: The Great Room, North Wall, c.* 1784. Pen, ink and wash with watercolour. By courtesy of the Trustees of the British Museum.

of rude nature. Both art forms functioned by creating images, which impressed themselves upon the reader's or viewer's mind. Dufresnoy's explorations of these ideas were well known to English audiences through John Dryden's translation in the late seventeenth century. Yet, Wright's catalogue cites Mason's more recent version, which had been published with a commentary by Reynolds. This might be seen as an act of homage, Hayley having expressed his admiration for this work elsewhere, but was also surely intended to rival this other contemporary collaboration of artist and poet.[48] With regard to the verse acting as the catalogue introduction, it might be suggested that the extract established a wider context in which the show as a whole was to be seen, allowing the more learned visitor to work through its implications from there. The lines selected are to be found in a section of Dufresnoy's work describing the need for artists to study, and the cost of a life spent in dedicated seclusion, where 'Comes age, comes sickness, comes contracting pain,/And chills the warmth of youth in every vein'. The inclusion of these sentiments gestures towards a conception of the modest artist in retirement increasingly assigned to Wright at this moment, having been initially cultivated by Hayley's *Ode*. But to evoke Dufresnoy was also to draw a parallel with another notable exile from the Academy, the French theorist having refused membership of the Paris Academie founded in 1648, preferring to stay loyal to the artists' guild, the Maîtrise.[49]

The identification of the artist with the tradition of *ut pictura poesis* and with a path of isolated study was continued in a series of impromptu verses, penned by

Hayley and published in the London press a little less than a month into the show's run. These were dedicated to individual exhibits, but culminated in lines addressed to the centrepiece picture:

> Ye Sons of Albion view, with proud delight,
> This Rock that blazes in the tints of Wright:
> Behold the proof, that British minds and hearts,
> Are Honour's darlings, both in arms and arts:
> With double triumph here, let Britons say –
> Britons alone could rule this fiery fray:
> This miracle of art a Briton wrought,
> Painting as boldly as his Country fought.[50]

These lines recall the sentiments of Hayley's earlier *Ode* to the painter; copies of which were very possibly for sale at Robins's Rooms.[51] They reinforced the

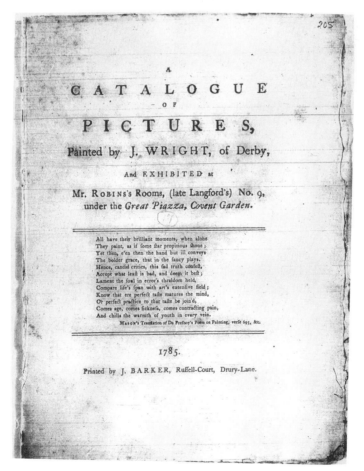

5.8 *A Catalogue of Pictures, Painted by J. Wright, of Derby, and Exhibited at Mr. Robins's Rooms, (late Langford's) No. 9, under the Great Piazza, Covent Garden*, 1785. Derby: Derby Local Studies Centre.

5.9 Joseph Wright, *The Lady in Milton's 'Comus'*, 1785. Oil on canvas, 101 × 127 cm. Liverpool: Walker Art Gallery.

patriotic nature of the artist's enterprise, elevating the painter to near heroic status. Once more, as in the *Ode*, such a line of argument needs to be understood in contrast with the apparent failing of the Royal Academy to pursue a similarly elevated path. This was a comparison also made, as we shall see, by contemporary critics. For now, it is worth noting that this proudly patriotic narrative was being generated, not only by the placement of notices in the press but also through the actual layout of Wright's show.

For *View of Gibraltar* is positioned in the exhibition catalogue at the close of a carefully plotted sequence. If each picture obviously bore individual scrutiny, or was in some instances to be compared with its companion, it might be suggested that the exhibition, as a whole, had a cumulative effect that reinforced the central qualities of the lead picture. *The Lady in Milton's 'Comus'* and its companion, *The Widow of an Indian Chief watching the arms of her deceased husband*, are the first pictures listed in the catalogue (plates 5.9 and 5.10). They are identical in size, and follow a broadly similar compositional format, based upon a diagonal division of the canvas, where a dark foreground mass opens out to a distant vista. The first of these paintings focuses on the distresses suffered by the chaste lady of Milton's poem, lost in eerie woodland at night and subjected to the terrors of the eponymous pagan god. Its companion focuses on what the exhibition catalogue calls the 'mournful duty' of the native American widow, guarding the 'martial

habilments' of her dead husband.[52] If we allow ourselves to be led by the exhibition catalogue, *William and Margaret* (plate 5.6) follows these works: a gothic narrative of ghostly visitation and unrequited love. This theme of love thwarted is also addressed in a painting of Ovid's despairing lover, *Julia*, and paired paintings of Hero and Leander. Listed in the catalogue at XIII and XIV, *The Maid of Corinth* (plate 5.1) and *Penelope unravelling her web, by lamp-light* (plate 5.11) were also companions: focusing respectively on the mythical inventor of portraiture, who is moved to trace the image of her soon-to-depart lover's face as an act of solace, and the patient and virtuous wife of Ulysses. These works might be seen to link back to the distressed women of the works encountered first. They are of the same size and share the cameo-like quality of those paintings. Indeed, these four pictures might be seen to comprise an ensemble that encouraged the viewer to reflect on the differing but complementary virtues of the protagonists: maintained in three instances despite the anguish of marking or mourning a husband's or lover's absence or passing.

Hayley had conceived, directly inspired, or advised on the imagery of all of these works, and their subjects all conform to a model of virtuous femininity established by his own signature work, *The Triumphs of Temper*. This long, didactic poem had instructed young women in the benefits of preserving a good temper and gentle disposition even under the most trying conditions. Its heroine, Serena,

5.10 Joseph Wright, *The Widow of an Indian Chief watching the arms of her deceased husband*, 1785. Oil on canvas, 101.6 × 127 cm. Derby: Derby Museum and Art Gallery.

5.11 Joseph Wright, *Penelope unravelling her web, by lamp-light*, 1785. Oil on canvas, 101.6 × 127 cm. Malibu: J. Paul Getty Museum.

is subjected to many trials in her journey through the realm of Spleen, surviving a series of encounters with the torturous monsters of ill temper. By exercising her courage and will, she gradually enters the sphere of Sensibility in which virtue and happiness reside. Her patience and good nature throughout these tests is rewarded with an intelligent, handsome and gentle husband. Characters of this kind were, of course, an established feature of the literature of sensibility. They excited sentimental feeling by bearing their misfortunes with dignity; the woman as virtuous victim being regarded, as John Brewer has recently observed, as 'exceptionally erotic and appealing'.[53] Critics reviewing Wright's show responded appropriately, finding 'great sobriety' in the grief of Penelope, and 'a striking representation of dejection, unmoved by surrounding terrors' in the Indian widow.[54]

These canvases of virtuous women might be seen to engage the passions and so moderate the excesses of the violent narrative that dominated the room. Their example prompted the requisite kind of sympathetic feeling necessary to temper the narrative of sublime action found in *View of Gibraltar*. Indeed, the sublime was recognized to be reliant on the capacity for sympathy, with contemporary theorists, such as Lord Kames, recognizing that 'the histories of conquerors and heroes' or 'some grand and heroic action' provoked '*the sympathetic emotion of virtue*'.[55] In addition, Wright's paragons of feminine virtue, bearing their

5.12 Joseph Wright, *A View in Dovedale. Evening*, 1785. Oil on canvas, 62.5 × 77.8 cm. Oberlin College, OH: Allen Memorial Art Museum.

suffering with a stoic quietude, separated from their husbands, lovers or family, in the case of Penelope and the Indian widow by war, might be seen as icons of the civilizing, domestic virtues and social continuity under the warrior's protection.

In Wright's exhibition, the sensibilities of the audience were to be further mobilized by a series of views, interspersed between these subject pictures, taking in the Mediterranean and native landscape. If the show did much to assert Wright's credentials as a literary painter, then there was a like effort to promote his skills as landscapist. Though the majority of these works remain untraced, titles and other works on these subjects from the period provide a good sense of their likely character. Concerned to demonstrate an equal facility across various modes of landscape depiction, the exhibits saw the artist moving between works in a classicizing, Claudean manner, to a Rosa-like portrayal of the sublime, or to pictures demonstrating a more unconventional application, to what Reynolds dismissed memorably as the 'Accidents of Nature'.[56] These paintings included views of the cascades, grottos, lakes and volcanoes of the Neapolitan landscape and coastline, likely to summon a rich array of cultural and historical associations. But the display also incorporated scenes of dramatic, craggy landforms derived from studies of the artist's native Derbyshire (plate 5.12). This was a landscape that itself attracted no little admiration, as a site of philosophical

speculation – through the activities of figures like John Whitehurst – and scenic tourism. Views of Dovedale and Matlock, High Tor, as exhibited by Wright, were very soon to enjoy a very particular resonance, featuring prominently in William Gilpin's influential 1786 publication, *Observations relative to Picturesque Beauty*. This celebration of the rugged beauties and wonders of the national topography was, of course, central to a broader cultural concern with the representation of Britain and Britishness during this period, often associated with an apparently unspoilt, untouched vision of the countryside. In the context of the display in Robins's Rooms, such images were, therefore, entirely congruent with the commemoration of patriotic virtues in the exhibition's centrepiece, while the views of the Italian landscape on show reinforced conceptions of the nation's position as heir and protector to the values of classical culture.

A mental reshuffling of the exhibition's pictorial and textual elements reveals, then, any number of possible visual links or thematic exchanges between supporting works and the centrepiece *View of Gibraltar*. For this image of the nation's forces engaged in bloody conflict, yet benevolent in victory, is reinforced by an imagery celebrating the land and values they protect and the domestic virtues they safeguard. The exhibits establish a complex series of crisscrossing narratives, couched in essentially emotive terms, intended to invite contemplation and emulation, in a manner consistent with the recommendations of Hayley's *Essay on Painting*. Unsurprisingly, given the level of the poet's involvement, Wright's Covent Garden show conformed closely to the vision of an appropriately civilized and patriotic showcase for the artist's talent that the poem proposed: celebrating the values of sensibility, most conspicuously through a painting addressing a suitably dramatic, yet also edifying, episode from the nation's military history. Yet, as we have seen, there was also a concern to demonstrate the distinctiveness of Wright's art, a point recognized by the *Artist's Repository* in its review of the exhibition's centrepiece:

> We have had many representations of this event, in almost all degrees between good and bad. Shall we say their more early appearance prevented this picture from being *bespoke*? We rather think so, than to suppose Mr. W.'s merit on the subject *could* be overlooked; or that no one thought of employing the only Artist capable of defending Gibraltar *upon canvas* as it should be.[57]

These words were obviously intended to evoke memories of previously exhibited paintings. But the comparison was given additional weight by works on display at that very moment just a few hundred yards away from Covent Garden.[58]

George Carter's one-man show, also centred on a large-scale painting of the siege of Gibraltar, opened at Pall Mall, in rooms formerly used by the Royal Academy, within days of Wright's show.[59] Other rival versions of events put before the public at this moment included a print by Benjamin Pouncy and Paul Sandby and a *View of Gibraltar* by Serres shown at Somerset House.[60] If it is unlikely that Wright would have anticipated this kind of competition, he was – as we have seen – clearly concerned to invite comparison with the Royal Academy. Critical responses to that year's show amply demonstrate the success of this tactic. For reviewers of the 1785 Royal Academy exhibition were all but unanimous in expressing their disappointment, with one critic finding many works not even

'worthy of the honour of a place in a country ale house club-room'.[61] Most newspapers agreed with the *General Advertiser*'s assessment, that 'The exhibition, this year, affords either a melancholy proof of the arts declining, or that men of merit, except a few, have taken some dislike to the Royal Academy.'[62] As such remarks indicate, critics were as exercised by those artists absent from the walls of Somerset House, as by those who had sent works. According to the *General Evening Post*, 'envious partialities' in the Academy had meant that 'some of the most considerable masters have retired in disgust.'[63] One reviewer who lamented the absence of 'Mr. Wright, Mr. Gainsborough, Mr. Romney, Mr. Stubbs, Mr. Marlow, & c.', however, found comfort in that 'The first of these gentlemen (Mr. Wright) has opened an Exhibition, consisting entirely of his own works.'[64]

Wright's dispute with the Royal Academy was evidently common knowledge, as indicated by Neville's journal cited at the beginning of this essay. But if Neville had, at the time, been unclear as to the reasons for the break, he would have found an explanation in an open letter to the public from one 'Timothy Tickle' published a fortnight after his visit. In a series of despatches printed in the *Public Advertiser*, Tickle highlighted 'several artists of the first rank' who had abandoned the Academy 'on account, as it is said, of ill treatment they received from the leading members'.[65] These letters, like the views of the exhibition critics, are to be seen as part of that more general antipathy towards the Academy considered earlier. Too great a concern with the more overtly commercial genres like portraiture was seen as one of the contributing factors prompting an inability to pursue forms of artistic practice likely to serve the interests of the Academy's publics. Its high-handed, tyrannical treatment of its own membership was only further demonstration of this failure. One of the notable features of Tickle's approach to these issues, coming in his defence of Wright having been 'driven to make an exhibition of his own', is the way in which that artist's disaffection is traced back beyond the humiliation of Garvey's preferment to the schisms of the late 1760s, occasioned by the founding of the Royal Academy.[66] Tickle called for a return to the model of establishment represented by the Society of Artists, and for those artists marginalized by the Academy to 'form a rival exhibition'.[67] In this light, Wright's Covent Garden show was surely to be seen as an exemplary rallying point; suggestive of the ways in which the general decline of British art might be reversed. That Wright's exhibition was calculated to prompt such suggestions is indicated by the catalogue, with its incorporation of complementary verse (a practice disallowed by the Academy since the mid-1770s) or by its advertising of works as available for purchase (a vulgarity long abandoned by the Academy) or the references to Dufresnoy (the pseudonym adopted by the Society of Artists' chaplain, James Wills, in a series of vicious attacks on the Academy back in the late 1760s).[68]

This sense of old rivalries renewed had been foremost in the painter's plans for his painting and its exhibition from the beginning. The artist's Covent Garden show, centred on his epic *View of Gibraltar*, was always intended to expose the inadequacies of the country's premier artistic body by highlighting the conflicts, confrontations and infighting that marked the metropolitan art world of the mid-1780s. Visitors to Wright's one-man exhibition were not only encouraged to place its centrepiece in the context of the other exhibits. They were also invited to relate this canvas to works on display across the city. In this light, the artist's *View of*

Gibraltar was to be understood as representing an authentic expression of a properly public-minded and patriotic artistic practice. Those reviewers cited above offer eloquent testimony to the success of such tactics.

Yet, for all of these achievements, the show evidently cost Wright dearly. In not being able to execute the painting as originally intended, arriving at the compromise of a scene of distant action rather than a more immediate work, along the lines pioneered so successfully by Copley, Wright had not been able to capitalize on the potential for a print after the picture. This must surely have been his original intention, having proved so lucrative for the American painter, and been at the forefront of his mind in planning an exhibition around the painting. Wright's problems were compounded by the fact that, despite being advertised as available for purchase in the Covent Garden exhibition catalogue, *View of Gibraltar* went unsold. Having invested a great deal of his energies and professional reputation in the picture, he was left to contemplate taking the rather desperate measure of disposing of the work by lottery. That is, until his most enthusiastic and loyal patron, John Milnes, took the painting for the extravagant sum of 420 guineas, some twelve months after the show had first opened.[69]

Notes

My thanks to Matthew Craske for discussing the material contained in this chapter with me.

1 S. Neville, *The Diary of Sylas Neville 1767–1788*, ed. B. Cozens-Hardy, Oxford, 1950, 326–7.

2 The fullest discussions of these issues are to be found in W.T. Whitley, *Artists and their Friends in England 1700–1799*, 2 vols, London, 1928, vol. 2, 340–3 and B. Nicolson, *Joseph Wright of Derby: Painter of Light*, 2 vols, London and New York, 1968, vol. 1, 14–16.

3 For a complete list of the artist's exhibited works, see Nicolson, *Joseph Wright*, vol. 1, 273–8.

4 [W. Hayley], *A Catalogue of Pictures, Painted by J. Wright, of Derby, and Exhibited at Mr. Robins's Rooms, (late Langford's) No.9, under the Great Piazza, Covent Garden*, London, 1785.

5 The picture illustrated here was first identified as Wright's work in the early 1970s, and was later accepted by Nicolson: see B. Erdman, 'Wright of Derby's *The Siege of Gibraltar*', *Burlington Magazine*, 116, 1974, 270–4; B. Nicolson, 'Wright of Derby: addenda and corrigenda', *Burlington Magazine*, 130, 1988, 745–58. This initial acceptance was later to be questioned, resulting in the picture being re-attributed to a copyist. However, documentary evidence, together with recent analysis of the paint, suggests that this is the work identified as Wright's and known to be in the Overstone Park collection (Northamptonshire) by the mid-nineteenth century. This badly damaged picture is now undergoing restoration before taking centre stage at an exhibition demonstrating its provenance organized by its present home, the Agnes Etherington Art Centre, Queen's University, Kingston, Ontario. I am grateful to Dr Alfred Bader and the Centre's Director, Janet Brooke, for communicating their findings on the picture's history to me.

6 Cf. *Morning Post, and Daily Advertiser*, 18 April 1785, 1; *Morning Herald, and Daily Advertiser*, 19 April 1785, 1.

7 D.H. Solkin, *Painting for Money: The Visual Arts and the Public Sphere in Eighteenth-Century England*, New Haven and London, 1993, 270, and more recently 'Joseph Wright of Derby and the Sublime Art of Labour', *Representations*, 83 Summer 2003, 167–94, esp. 187–8.

8 Contemporary accounts of Gainsborough's relationship with the Academy indicate an unhappiness with the 'improper situation' of his pictures in the Great Room at Somerset House, leading him to exhibit his pictures in his own studio (see *Public Advertiser*, 26 May 1785, 2).

9 The price is confirmed in a letter from J. Wright to W. Hayley, 12 April 1786, pasted in an extra-illustrated copy of William Bemrose, *The Life and Works of Joseph Wright, Commonly Called 'Wright of Derby'*, London and Derby, 1885, Derby Museum and Art Gallery.

10 The artist's remark on the timing of his exhibition is to be found in a letter from J. Wright to W. Hayley, 17 February 1785, in Bemrose, *Life and Works*, Derby Museum.

11 For the exhibition of these paintings, see J. Prown, *John Singleton Copley*, 2 vols, Cambridge, MA, 1966, II, 275–91, 290, 302–310.

12 See R. Dias, '"A world of pictures": Pall Mall and the Topography of Display', in M. Ogborn and C.J. Withers, eds, *Georgian Geographies: Essays on Space, Place and Landscape in the Eighteenth Century*, Manchester, 2004, 92–113. I am grateful to Stephen Daniels for bringing this important essay to my attention.

13 For modern accounts of the siege, see T.H. MacGuffie, *The Siege of Gibraltar 1779–1783*, Basingstoke, 1965, and J. Russell, *Gibraltar Besieged 1779–83*, London, 1965.

14 *London Gazette Extraordinary*, 8 November 1782, 3.

15 Curtis and Howe's communiqués appear in the issue cited in the previous note, and Elliot's in the edition for 12 November 1782.

16 *London Gazette Extraordinary*, 8 November 1782, 3.

17 Hayley's politics during this period are best exemplified by his verse tribute to the oppositionist hero, Augustus Keppel, *Epistle to Admiral Keppel*, London, 1779.

18 J. Wright to W. Hayley, 13 January 1783, Derby Local Studies Centre.

19 J. Wright to W. Hayley, 9 March 1783, Fitzwilliam Museum, Cambridge.

20 *Proceedings of the Committee to consider the most suitable mode to be adopted by the Court of Common Council to express its gratitude to General Elliott, Lord Howe etc.*, Corporation of London Record Office, Guildhall, Misc.Mss/19515, 18 March 1783.

21 *Morning Chronicle and London Advertiser*, 30 May 1783, 3.

22 J. Wright to W. Hayley, 26 April 1783, Fitzwilliam Museum, Cambridge.

23 J. Wright to W. Hayley, 26 April 1783. Copley had actually undertaken the work for the reduced fee of 1,000 guineas, 'hoping the Advantages of an Exhibition of the Picture and the publication of a print from it' would 'compensate him for the time and study requisite for completing so large a Work' (*Proceedings*, 18 March 1783).

24 W. Hayley, *Memoirs of the Life and Writings of William Hayley, Esq., ... and Memoirs of his Son Thomas Alphonso Hayley, the Young Sculptor*, 2 vols, ed. J. Johnson, London, 1823, vol. 1, 303.

25 W. Hayley, 'Ode to Mr. Wright of Derby, 1783', in *Poems and Plays*, 6 vols, London, 1785, vol. 1, 142. The poem was originally published as *Ode to Mr. Wright of Derby*, Chichester, 1783.

26 Hayley, 'Ode to Mr. Wright of Derby', vol. 1, 144.

27 William Hayley, 'An Essay on Painting', in *Poems and Plays*, vol. 1, 32. This verse was originally published as *A Poetic Epistle to an Eminent Painter*, London, 1778.

28 For discussions of the painting and its commission, see Nicolson, *Joseph Wright of Derby*, vol. 1, 143–6; J. Egerton, ed., *Wright of Derby*, London, 1990, 132–4; and, most illuminatingly, A. Bermingham, 'The Origin of Painting and the Ends of Art: Wright of Derby's Corinthian Maid', in J. Barrell, ed., *Painting and the Politics of Culture: New Essays in British Art*, Oxford, 1992, 135–66.

29 Hayley, 'An Essay on Painting', vol. 1, 98–9.

30 Hayley, *Memoirs*, vol. 1, 172.

31 Hayley, 'Ode to Mr. Wright of Derby', vol. 1, 145.

32 Hayley, 'Ode to Mr. Wright of Derby', vol. 1, 145.

33 J. Wright to W. Hayley, 31 August 1783, Fitzwilliam Museum, Cambridge.

34 This aspect of Copley's picture is considered at length in J. Bonehill, 'Exhibiting war: John Singleton Copley's *The Siege of Gibraltar* and the staging of history', in J. Bonehill and G. Quilley, eds, *Conflicting Visions: War and Visual Culture in Britain and France, c.1700–1830*, Aldershot, 2005, 139–68.

35 J. Wright to W. Hayley, 9 March 1783, Fitzwilliam Museum, Cambridge. Details of a second expedition to the Treasury to make sketches are given in a letter to Hayley dated 26 April 1783, Fitzwilliam Museum, Cambridge.

36 [Hayley], *Catalogue of Pictures*, 8.

37 Wright may have wanted to encourage such a comparison, in showing *A distant view of Vesuvius from the shore of Posilipo* and *The Companion, in the gulf of Salerno*, alongside *View of Gibraltar* in the Covent Garden show.

38 J. Wright to W. Hayley, 17 February 1785, in Bemrose, *Life and Works*, Derby Museum.

39 *General Evening Post*, 20-22 January 1785, 4.

40 The print bears a publication date of 12 April 1785. Wright's friendship and professional relationship with Smith is discussed in E.G. D'Oench, *'Copper into Gold': The Prints of John Raphael Smith 1751–1812*, New Haven and London, 1999, esp. 106.

41 *Morning Post, and Daily Advertiser*, 16 April 1785, 2.

42 'A Lover of the Arts' found *The Experiment with a Bird in an Air Pump* demonstrated 'a very great and uncommon genius in a peculiar way', for example. This much-quoted review is from the *Gazetteer and New Daily Advertiser*, 23 May 1768, 4.

43 [C. Taylor], *The Artist's Repository and Drawing Magazine*, 5 vols, London, 1794, vol. 4, part 1, 45. For an illuminating and apposite discussion of the role of genius in the cultivation of a distinctive artistic sensibility during this period, see M. Craske, *Art in Europe 1700-1830*, Oxford, 1997, 35–6.

44 *Morning Post, and Daily Advertiser*, 20 April 1785, 2.

45 J. Wright to W. Hayley, 17 February 1785, in Bemrose, *Life and Works*, Derby Museum.

46 M. Hallett, 'Reading the Walls: Pictorial Dialogue at the British Royal Academy', *Eighteenth-Century Studies*, 37 (2004), 581–604. Hallett's arguments provided much of the stimulus for the discussion that follows.

47 Suggestive remarks on the role of the catalogue in ordering a viewer's experience of contemporary Royal Academy exhibitions are to be found in C.S. Matheson, '"A shilling well laid out": the Royal Academy's Early Public', in D.H. Solkin, ed., *Art on the Line: The Royal Academy Exhibitions at Somerset House 1780-1836*, New Haven and London, 2001, 39–53.

48 Mason had evidently sent a copy of the translation to Hayley, inspiring the latter to pay tribute in verse to the older poet and his collaborator: see 'To Mr. Mason', in *Poems and Plays*, vol. 1, 181–2.

49 Matthew Hargraves has recently demonstrated that Dufresnoy's name might be evoked in order to summon such associations in an earlier instance of anti-Academic polemic, in his *Candidates for Fame: The Society of Artists of Great Britain 1760–1791*, New Haven and London, 2005, 100.

50 'On Wright's, of Derby, Picture of Gibraltar. Caple's Address to Britain', *Morning Post, and Daily Advertiser*, 7 May 1785, 3. Verses to other exhibits appeared in the *Morning Post, and Daily Advertiser*, 29 April 1785, 4 and *Public Advertiser*, 3 May 1785, 2.

51 This suggestion derives from a letter from J. Wright to W. Hayley, 28 December 1783, in Bemrose, *Life and Works*, Derby Museum.

52 [Hayley], *Catalogue*, 4.

53 J. Brewer, '"Love and Madness": Sentimental Narratives and the Spectacle of Suffering in Late Eighteenth-Century Romance', in P. de Bolla, N. Leask and D. Simpson, eds, *Land, Nature and Culture 1740-1840: Thinking the Republic of Taste*, Basingstoke, 2005, 131–47, 132.

54 *Morning Post, and Daily Advertiser*, 20 April 1785, 2.

55 H. Home, Lord Kames, *Elements of Criticism*, 2 vols, 6th revised edn, Edinburgh, 1785, vol. 1, 63.

56 J. Reynolds, *Discourses on Art*, ed. R. Wark, New Haven and London, 1975, 70.

57 [Taylor], *The Artist's Repository*, vol. 4, part 1, 101–102.

58 For a fascinating discussion of the topography of display in this period, see Dias, 'A world of pictures'.

59 The first announcement I have been able to find comes in *Morning Herald, and Daily Advertiser*, 26 April 1785, 1.

60 For Pouncy and Sandby's work, see *Morning Herald, and Daily Advertiser*, 2 May 1785, 2. Serres had exhibited a similar titled work at the Royal Academy the previous year, and was to send a further two in 1787.

61 *General Advertiser*, 28 April 1785, 3.

62 *General Advertiser*, 28 April 1785, 3.

63 *General Evening Post*, 26–28 April 1785, 4. See also *General Advertiser*, 2 May 1785, 3.

64 *Public Advertiser*, 27 April 1785, 2.

65 *Public Advertiser*, 17 May 1785, 1. Letters defending Stubbs and Gainsborough were to follow on 23 and 26 May respectively.

66 *The Public Advertiser*, 17 May 1785, 2.

67 *Public Advertiser*, 17 May 1785, 2.

68 The 'Fresnoy' letters of the 1760s have been discussed most fully of late in Hargraves, *Candidates for Fame*, 100 passim.

69 Details of Wright's plans to dispose of the painting by lottery are given in a letter to D. Daulby dated 14 November 1785, in Bemrose, *Life and Works*, Derby Museum.

6

'WALKING FOR PLEASURE'? BODIES OF DISPLAY AT THE MANCHESTER ART-TREASURES EXHIBITION IN 1857

HELEN REES LEAHY

6.1 The Manchester Art-Treasures Exhibition: The Grand Hall, *Illustrated London News*, 9 May 1857.

In the centre of the Grand Hall of the Art-Treasures Palace a man wearing a top hat, neat tie and light-coloured trousers stands apart from his fellow spectators and surveys the scene (plate 6.1). His detachment from the chattering visitors who surround him is marked not only by his solitude, but also by his self-assurance and equipoise. By contrast, few of his fellow spectators are alone: most stand or sit

in pairs or groups, walking arm in arm, and a number are consulting printed catalogues. It is not a famous painting or sculpture that has caught this man's attention; he is looking up at the balcony galleries ranged around the Hall, from which his fellow spectators can, in turn, look down at the scene below. For this visitor at least, the mobile transience of the assembly of bodies appears more captivating than the collection of art treasures that he has, ostensibly, come to see. Like Charles Baudelaire's *flâneur*, he appears at ease in the 'heart of the multitude, amid the ebb and flow of movement, in the midst of the fugitive and the infinite'.[1] And being both part of and distinct from the crowd, he seems to embody the 'metropolitan individuality' that was described by Georg Simmel as prone to self-distanciation, reserve and fastidiousness as strategies of, simultaneously, self-preservation and self-assertion within the modern city.[2]

But this is not the Paris of Baudelaire, nor Simmel's Berlin; it is Manchester in May 1857. The scene is the Art-Treasures Exhibition that had just opened in a vast iron and brick building covering three acres, erected on the grounds of Manchester Cricket Club at Old Trafford, two miles from the centre of the city (plate 6.2).[3] The scale, ambition and art-historical significance of the Art-Treasures Exhibition was unprecedented in Britain, and has not subsequently been equalled in the history of art exhibitions.[4] In all, over 16,000 works of art were gathered together in the Art-Treasures Palace, including 1,173 works of the Ancient Masters, 689 productions of the Modern Masters and 386 British portraits.[5] In addition, there were 969 watercolours and drawings, 260 Old Master drawings, 1,475 engravings, 597 photographs and some 10,000 objects that comprised the 'Ornamental Art Museum'.[6] The majority of exhibits were the property of private

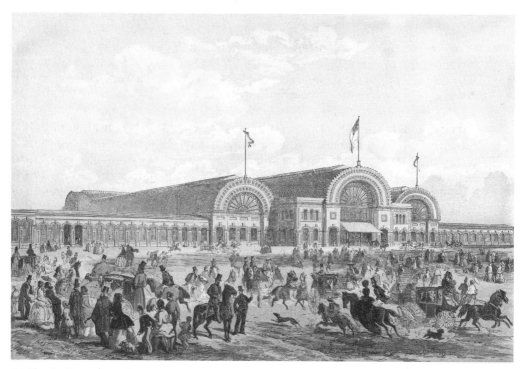

6.2 The Art-Treasures Palace, Manchester: Exterior, *Art-Treasures Examiner*, 1857.

6.3 Unpacking the Art Treasures, *Illustrated London News*, 2 May 1857.

individuals and many were on public show for the first time.[7] Gustav Waagen, whose catalogues of British private collections had provided both the intellectual stimulus and a practical tool for the exhibition organizers, calculated that approximately one third of all the pictures in English collections were assembled in Manchester (plate 6.3).[8]

Prince Albert had formally approved the venture on condition that the proposed exhibition would provide more than the 'mere gratification of public curiosity' and should instead 'illustrate the history of Art in a chronological and systematic arrangement, [so as to] speak powerfully to the public mind, and enable, in a practical way the most uneducated eye to gather the lessons which ages of thorough and scientific research have attempted to abstract.'[9] Again, the influence of Waagen was evident in the Consort's recommendation, as well as in the organizers' response: it was in Manchester (rather than the National Gallery, London) that Old Master paintings were first displayed in chronological order with the Northern and Southern Schools ranged across from each other, on either side of corridor-like galleries. Significantly, the prince insisted that this experiment in comparative art history should not be aimed primarily at the connoisseur, but rather should address the 'uneducated eye' to some productive, practical effect. That is to say, a wide and inclusive public was being invoked via the familiar metonymic substitution of the disembodied 'eye' for the person of the spectator and yet, as I argue in this chapter, it was the quantity and conduct of visitors' walking, looking and consuming *bodies* which provoked a stream of

commentary and debate that constituted an unofficial register of the exhibition's success. The direct impact of the exhibition on the eyes and minds of its visitors was impalpable, but their behaviour could be both monitored and evaluated as evidence of its scopic effect.

Based on personal memoirs, eye-witness accounts and contemporary critique, this chapter seeks to repopulate the Art-Treasures Exhibition with bodies that enacted, ignored or were impervious to both the subliminal and the explicit intentions of its organizers. My aim is first to re-attach Prince Albert's disembodied 'eye' to the animated, talking and walking bodies of its spectators, and then to show how the exhibition stimulated a commentary of comportment that was intended to rectify a lack of decorum – and, by extension, of aesthetic apprehension – among certain visitors. This chapter also shows that the Art-Treasures Exhibition was an accommodating space that, briefly, authorized an expanded range of visiting practices, while simultaneously guiding its spectators towards polite sociality and aesthetic receptivity (plate 6.4).

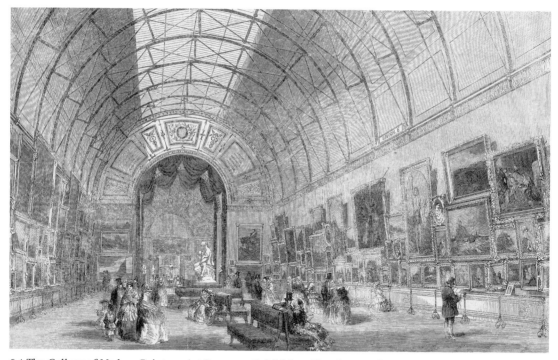

6.4 The Gallery of Modern Painters, Art-Treasures Exhibition, Manchester, *Illustrated London News*, 4 July 1857.

Although more than 1,300,000 people visited the exhibition between May and October 1857, opinions differed as to its success in attracting the participation of diverse bodies and in 'speaking to' the minds of its visitors. After the show closed one local newspaper commented that it had contributed to the 'education of not only the working people around us, but of multitudes from distant parts of the country, and in this way Manchester will have conferred a lasting benefit to the Kingdom as a whole.'[10] Predictably, London commentators tended to be more sceptical. For example, Charles Dickens (who visited the Exhibition on 1 August)

claimed that the organizers were disappointed not to have sold more shilling tickets and had been obliged to rely on receipts from two-guinea season tickets to recover their financial outlay. He believed that, on balance, the exhibition had failed to capture the interest and imagination of working-class visitors who lacked the knowledge to decipher and appreciate any but the most naturalistic works of art: 'The plain fact is, that a collection of pictures of various "schools" excites no interest, and affords but little pleasure to the uninstructed eye.'[11] There was, however, one aspect on which everyone agreed: namely, that throughout the exhibition, there was very little unruly, mischievous or criminal behaviour.[12] Dickens was among those who noted that worries about the 'destructive properties of the English mob' were shown to be misplaced when, at the end of the exhibition, over one million visitors of all classes had not 'misbehave[d] themselves while partaking of a tempting Art-banquet'.[13]

However, the 'good behaviour' required of the public was more nuanced and more demanding than the absence of damage to the exhibits. Visitors' conduct was closely observed as evidence of their response not only to the art on display, but to the material and symbolic space of the Art-Treasures Palace itself. Deportment, posture, gesture and speech were scrutinized as a means of calibrating the degree to which the exhibition produced the desired effect of speaking to the minds and educating the eyes of its public. The gait of 'lounging', 'parading' or 'wandering' visitors was translated as a register of affects, and such evidence of 'languor', 'vanity' or 'confusion' was deemed symptomatic of a failure adequately to interiorize the aesthetic encounter provided by the exhibition. Thus, the acquisition of a repertoire of appropriate 'bodily techniques'[14] via the emulation of more practised spectators was an important aspect of art education performed within the arena of the exhibition: if visitors could be made to walk properly, they would also learn to look properly. Both the spatial organization of the Art-Treasures Palace and the 'educational' presentation of art history within the exhibition were devised to direct visitors' walking and looking in a systematic and productive alliance, albeit one that proved to be more conducive to the apprehension of the vast exhibition *en masse* than the appreciation of the individuated work of art.

Both Carol Duncan and Tony Bennett have convincingly associated the regulation of walking and looking within the modern museum or art gallery with its conception as a site for the enactment of 'civic rituals'.[15] As Bennett puts it, the museum's regime of vision is designed to produce particular forms of 'civic seeing': a process whereby the lessons embodied in the display of collections are 'to be seen, understood and performed by the museum's visitors'.[16] From this perspective, an exhibition acts on visitors' bodies as a medium of physical as well as mental instruction. Yet our own experience tells us that the performance of an exhibition's lessons is often half-hearted, tiring or confusing. It is easy to recognize the 'sense of constraint' experienced by Paul Valéry at the threshold of the Louvre when '. . . a hand relieves me of my stick, and a notice forbids me to smoke.' Deprived of the props that mediate his encounter with the world of people and objects, and, in turn, bored, admiring and distracted, Valéry finds that he loses his capacity to behave normally: 'My voice alters, to a pitch slightly higher than in church, to a tone rather less strong than in every day.'[17] Staggering from one masterpiece to another, his body rebukes rather than obeys the coded messages of

the art museum. Famously, Stendhal suffered an even more intense, if less rebellious, reaction to proximity of an over-abundance of art during his visit to Florence, including palpitations of the heart and dizziness.[18] Whether or not there were any cases of the 'Stendhal Syndrome'[19] in Manchester during the summer of 1857, reports of bewildered minds and exhausted bodies enable us to recover (and identify with) at least some visitors' experiences inside the Art-Treasures Palace.

A DIARY OF THE EXHIBITION

The most elusive document of any exhibition is the response of the individual visitor, as opposed to the professional critic. Those who do record their feelings are, of course, self-selecting, and those records that survive may be the product of chance as well as design. In the case of the Art-Treasures Exhibition, the letters and diaries of famous visitors provide tantalizing glimpses of what may (or may not) have been common responses among an educated, but non-specialist, public. After a long afternoon at the exhibition, William Gladstone wrote in his diary that it was 'a wonderful sight materially, & not less remarkable morally, but bewildering to the mind & exhausting to the eye from vastness when viewed wholesale'.[20] Gladstone's visit was listed in the weekly roll-call of visiting dignitaries published in the *Art-Treasures Examiner*, whereas the presence of Fried-rich Engels went unnoticed. Engels was an enthusiastic supporter of the exhib-ition, and working at his family's Manchester cotton mill, he had the advantage over Gladstone in being able to visit more than once.[21] Another regular visitor was Elizabeth Gaskell, who wrote to her publisher, George Smith, in early June urging him to visit the 'beautiful' exhibition, adding 'I think Italy makes us enjoy seeing the pictures of our friends, the great Masters, all the more.'[22] However, by the end of the summer the 'commotion'[23] of hosting a stream of friends' visits had become exhausting: 'Oh I am so tired of it. X I mean, – I shd like it dearly if I weren't a hostess.'[24] By now she was visiting the exhibition only for the sake of others and had lost patience with 'showing the same great pictures over & over again to visitors, who have only time to look superficially at the collection'.[25]

Unlike Gaskell, whose recorded response to the exhibition was primarily mediated through a network of social obligations and her duties as a hostess, the novelist Nathaniel Hawthorne, also a frequent visitor to the Art-Treasures Palace, usually visited by himself and always for his own gratification. Hawthorne's diary provides the most sustained personal response to the Art-Treasures Exhibition throughout the summer of 1857. Having been appointed American Consul in Liverpool in 1853, he was now at the end of his term of office and had the leisure to make a close study of the exhibition, prior to an impending trip to France and Italy. Hawthorne stayed in Manchester from 22 July to 8 September, his 'principal object being to spend a few weeks in the proximity of the Arts' Exhibition'.[26] To that end, he first took lodgings close to Old Trafford on Stretford Road, along which special scarlet and white buses passed every three minutes on their way to the Art-Treasures Palace.[27] Hawthorne's diary records that he went to the exhib-ition at least twelve times, and successive entries provide a singular insight into the arc of his experience there: from his initial dismay at the size and impossi-bility of the whole thing, to the serious reflections of the autodidact, measured enjoyment of the exhibits, the fascination of his fellow spectators and, finally,

boredom with the whole event. Perhaps we can see something of the solitary Hawthorne (if not his dress) as he absorbed the social spectacle, in the image of the lone figure in the middle of the Grand Hall (plate 6.1).

The day after Hawthorne and his family moved into the rented house in Old Trafford, he walked to Art-Treasures Palace, but did not go in. His immediate impression was that it was 'small compared with my idea of it, and seems to be of the Crystal Palace order of architecture, only with more iron to its glass'.[28] The next day, once inside, his view was rather different:

> The edifice, being built more for convenience than show, appears better in the interior than from without, – long vaulted vistas, lighted from above, all hung with pictures; and on the floor below, statues, knights in armor, cabinets, vases, and all manner of curious and beautiful things, in a regular arrangement. Scatter five thousand people through the scene, and I do not know how to make a better outline sketch.[29]

If the external proportions of the Art-Treasures Palace were deceptively modest and the brick and iron construction less spectacular than the Crystal Palace, then the interior galleries were undoubtedly vast. The building was 704 feet long and 200 feet wide (plate 6.5), and the galleries alone (excluding the refreshment rooms, offices and stores) covered 15,131 square yards.[30] On entering the building, Hawthorne found himself at the end of the Great Hall or Nave that ran the entire length of the building, flanked by lines of sculpture and armour. At the far end the Nave was dissected by the Transept beyond which, in a sanctuary-like space, was the orchestra stage and organ, where daily musical concerts were performed. On either side of the Nave there was an *enfilade* of galleries that housed the Ancient and Modern Masters respectively. Designed by a firm of Edinburgh iron founders, C.D. Young and Co, and erected in less than nine months within a budget of £25,000, the Art-Treasures Palace combined structural economy with the space syntax of a cathedral.[31] Nobody thought that it was beautiful, but museum professionals such as Waagen praised its natural lighting and internal proportions as being conducive to the study of art.

Hawthorne's initial experience of the Art-Treasures Exhibition was simultaneously overwhelming and disappointing; he writes that he was 'unquiet, from a hopelessness of being able to enjoy it fully'.[32] Such unease was symptomatic of those who, from Quatremère de Quincy onwards, have resisted the very concept of the art museum as an assault on the intellect, the senses and the soul of the viewer.[33] For Hawthorne, nothing was 'more depressing ... than the sight of a great many pictures together; it is like having innumerable books open before you at once, and being able to read only a sentence or two in each. They bedazzle one another with cross lights.'[34] His sentiments predict Valéry's famous comment that 'just as a collection of pictures constitutes an abuse of space that does violence to the eyesight, so a close juxtaposition of outstanding works offends the intelligence.'[35] Like Valéry, who 'staggers' from one picture to the next in the Louvre, Hawthorne could not fix on any one object because he was continually distracted by its neighbours. He therefore resolved to get 'a general idea' of the exhibition as a whole, rather than look at anything in particular. Overall the exhibition was, he thought, 'very fine' and yet, he added, 'every great show is a kind of humbug' because everyone else was '... skimming the surface, as I did,

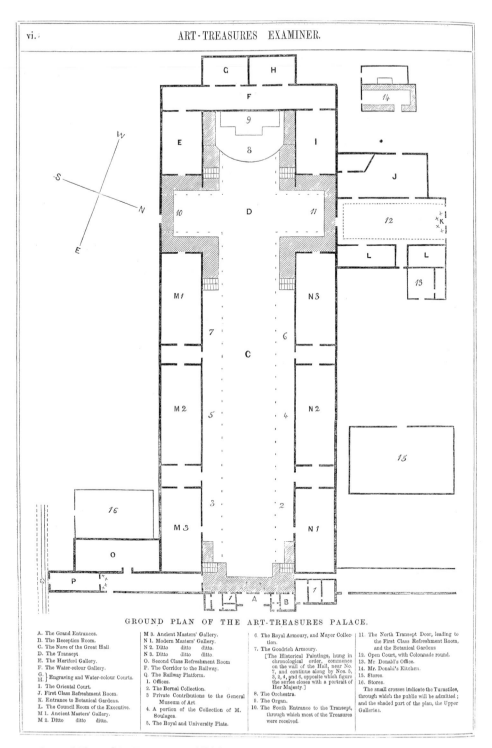

GROUND PLAN OF THE ART-TREASURES PALACE.

A. The Grand Entrances.
B. The Reception Room.
C. The Nave of the Great Hall
D. The Transept
E. The Hertford Gallery.
F. The Water-colour Gallery.
G. }
H. } Engraving and Water-colour Courts.
I. The Oriental Court.
J. First Class Refreshment Room.
K. Entrance to Botanical Gardens.
L. The Council Room of the Executive.
M 1. Ancient Masters' Gallery.
M 2. Ditto ditto ditto.

M 3. Ancient Masters' Gallery.
N 1. Modern Masters' Gallery.
N 2. Ditto ditto ditto.
N 3. Ditto ditto ditto.
O. Second Class Refreshment Room
P. The Corridor to the Railway.
Q. The Railway Platform.
1. Offices.
2. The Bernal Collection.
3 Private Contributions to the General Museum of Art
4. A portion of the Collection of M. Soulages.
5. The Royal and University Plate.

6. The Royal Armoury, and Mayer Collection.
7. The Goodrich Armoury.
[The Historical Paintings, hung in chronological order, commence on the wall of the Hall, near No. 7, and continue along by Nos. 5, 3, 2, 4, and 6, opposite which figure the series closes with a portrait of Her Majesty.]
8. The Orchestra.
9. The Organ.
10. The South Entrance to the Transept, through which most of the Treasures were received.

11. The North Transept Door, leading to the First Class Refreshment Room, and the Botanical Gardens
12. Open Court, with Colonnade round.
13. Mr. Donald's Office.
14. Mr. Donald's Kitchen.
15. Stores.
16. Stores.
 The small crosses indicate the Turnstiles, through which the public will be admitted; and the shaded part of the plan, the Upper Galleries.

6.5 Ground Plan of Art-Treasures Exhibition, *Art-Treasures Examiner*, 1857.

and none of them so feeding on what was beautiful so as to digest it, and make it a part of themselves'. [36] Although his fellow visitors were 'very well behaved', the very size of the exhibition meant that their enjoyment was inevitably superficial: to borrow Dickens's metaphor, the 'art banquet' was simply too rich and too dense to absorb in a single sitting.

Hawthorne was not alone in finding that there was an inherent tension arising from the size of the Art-Treasures Exhibition, between the experience of the spectacle in its entirety and the possibility of concentrating on an individual object. Of course, this was not an unfamiliar problem: two years earlier, the *Daily Telegraph* correspondent in Paris had written that he had never met anyone who felt satisfied after a single visit to the Louvre because it was so vast that it took a day just to find your way around.[37] However, the same writer was also critical of those English families who marched through the galleries too fast to absorb any of their contents, yet loudly passed opinions on what they had not properly looked at. Evidently, in the Art-Treasures Palace, as in the Louvre, the pace of walking should be moderated so as to accommodate both economy of motion and also aesthetic receptivity. The authors of various guidebooks to the exhibition were sensitive to the problem: assuming that the majority of their readers would visit just once, how could they be steered around the Palace with maximum efficiency while also finding time to linger in front of the most important works on show? One writer was quick to allay any qualms about the size of the exhibition at the outset: 'If the idea of confusion should suggest itself to the mind of anyone, we should recommend its instant suppression.' [38] He then led his readers on an exhaustive 'tour of inspection' of the entire Palace, before recommending a walk in the fresh air to finish the day.

Addressing a different readership, the author of *What to see and where to see it! Or the Operative's Guide to the Art Treasures Exhibition* says that he has produced his 1d pamphlet to meet the needs of those operatives and their families who appeared 'somewhat bewildered and dazzled' by the size of the exhibition, and whose time for visiting was necessarily limited. Whereas the majority of exhibition guides began with the gallery of Ancient Masters, this author advised his readers to start their visit in the Museum of Ornamental Art where they would find objects whose design and craftsmanship they could appreciate more readily than '... the ideal productions of the painter'.[39] Even so, the itineraries recommended in all of the guidebooks are daunting, and we can only surmise how many readers adhered to their prescribed route for a whole day. Evidence suggests that many did not: at the end of the first month, one commentator wrote that, 'The novelty of the show as a whole, the distraction afforded by its magnitude and variety, leading people hither and thither without a fixed purpose, have held the educational and refining influences of the affair in suspense'[40]

Hawthorne, however, had the advantage of being able to come back to the exhibition throughout the summer and, after his first visit, resolved to 'take each day some one department, and so endeavour to get some real use and improvement out of what I see'.[41] Accordingly, subsequent diary entries record his impressions of the modern paintings followed by the historical portraits, the Ancient Masters, Old Master drawings, the watercolour gallery, and the engravings and photographs. While he enjoyed looking at the 'relics of antiquity' that conjured up figures and events from the past as well as the modern paintings, he

persevered in studying the Ancient Masters, which, he said, 'give me more and more pleasure the oftener I come to see them.'[42] For Hawthorne, they were an acquired taste 'like that for old wines; and I question whether a man is really any truer, wiser or better for possessing it.'[43] Having visited the exhibition regularly for a month, he was increasingly of the view that 'a picture cannot be fully enjoyed except by long and intimate acquaintance with it.'[44] Like others, Hawthorne complained that, because of the dense triple and quadruple hang of pictures, many cannot 'be more than half seen, being hung too high, or somehow or other inconvenient'. [45] At last, however, he developed a sense of *ennui* with the whole affair. By the time he left Manchester in early September, the exhibition 'was fast becoming a bore; for you really must love a picture to tolerate the sight of it many times.'[46]

Hawthorne's reflections on the paintings were frequently peppered with comments on the composition and behaviour of his fellow visitors. Like the solitary onlooker in plate 6.1, he was always ready to be distracted from looking at a picture by the competing spectacle of the crowd. He admitted that he had often visited the second-class refreshment room in order to see 'John Bull and his wife ... in full gulp and guzzle, swallowing vast quantities of cold boiled beef, thoroughly moistened with porter or bitter ale; and very good meat and drink it is'.[47] His initial impression was that the majority of visitors were 'middling-class people', adding that the exhibition 'does not reach the lower classes at all' because even if they came, they required 'a good deal of study to help it out'. [48] In this respect, they are in the same position as their 'betters' because no one has the capacity 'to take in the whole of it' in a single visit.[49] Two weeks later, on Saturday 8 August, he noticed the effect of 6d admission from two o'clock onwards when, as a result, the exhibition 'was thronged with a class of people who do not usually come in such numbers'.[50] On this occasion, he observed that 'it was both pleasant and touching to see how earnestly some of them sought to get instruction from what they beheld.'

It was not only the presence of the workers and their families that captured Hawthorne's imagination. One day a fellow visitor informed him that Tennyson, the Poet Laureate, was in the exhibition and Hawthorne was delighted when he tracked him down: 'Gazing at him with all my eyes, I liked him well, and rejoiced more in him than all the other wonders of the Exhibition.'[51] However, an adequate sketch of the poet eluded him, and in the end he gave up trying to pin down what it was that fascinated him about Tennyson 'for I cannot touch the central point'. This, he felt, was also the failure of the portrait painter, whose own 'conceit' stands in the way of a true likeness of appearance and penetration of character.

Finally, Hawthorne had 'had enough' both of the Exhibition and of Manchester.[52] For the previous seven weeks, he had recorded his experiences at and feelings about the Art-Treasures Palace, and even though Hawthorne was a professional writer and a public man, the inconsistencies of his account (veering from pleasure to boredom, confusion to understanding) reveal a very plausible personal response to the Exhibition as a social, cultural and physical encounter.[53] In many ways Hawthorne was a model visitor – systematic, studious and reflective – yet in the end, he felt that the Art-Treasures Exhibition was a failure

because it 'must be quite thrown away on the mass of spectators' who had neither his time nor inclination to make a prolonged study of it.[54]

DISQUIETING BODIES: 'LADS OF THE LOOM' AND 'THOUGHTLESS BLOCKS OF MILLINERY'

Hawthorne's keen interest in the conduct of the 'lower classes' at the exhibition was typical of the social commentary of his own social *milieu*. His diary echoes a familiar refrain of alternating questioning and approbation of the effects of an expanded and diversified public for art exhibitions. [55] In London, this debate had acquired added impetus since the foundation of the National Gallery in 1824, while in Manchester, the foundation of the Royal Manchester Institution (RMI) in 1823 (plate 6.6) and the Mechanics' Institute the following year, had demarcated two distinct exhibitionary and educative spaces within the city. The former primarily attracted the 'settled man of business', his family and his professional associates, while the latter's constituents included 'the shopkeeper, the shopman, the shopboy, the mechanic and the artisan'.[56] Exhibitions of both modern and Old Master paintings were held regularly at the RMI's premises on Mosley Street,[57] and in 1838 the Mechanics' Institute embarked on a programme of annual exhibitions of 'natural history, works of art and mechanical contrivance' at its premises on Cooper Street.[58] Unlike the exhibitions at the RMI which habitually attracted a few thousand visitors, those at the Mechanics' Institute were immensely popular, drawing audiences of more than 50,000 'working men, their wives and their children'.[59] The exhibition programme was revived when the

6.6 The Royal Manchester Institution, Mosley Street. Engraving, from W.H. Pyne, *Lancashire Illustrated*, London, 1828–31

Mechanics' Institute opened new, enlarged premises in 1856, the timing of the inaugural exhibition being brought forward so as not to coincide with the Art-Treasures Exhibition.

Against this backdrop of socially differentiated, associational civic culture, the level of working-class participation in the Art-Treasures Exhibition was bound to attract considerable attention. The presence of 'operatives' and 'artisans' in the Art-Treasures Palace provided commentators with an unprecedented opportunity to observe the character and conduct of the urban poor within the sphere of visual culture, not least as a means of assessing the efficacy of the exhibition as an educative and refining medium. Already, the scrutiny and analysis of working-class bodies and lives was well established in the city as a means of measuring and managing social issues. Notably, the Manchester Statistical Society had been formed in 1834 with the purpose of gathering facts on subjects such as housing conditions, access to clean water, the consumption of fresh meat and the circulation of books and pamphlets, thereby rendering the lives of working people both visible and, to an extent, explicable to middle-class investigators. [60] In this context, the assembly of gendered, aged, labouring and leisured bodies of all social classes within the Art-Treasures Palace functioned as temporary social laboratory, in which the behaviour of particular groups could be isolated and evaluated in terms of their capacities as cultural consumers.

Mary Poovey describes those processes of quantification and aggregation of persons and classes as a means of 'making a social body' that comprises the entire population.[61] She argues that this process of aggregation went hand in hand with a process of disaggregation, whereby the social sphere was increasingly distinguished from the economic and political spheres. And just as the aggregation of persons (via the accumulation of statistics) enabled the delineation of the social body, so 'innovations like affordable transportation, cheap publications, and national museums' enabled its materialization by bringing 'groups that had rarely mixed into physical proximity with each other and represent[ing] them as belonging to the same, increasingly differentiated whole'.[62] From this perspective, mass participation in the Art-Treasures Exhibition can be viewed as a critical event in the abstraction and formation of the 'social' in Manchester. Within this temporary materialization of the 'social body', there were two groups of visitors whose unprecedented visibility and ungoverned sociality within the public sphere prompted scrutiny and also disquiet among the exhibition's commentators: namely, working-class men and middle-class women. Inside the physical and symbolic space of the exhibition, each category became disconcertingly visible as members of a single social body.

As I have indicated, opinions as to the extent and effect of workers' participation in the exhibition were divided between those who argued that their absence was more noticeable than their presence and that they were largely 'untouched' by the experience – and vice versa. The fact that Hawthorne himself held each of these opinions at different times suggests that there was no definitive answer on either point. However, on one aspect of the matter commentators were unanimous: it was working men – and specifically working men's bodies – within the exhibition that were of primary interest. By contrast, working-class women went almost entirely unnoticed, yet they undoubtedly took part in both family and works outings. Moreover, their responses to the exhibition were deemed by some writers to be of

little interest, inasmuch as it was assumed that they would be influenced by their men folk whose 'taste for the fine arts' (rather than their wives' or daughters') had the potential to 'throw an additional charm over the felicities of family life, and add a silken cord to the ties that unite the family circle'.[63]

In contrast to such lofty aspirations, Dickens believed that the organizers were disappointed at the level of working-class participation in the exhibition, asserting that 'the working man has not come forward eagerly, neither with his shilling, nor with that glow of enthusiasm for the thing of beauty, which, it was promised him, would be a joy forever.'[64] For all of Dickens's irony, 'the glow of enthusiasm' is a telling phrase because it was precisely such evident, but controlled, eagerness among 'lads of the loom' that attracted the approbation of commentators. The *Art-Treasures Examiner* conjured up an idealized artisan in the art gallery who was characterized by his 'quick glance, flushing cheek, the healthy, hearty admiration that expresses itself curtly, coarsely it may be, but earnestly and forcibly'. Such spontaneous expressions of appreciation were considered preferable to 'the cold eye of languid inspection' and the 'vapid common-places of conventional rule-criticism' uttered by the seasoned visitor, who has seen it all before.[65] During the course of the exhibition certain pictures acquired a kind of celebrity status arising from and, simultaneously contributing to, their popularity among working-class visitors in particular. According to the *Art-Treasures Examiner*, the first Saturday afternoon of 6d admission attracted a large number of 'young factory operatives who crowded round the most showy pictures with evident delight'.[66] The word 'showy' indicates that these were not paintings that elicited the admiration of art experts; instead, their public appeal was attributed to their drama, emotionalism and pathos.[67] Most celebrated of all were *The Death of Chatterton* by Henry Wallis in the Gallery of Modern Masters (plate 6.7) and *The Three Maries* by Annibale Carracci (plate 6.8) in the Gallery of Ancient Masters, the latter being frequently cited as the most visited picture in the entire exhibition.[68] The disjunction between the more measured scholarly view of these works and their public popularity also marks the shift from decorum to enthusiasm: the latter is to be encouraged, but also checked if it becomes excessive.

If a spectator as worldly as Hawthorne experienced a sense of unease on first entering the Art-Treasures Palace, it was hardly surprising that those less familiar with the ritual space of the art gallery were bewildered by the scale and logic of the exhibition. Before long, the failure of some working-class visitors to grasp both the concept and the conventions of the exhibition became the butt of satirical anecdotes. For example, when a group of mill workers was asked what they thought of their visit, one of the hands reputedly answered: 'Aye, we be theer . . . [but] there wur nought to see!' [69] Similarly, the *Art Journal* reported that another group of factory workers had spent a couple of hours wandering around the Art-Treasures Palace 'with puzzled anxiety. Then, eagerly and with a mixture of apprehension and weariness, they inquire, "when the exhibition would begin?" Obtaining no such answer as they desired, they gradually dispersed, to seek consolation for themselves in the neighbouring places of "good entertainment." '[70] Dickens attributed such defections from the exhibition to indifference and boredom. He recounted a tale of 1,200 factory workers from Sheffield whose visit to Manchester was organized and paid for by their employer; 1,000 of whom had disappeared before their lunch was served in the second-class refreshment room, thereby leaving just two hundred of the original party to eat the meal

6.7 Henry Wallis, *The Death of Chatterton*, 1856. Oil on canvas, 62.23×93.3 cm. London: Tate.

provided for them.[71] The problem was that 'the care for the common people, in the provision made for their comfort, and refreshment, is ... admirable and worthy of all commendation' but, he argued, 'they want more amusement, and particularly something in motion, though it were only a twisting fountain. The thing is too still after their lives of machinery; the art flows over their heads in consequence.'[72] If this was true, then the Art-Treasures Exhibition was not in direct competition with the educative displays at the Mechanics' Institute, but with more spectacular entertainment on offer at Madame Tussaud's Wax Museum near Portman Square, Belle Vue Zoological Gardens and Pomona Gardens, advertised as being just 'three minutes walk' from the Art-Treasures Palace.[73]

During the summer of 1857, Pomona Gardens offered diverse 'sources of Amusement and delight' including Dickens's twisting fountains, as well as 'classical works of statuary, an archery ground, maze, shooting gallery, gymnasium, magic bridge, camera obscura, cosmorama, flying swings, billiard room, pleasure boats, and concert room'. The main attraction of the season was a panoramic 'Representation of the city of Paris' depicting all the major buildings and sights, painted by painted by Messrs Rowe, Whaite, and Assistants. Given the perceived popular preference for 'amusement', 'motion' and mimesis, the proximity of such entertainment must have been tempting to many with a shilling to spare who wearied of the Art-Treasures Exhibition. However, there was also an important acknowledgement of the physical and mental challenge of viewing art on such a vast scale within the Art-Treasures Palace itself: namely, the daily musical

performance under the superintendence of Charles Hallé.[74] Each afternoon, the concert transformed the Palace into a kind of indoor pleasure garden where visitors could stroll or sit while listening to the music. For many visitors, the combination of sound and spectacle provided by Hallé must have been redolent of Pomona and Belle Vue, while the carefully chosen programme upheld 'the dignity of the art of which he is so great an ornament, and daily provided to the public the *chefs-d'oeuvre* of the greatest masters of music.'[75] Even if many visitors continued to look at the displays during the performance, for a couple of hours each day, the collective activity of listening overlay the atomized viewing of art.

By the end of the summer, similarly innovative participatory practices had developed among organized parties of working-class visitors to the Art-Treasures Exhibition. Nowadays an organized outing to an exhibition usually comprises an aggregate of private individuals; in 1857 it provided an opportunity to perform the communal identity of a school, club or association through processional walking, carrying banners, wearing uniforms or playing music. By the mid-nineteenth century working-class practices of processional walking were well established in Manchester and across the north of England. The custom of local 'Walking Days' or 'Whit Walks' had first emerged within the Sunday School Movement in recognition of the need of child workers, literally, to stretch their

6.8 Annibale Carracci, *The Three Maries*, *c.*1604. Engraving, in *Art-Treasures Examiner*, 1857.

85

6.9 Opening Ceremony of the Art-Treasures Exhibition, *Illustrated London News*, 16 May 1857.

legs out of doors after a week confined to the factory or workshop.[76] Now, similar processions of schools, temperance societies and boys clubs entered the Art-Treasures Palace, walking behind their flags and banners, and sometimes accompanied by their own bands. Their attendance was recorded in the weekly *Art-Treasures Examiner*, next to the names of visiting dignitaries, thereby conferring both publicity and approval on their collective presence in the exhibition.[77]

Many factory owners followed suit by arranging and financing outings for their workers and their families, confident in the expectation that the assembly of their workforce would enhance the reputation of the company. Perhaps the largest and most spectacular single visit took place on Saturday 19 September, when 2,500 workers from the 'monster manufactory of Messrs Titus Salt and Co, of Saltaire' near Bradford, came to Old Trafford 'all attired in their Sunday best'.[78] They travelled to Manchester in three special trains, accompanied by a brass band and a drum and fife band. Marching behind their banners and the two bands, the workers processed into the Palace 'in an orderly manner, with the bands playing "The Fine Old English Gentlemen"'.[79] The bands continued to play during the workers' visit, entertaining

their colleagues and their families during lunch (served in two sittings of 1,250 in the large dining room next to the second-class refreshment room) and then, taking up 'a commanding position in the upstairs gallery, the drum and fife band played a selection of their most popular pieces to the "evident gratification of many of the visitors".' Some apparently regarded the music as hardly 'fit' for an art gallery, 'but even these cheerfully acquiesced on the principle that some license should be conceded on such an extraordinary occasion.' [80] The evident sense of occasion and the display of the workers' *esprit de corps* contrasted with the confusion and fatigue felt by other visitors; the purpose of the Saltaire outing was to participate in the exhibition as an event in itself, not to look at 16,000 works of art in one day.

An equally successful arrangement for enjoying the exhibition was devised by the manager of the Belfield Printing Company when he brought 300 workers and their families to Old Trafford on 19 August. Before entering the Art-Treasures Palace, the workers first visited the adjacent Botanical Gardens and only 'after examining the beauties of the place, and discussing the merits of the carnations and picotees, which many of them seemed able to do, the remainder of the day was spent in the Exhibition.'[81] Such a display of erudition was not surprising given the number of local botanical societies that flourished all around Manchester, and the acknowledged expertise of Lancashire botanists. [82] But although the popularity and seriousness of amateur botany in the region was well known, this was the only recorded instance of an employer making use of the proximity of the Botanical Gardens to provide his workers with the opportunity to practise their own cultural competence, before encountering the less familiar space of the art exhibition.[83]

Hawthorne never tired of watching the crowd in the Art-Treasures Palace, but did not seek to make a spectacle of himself on his solitary visits. Others were evidently less self-effacing, and critics of the exhibition frequently complained that many visitors were more interested in the social ritual of mutual recognition than in the works of art:

> If ladies and gentlemen had to go to Old Trafford in deal cases, and see each for himself the
> several pictures so shrouded, only the light above and the art-treasures before them; in other
> words, if they had to go solely for the pictures – to look at the pictures and not at their
> neighbours – how many season tickets would have been sold, how many crinolines would have
> choked the turnstiles?[84]

In the same vein, Dickens noted that 'The experience of the regular frequenter of the Manchester galleries was that, the majority of the well-dressed crowd gossiped and grouped around the music, promenaded and looked and admired each other – did everything, in short, except examine the pictures.'[85] Perhaps he counted himself among this crowd, because among the pleasures of the exhibition he described '... the moving spectacle of well-dressed, ever-changing company, always delightfully sprinkled with Lancashire witchcraft, which spreads its incantations (and its ample drapery) broadcast over the scene'.[86] Dickens was not alone in his ambivalence about the performance of specifically female sociality staged in the Art-Treasures Palace. The *Illustrated London News* reported that 'forms of witching beauty and female loveliness moved gracefully amid the treasures of art' at the opening of the Exhibition (plate 6.9).[87] But once the glitter and majesty

of the opening ceremony had dimmed, critics increasingly condemned the behaviour of 'the frivolous and the idle' for 'making that temple a parade ground, insulting the shades of the mighty men of genius with the silly vanities of fashion'.[88] The display of women's clothes and the view that they had occupied the exhibition for the purpose of a fashion parade was a recurring theme among (male) commentators. Expressions such 'a crinoline' or 'the most thoughtless block of millinery' were used by many, signifying metonymically the woman who wore it.[89]

The organization of the Art-Treasures Exhibition had been an entirely male affair;[90] once it opened, middle-class women were enjoined to participate as cultural consumers whose presence and conduct would add to its refining effects. In practice, their visibility within the Art-Treasures Palace was more disquieting, and women's bodies were scrutinized for evidence of their ability to absorb the lessons of the exhibition. Although their fine clothes signalled their (and their husbands') social status, their failure to master the choreography of walking, talking and looking at art, as well as at each other, destabilized the 'play of appearances' within the Palace.[91] While advertisements for milliners, shawlmen, drapers, glovers and bootmakers in one guidebook to the exhibition were directly aimed at women as consumers of fashion, the evident conspicuousness of their bodies and their dress in 1857 presaged a longer term re-gendering of the economy of cultural consumption, particularly in the visual arts.[92]

CONCLUSION: WALKING FOR PLEASURE?

To many commentators Manchester was, to say the least, an incongruous setting for an exhibition of Art Treasures.[93] Hawthorne reflected that 'It is singular that the great Art-Exhibition should have come to pass in the rudest great town in England.'[94] During the previous decade, authors such as Benjamin Disraeli, Gaskell and Dickens had fixed the city within the national imaginary via its literary aliases, 'Mowbray', 'Coketown' and 'Milton'.[95] Each denoted a city whose skyline was delineated by chimney stacks, and whose daily rhythms were regulated by the exigencies of the cotton mill. Within its heart, '... the ceaseless roar and mighty beat, and dizzying whirl of machinery, struggled and strove perpetually.'[96] If this was an unlikely setting for an exhibition of art, its fictive inhabitants such as Messrs Gradgrind, Thornton and Carson were equally unlikely in the role of cultural philanthropists. In literature, the stereotypical Manchester man was energetic, industrious, plain-speaking and uncultured; the Art-Treasures Exhibition shows that the reality was, of course, more complex than the stereotype suggests.

Gaskell's Manchester novels repeatedly evoke a city of 'haste, bustle and speed' where both masters and men were equally and continually 'busy and restless'.[97] In her 'Milton', '... there were few loiterers – none walking for mere pleasure'.[98] This city is not the urban playground of the *flâneur*, and rather than 'botanising on the asphalt',[99] Manchester men delighted in botanizing in the fields away from the smoky city. Yet the constant weekday motion of men and machines meant that its inhabitants relished the chance to stroll whenever they could. Gaskell describes how, on a Sunday morning, '... there was a pleasure, an absolute refreshment in the dawdling gait they, one and all of them, had.'[100] Just walking, rather than hurrying, was a means of physical and mental recuperation.

The invitation to participate in the Art-Treasures Exhibition invoked a choreography of walking and looking that involved neither hurrying nor loitering. As the exhibition progressed, a code of etiquette emerged from the observation and description of misguided, ignorant or foolish behaviour. Given the scale of the Art-Treasures Palace, guidebooks encouraged a mode of purposive strolling along a predetermined route, in order to apprehend the exhibition in an unhurried, yet efficient, manner in a single visit. However, it was also clear that within the 'social body' of the Exhibition's public, the disaggregated bodies of individual visitors were more or less willing and competent to conform to the prescription of walking both for pleasure and for edification. Yet the Art-Treasures Palace was also an inclusive space, in which a wider repertoire of recreational practices was authorized, even if the presence and behaviour of certain categories of visitors aroused a degree of censure or anxiety. Within the daily programme of the exhibition, the afternoon concert must have provided a welcome diversion, both physically and mentally, as the promenade was briefly licensed, and listening accompanied looking. Similarly, the organized outings of workers and children staged the performance of communal, rather than individual, spectacle and spectatorship that reflected local cultural practices. For many, the Art-Treasures Palace was a temporary event that could be comprehended, enjoyed or resisted within a cityscape of factories, warehouses, shops, pubs, markets, chapels, libraries, slums, suburbs, parks and pleasure gardens. Recovery of the experiences and observations of the 'social body' of the exhibition shows that neither the coded messages of the display schema nor the example set by prestigious visitors were able to direct the behaviour and aesthetic responses of many spectators. In that sense, the practices and public of the Art-Treasures Exhibition were very specific to the conditions of mid-nineteenth-century Manchester, yet stand as a salutary example to exhibition historians and curators today.

Notes

1 Charles Baudelaire, 'The Painter of Modern Life', trans. Jonathan Mayne, *The Painter of Modern Life and Other Essays*, London and New York, 1995, 5.

2 Georg Simmel, 'The Metropolis and Mental Life', Donald N. Levine, ed., *On Individuality and Social Forms*, Chicago and London, 1971, 324–39.

3 Old Trafford is to the west of Manchester and was chosen as the site for the Art-Treasures Exhibition because, due to the prevailing 'aerial currents', the western suburbs were generally less smoky than the rest of the city. Thomas Morris, *An Historical, Descriptive and Biographical Handbook to the Exhibition of the United Kingdom's Art Treasures at Manchester*, 1857, 9.

4 The literature on the Art-Treasures Exhibition is not extensive compared with, say, the critical and historical attention devoted to the Great Exhibition of 1851. See: C.P. Darcy, *The Encouragement of the Fine Arts in Lancashire 1760–1860*, Manchester, 1976; Francis Haskell, *Rediscoveries in Art*, London, 1976; Ulrich Finke, 'The Art-Treasures Exhibition', in John Archer, ed., *Art and Architecture in Victorian Manchester*, Manchester, 1985; Giles Waterfield, ed., *Palaces of Art. Art Galleries in Britain 1790–1990*, London, 1991; Francis Haskell, *The Ephemeral Museum: Old Master Paintings and the Rise of the Art Exhibition*, New Haven and London, 2003; Elizabeth A. Pergam, '"Waking the Soul": The Manchester Art Treasures Exhibition of 1857 and the State of the Arts in Mid-Victorian Britain', unpublished PhD thesis, New York University, 2002.

5 The National Portrait Gallery had been established the previous year by a Treasury Minute dated 2 December 1856; in March 1857 the Gallery Trustees appointed George Scharf as Secretary (subsequently, Director), a post that he held until 1895. Meanwhile, Scharf was also one of main organizers of the 1857 exhibition, responsible for the selection and hanging of the gallery of Ancient Masters (Haskell, *Ephemeral Museum*).

6 *Catalogue of the Art Treasures of the United Kingdom. Collected in Manchester in 1857*, London, 1857.

7 A proposal to organize an exhibition of art treasures was mooted and approved at a meeting held in Manchester Town Hall on 28 March 1856.

8 Gustav Waagen, *Treasures of art in Great Britain : being an account of the chief collections of paintings, drawings &c*, 4 vols, trans. Lady Eastlake, London, 1854.

9 Letter from H.R.H. Prince Albert to the President of the General Council of the Exhibition. *Exhibition of Art Treasures of the United Kingdom held in Manchester in 1857 Report of the Executive Committee*, Manchester, 1859.

10 'Close of the Exhibition of Art Treasures', *Manchester Courier*, 24 October 1857, 6.

11 Charles Dickens, 'The Manchester School of Art', *Household Words*, 16, London, 1857, 348.

12 The exhibition was policed by forty-two officers each day and by eleven each night. According to Messinger, the number of crimes committed at the Art-Treasures Exhibition was lower than the number recorded at the Great Exhibition, London in 1851. Gary Messinger, *Manchester in the Victorian Age. The Half-Known City*, Manchester, 1985, 126.

13 Dickens, 'The Manchester School of Art', 348.

14 Marcel Mauss, 'Techniques of the Body', trans. Bill Brewster, *Economy and Society*, 2, 1973, 70–88.

15 Carol Duncan, *Civilizing Rituals: Inside Public Art Museums*, London and New York, 1995; Tony Bennett, *Pasts beyond Memory: Evolution, Museums, Colonialism*, London, 2004; Tony Bennett, 'Civic Seeing,' in Sharon MacDonald, ed., *A Companion to Museum Studies*, Oxford, 2006.

16 Bennett, 'Civic Seeing', 263.

17 Paul Valéry, 'The Problems of Museums', J. Matthews, ed., *The Collected Works of Paul Valéry*, New York, 1960, 202.

18 Stendhal, *Rome, Naples and Florence*, trans. Richard N. Coe, London, 1959, 302.

19 The 'Stendhal Syndrome' was named in 1979 by the Italian psychiatrist Graziella Magherini, who observed and described over one hundred similar cases among tourists and visitors in Florence.

20 Gladstone visited the Art-Treasures Exhibition on 29 June. William Gladstone, *The Gladstone Diaries*, 5, *1855–1860*, ed. H.C.G. Matthew, Oxford, 1978, 234.

21 Ulrich Finke, 'The Art-Treasures Exhibition', 102.

22 J.A.V. Chapple and Arthur Pollard, eds, *The Letters of Mrs Gaskell*, Manchester, 1966, 452.

23 Chapple and Pollard, *The Letters of Mrs Gaskell*, 461.

24 Chapple and Pollard, *The Letters of Mrs Gaskell*, 470.

25 Chapple and Pollard, *The Letters of Mrs Gaskell*, 476.

26 Nathaniel Hawthorne, *Passages from the English Note-books*, Cambridge MA, 1898, 518.

27 Two weeks later, the discomfort of these lodgings prompted a move to Chorlton Road, where the house was hardly better, but the landlady was more amenable.

28 Hawthorne, *English Note-books*, 519.

29 Hawthorne, *English Note-books*, 520.

30 By comparison, the Grande Gallerie in the Louvre is 1,300 feet long and 115 feet wide.

31 Bill Hillier, *Space is the Machine*, Cambridge, 1996.

32 Hawthorne, *English Note-books*, 520f.

33 Francis Haskell, 'Museums and their Enemies', *Journal of Aesthetic Education*, 19:2, 1985.

34 Hawthorne, *English Note-books*, 521.

35 Valéry, 'The Problem of Museums', 205.

36 Hawthorne, *English Note-books*, 521.

37 S-J. Bayle, *The Louvre, or Biography of a Museum*, London, 1855, 7. For further accounts of visitors' experiences of the Louvre, see J. Galard, ed., *Visiteurs du Louvre*, Paris, 1993.

38 Morris, *An Historical, Descriptive and Biographical Handbook*, 21.

39 E.T.B., *What to see and where to see it! Or the Operative's Guide to the Art Treasures Exhibition*, Manchester, 1857, 4.

40 P.I., 'The Exhibition Undressed', *Art-Treasures Examiner*, Manchester and London, 1857, 60.

41 Hawthorne, *English Note-books*, 521.

42 Hawthorne, *English Note-books*, 534f.

43 Hawthorne, *English Note-books*, 535.

44 Hawthorne, *English Note-books*, 539.

45 Hawthorne, *English Note-books*, 530.

46 Hawthorne, *English Note-books*, 545.

47 Hawthorne, *English Note-books*, 543.

48 Hawthorne, *English Note-books*, 527.

49 Hawthorne, *English Note-books*, 527.

50 Hawthorne, *English Note-books*, 535.

51 Hawthorne, *English Note-books*, 530f.

52 Hawthorne, *English Note-books*, 543.

53 The diaries were published posthumously by his widow.

54 Hawthorne, *English Note-books*, 538.

55 Colin Trodd, 'Culture, Class, City: The National Gallery, London and spaces of education, 1822–57', in Marcia Pointon, ed., *Art Apart: Art Institutions and Ideology across England and North America*, Manchester, 1994, 33–49; Andrew Hemingway, 'Art Exhibitions as Leisure-Class Rituals in Early Nineteenth-Century London', in Brian Allen, ed., *Towards a Modern Art World*, New Haven and London, 1995; Taylor, *Art for the Nation*; David Solkin, ed., *Art on the Line: The Royal Academy Exhibitions at Somerset House, 1780–1836*, New Haven and London, 2001.

56 'The Manchester Mechanics Institution', *Illustrated Times*, 8 November 1856, 309.

57 Designed by Charles Barry and opened in 1830.

58 C.P. Darcy, 'The Encouragement of the Fine Arts in Lancashire 1760–1860, Manchester, 1976, 109.

59 The exhibitions initially ran from 1838 to 1845 and were revived in 1856. Benjamin Heywood quoted in Darcy, Fine Arts in Lancashire, 111.

60 B. Love, Manchester as it is, Manchester, 1841; Messinger, Manchester in the Victorian Age.

61 A concept that had been institutionalized since the introduction of the census in 1801. Mary Poovey, Making a Social Body. British Cultural Formation, 1830–1864, Chicago, 1995.

62 Poovey, Making a Social Body, 4.

63 'Workng Men and the Art-Treasures Exhibition', Art-Treasures Examiner, 40.

64 Dickens, 'The Manchester School of Art', 350.

65 Art-Treasures Examiner, x.

66 Art-Treasures Examiner, 180.

67 Pergam, Waking the Soul, 273.

68 Hawthorne was surprised to discover the fame of The Three Maries, as he had 'hardly looked at it'. Hawthorne, English Note-books, 554.

69 'The Functions of Art by R.M', Art-Treasures Examiner, 176.

70 'Lectures at the Crystal Palace', Art Journal, 3, 1 October 1857, 325. See also Pergam, Waking the Soul, 290f.

71 Dickens, 'The Manchester School of Art', 330.

72 Charles Dickens, The Letters of Charles Dickens, 2 (1857–1870), London, 1880, 23.

73 Morris, Handbook to the Exhibition, unpaginated.advertisement.

74 Following the success of the orchestral programme at the Art-Treasures Exhibition, Charles Hallé formed the Hallé orchestra in 1858.

75 Art-Treasures Examiner, 300.

76 As the Whit Walks developed, the pattern was for children (and later adults) from different Sunday schools and churches to parade behind their banners through the streets to a common meeting place of worship. On Whit Sunday especially, the walk had an especially festive air, when people wore new clothes to symbolize rebirth into the church.

77 For example, on Saturday 7 September, 'There were several excursion trains to Manchester. Mr [Thomas] Cook had another "moonlight trip" from Newcastle, by which about 1,000 passengers reached Manchester about seven o'clock in the morning ... About 450 of the work people in the employment of Messrs. Winkworth, Proctor, & Co., of Macclesfield; about 800 in the employment of Messrs. Cooke, of Oxford Road; about 400 in the employment of Messrs. Houldsworth and Co., of Manchester; and

about 520 connected with temperance societies in Bradford and Halifax were also among the throngs who, by special train or otherwise, visited the Palace.' Art-Treasures Examiner, 240.

78 Art-Treasures Examiner, 252.

79 Art-Treasures Examiner, 252.

80 Art-Treasures Examiner, 252.

81 Art-Treasures Examiner, 204.

82 See Leopold Hartley Grindon, Manchester Walks and Wild Flowers, Manchester, 1859.

83 In fact, during the course of the Art-Treasures Exhibition the boundary between the Gardens and the Exhibition became a symbol of cultural distinction and exclusion instead. I am grateful to Ann Brooks, University of Manchester, for this information.

84 P.I. 'The Exhibition Undressed', Art-Treasures Examiner, 60.

85 Dickens, 'The Manchester School of Art', 350.

86 Dickens, 'The Manchester School of Art', 351.

87 'The Art-Treasures Exhibition at Manchester', Illustrated London News, 9 May 1857, 432.

88 P.I., 'The Exhibition Undressed', 60.

89 P.I., 'The Exhibition Undressed', 60.

90 D. Sachko Macleod, 'Homosociality and Middle-Class Identity', in A. Kidd and D. Nicholls, eds, Gender, Civic Culture and Consumerism. Middle-Class Identity in Britain, 1800–1940, Manchester, 1999, 65–80.

91 Simon Gunn, 'The Middle Class, Modernity and the Provincial City: Manchester c.1840–80', in Kidd and Nicholls, eds, Gender, Civic Culture and Consumerism. See also Wolff Janet, 'The Invisible Flâneuse: Women and the Literature of Modernity', Feminine Sentences. Essays on Women and Culture, Cambridge, 1990, 34–50.

92 Bootmakers Lulham Steadman and Co advertised a special line in ladies 'Promenade Boots' expressly made in their Brighton Establishment for those visiting the Art-Treasures Exhibition at 7s 6d a pair. Morris, Handbook to the Exhibition, unpaginated advertisement.

93 Pergam, Waking the Soul, 4f.

94 Hawthorne, English Note-books, 545. See also, Asa Briggs, 'Manchester, symbol of a new age', Victorian Cities, London, 1963; Gunn, 'The Middle Class, Modernity and the Provincial City'.

95 Benjamin Disraeli, Sybil, London, 1845; Charles Dickens, Hard Times, London, 1854, Elizabeth Gaskell, North and South, London, 1855.

96 Gaskell, North and South, 1995 edn, 407.

97 Gaskell, North and South, 296.

98 Gaskell, North and South, 296.

99 Walter Benjamin, Charles Baudelaire: A Lyric Poet in the Era of High Capitalism, London, 1973, 36.

100 Gaskell, Mary Barton, 1996 edn, 269.

7

MUSEUM STUDIES NOW

ANDREW McCLELLAN

The publication between 2004 and 2006 of three hefty anthologies – Donald Preziosi and Claire Farago's *Grasping the World: The Idea of the Museum*, Bettina Messias Carbonell's *Museum Studies: An Anthology of Contexts*, and Sharon Macdonald's *A Companion to Museum Studies* – marked a coming of age of Museum Studies.[1] A total of 128 articles and close to 2,000 pages, with remarkably little overlap among the volumes, points to a richness of scholarship across various disciplines – art history, history, sociology, anthropology. Museum Studies has emerged as a model of interdisciplinarity and intellectual vitality. Taken together, the books raise a number of questions about the field today. First, the contributors are mostly university-based academics in the United Kingdom and North America (a smattering of Continental European authors are included to lend intellectual heft and diversity), raising the question of whether museology is alive and well in, say, Poland, Japan, or Brazil, and if not, why not. Does the predominance of English-speaking authors reflect both growth in the museum sector and a greater openness of university curricula and museum career structures in the Anglo-American world? Second, the collections are almost exclusively theoretical and historical in focus; readers looking for practical, 'how to' guidance will be disappointed. Third, fewer than twenty (less than 15 per cent) of the articles are written by museum professionals. So, who is the audience for the growing literature in Museum Studies? Curators may not contribute much to the discourse, but are they consumers of it? Does the literature merely feed an expanding academic market, or is there some relation between museum history and theory and museum practice?

That museology has become a self-sustaining branch of academic study with strong debts to the leading lights of critical theory (Michel Foucault, Walter Benjamin, Jean Baudrillard, Pierre Bourdieu, Edward Said, etc.) should not obscure the extent to which it has been motivated by a desire to bring about change in real-world museums. If we briefly historicize museum criticism, an early phase propelled by the intellectual and social ferment of the 1960s attacked museums as instruments of state authority and elite influence, and sought to open their doors to previously marginalized groups, including women. A subsequent phase of the 1980s and 1990s, building on the first, pioneered case studies of prominent institutions and postmodern artists whose work deliberately resisted the museum's aesthetic and taxonomic norms. Critics exposed museum practices and narratives as culturally constructed and questioned the representation (or absence) of non-Western traditions in Western museums.

During the 1990s critics, joined by the mainstream press, also responded to two rising problems that further complicated museum governance and public relations, namely commercialism and cultural property. Escalating costs and decreasing government subsidies (at first in the USA, and more recently in Europe) forced many museums to increase admission fees and develop new commercial strategies – blockbuster exhibitions, shops, restaurants, singles' evenings and so on – to balance their budgets. According to critics on both the right and the left, such revenue-driven initiatives turned art museums into corporate billboards and costly amusement parks, diminishing access to the poor as well as the integrity of art. Fundraising and donor cultivation succeeded connoisseurship as the primary criteria for new museum directors. The decade of the blockbuster also witnessed the first firestorms over restitution, provoked by renewed attention to Nazi-era looting during the 1939–45 war and increased pressure from former colonies looking to reclaim their cultural patrimony from Western museums. Overnight, doubts were raised about the legitimacy of collections familiar to generations of museum-goers.

What effect has museum criticism had, and what lies ahead for museums and Museum Studies? Initially caught off guard by the assault on their values, museum professionals from the 1990s slowly began to absorb the lessons of criticism, adopting more reflexive practices (hanging, labelling) and promoting greater access. The range of temporary exhibitions became broader and more inclusive, helping to compensate for the glacial pace of change in permanent collections. Collections grow slowly, limited by cost and availability as well as curatorial taste, and no amount of revisionist desire can make up for the historical absence of once (still?) marginalized groups. At the same time mainstream museums have been reluctant to expand their definition of art to include genres that were open to women and minorities. But if traditional museums are subject to forces that limit change, new museums have sprung up to accommodate overlooked cultures and art forms. The broad museological landscape is much more diverse today than it was thirty years ago.

Predictions of the museum's demise under pressure from postmodernism have proven to be greatly exaggerated. Though some artists who challenge the museum's conventions face an uncertain destiny (can artists become 'famous' without museums?), others – for example, Robert Smithson, Christo and Jeanne-Claude, or Gordon Matta-Clark – have had their work enter the museum through the back door via drawings and photographs. Still others, such as Fred Wilson, have been welcomed into the fold even though their work directly criticizes the museum. There is logic to the mutual dependency, since if not for museums the work would lack bearing and by assimilating the work (in the palatably brief form of passing installations) museums demonstrate their open-mindedness and resilience. Thanks also to the increasingly institutionalized culture of the biennale, art forms once alien to the museum – video, installation, performance – become more collector- and museum-friendly with each passing year. The museum is (and perhaps ever was) little more than a rhetorical enemy of the avant garde.[2] One fruitful area for further study would be the productive tension between institutional resistance and collaboration within the avant-garde tradition.

Commercialism in museums is here to stay. While those on the left bemoan the corporate take-over of our institutions, traditionalists complain of dumbing-

down of cultural standards in pursuit of money. Fear of corporate meddling, acute at the height of the 'culture wars' of the late 1980s and 1990s, has given way to the equally pernicious reality of self-censorship, as museums in need of operating funds favour programming that attracts both sponsors and large fee-paying crowds. Hence the steady exhibition diet of impressionists, mummies and anything with gold in the title. But those who grumble should ask if the alternatives are any less constraining. Government funds come with strings attached, as do the benefactions of wealthy, and would-be, trustees. In any case, critics who complain that art museums have become billboards and funhouses overlook the fact that commerce has been kept separate from permanent collections. For those who care about high art and seek quiet contemplation, much of the old museum still remains. Commercialism is the cost of the peace and beauty that still reigns in the galleries far removed from the shops and restaurants.

Critics of commerce also dislike the bold structures often built to house new amenities and special exhibition spaces. They argue that dramatic architecture contributes to the spectacularization of the museum and diminishes the art on view. To be sure, behind every showpiece museum is an economic impact study that anticipates the financial benefits that flow from the development of new cultural infrastructure. Following the great success of the Pompidou Centre in Paris (opened in 1977), striking museums by celebrity architects – Frank Gehry, Daniel Libeskind, Zaha Hadid, Santiago Calatrava, among others – have demonstrated an ability to revitalize urban areas and draw donors, travelling exhibitions and new visitors. Build and they will come, but also build and they will give and lend. Well-endowed institutions in need of new space have shown a preference for the classical restraint of Renzo Piano or Tadeo Ando, whose understated buildings have become as much of an architectural cliché as the billowing curves and sharp angles of Gehry and Libeskind. Whatever the style, the building boom shows little sign of slowing down.

Proponents of new buildings and popular exhibitions justify innovative content and containers in terms of increased access and demographic diversity. While attendance figures have certainly increased in recent decades, diversity is harder to gauge. Have art museums audiences in fact become more diverse with regard to race and class? Programming no doubt makes a short-term difference in who comes, but lasting change will surely require structural modification of permanent collections and staffing at the decision-making level in the museum hierarchy. Collections do not develop overnight, and those who push for change need also to recognize that museums are socially conservative environments that depend on the privileged realm of donors, corporate heads and the market for their survival. Going back hundreds of years, curators have always been courtiers of a sort and the worlds of art and power have closely overlapped. Furthermore, so long as art is neglected in our primary and secondary schools, interest in art will continue to be strongest among social elites who cultivate it in the 'habitus' of the home and family, as Pierre Bourdieu pointed out decades ago.[3]

Emphasis on access, attendance figures and gate receipts overlooks a set of important questions that merit further study: What do people get from their visit to an art museum? What is the *quality* of their experience? Why does it matter if people go, or don't go, to art museums? What value do art museums (or art itself) provide to society? What justifies their expense and prime location in the world's

great cities? Most in the art world avoid these questions; they rarely, if ever, show up on visitor surveys conducted by museums.

Historically, museums were viewed as a powerful means of inculcating national pride and civil order in the masses, but those rationales would scarcely be put forward today. Lately, the great universal museums in the West have argued that they play a vital role in facilitating cross-cultural dialogue and exchange at a time of heightened global tension. Following the 9/11 attack on New York, the desire to foster better relations between the West and the Middle East has been especially strong. To give one example, in 2005 a Saudi prince donated $20 million to create a new Islamic wing at the Louvre in the belief that 'after 9/11, an increased appreciation of Islamic art can help bridge a cultural divide.' Welcoming the gift, the French culture minister described the Louvre as

> an essential instrument for the dialogue of cultures and the preservation of their diversities. In a world where violence expresses itself individually and collectively, where hate erupts and imposes its expression of terror, you dare to affirm the conviction that is yours – that is ours – that the dialogue of peoples and cultures, the richness of patrimonies, the values of sharing are the responses of intelligence to the bitter experience of conflicts.[4]

Can museums truly contribute to global understanding and world peace, or is this mere rhetoric fit for ceremonial occasions? It has been suggested that Western museums trumpet the value of cross-cultural dialogue to deflect mounting pressure to return cultural property. The Declaration on the Importance and Value of Universal Museums (2002), signed by the directors of nineteen of the most powerful art museums in Europe and the United States, aims to counter the parochial interests that motivate repatriation claims by insisting 'museums serve not just the citizens of one nation but the people of every nation.'[5] Those who are beyond the Euro-American orbit, however, suspect that what motivated the document was a fear of losing hold of their fabulous collections. For example, George Abungu, former director of the National Museums of Kenya, says that issuing the declaration 'is a way of refusing to engage in dialogue around the issue of repatriation.'[6] Whether, and if so how, to engage Abungu and others over disputed ownership of cultural property is among the most difficult issues facing art museums looking forward. For established European museums, repatriation problems mostly concern demands from former colonies that now want to control their cultural patrimony; for the newer American museums, troubles stem from postwar efforts to build collections quickly, which have led them into temptation to acquire undocumented objects that may have been looted and/or illicitly exported from their country of origin. Recent settlements involving Holocaust claims and between Italy, Greece and selected US museums have given new prominence to questions of provenance, but whether they put an end to the trafficking of artefacts from archaeologically rich, cash-poor parts of the world remains to be seen. Most developing nations lack the resources (legal, financial, media) to pressure museums and public opinion in the West.

The emergence of repatriation, access, commercialism and definitions of the canon as issues of public concern and museum governance in the past few decades shows that museums are hardly immune to the shifting world beyond

their walls. Museum Studies will follow, and help to define, whatever new issues arise in the years to come. Analysis and critique are vital to museums as to any social institution and should be viewed as the legitimate prerogative of all who care about their future.

A healthy development would be a more vigorous contribution to the literature from museum professionals, especially curators. Overworked and dedicated to the objects in their care, they have neither the time nor the inclination to engage in theoretical self-scrutiny, yet a failure to engage in debate with their critics leaves the field one-sided and risks allowing the crucial work museums do to go unappreciated. Meanwhile, the historical study of museums and exhibitions will surely continue; though a number of major European and North American museums have now been researched, precious little is known about many provincial institutions and museums in Latin America, Asia, Africa and the Middle East. Every museum has an interesting story to tell. What may inhibit further study is the conservative, object-based penchant of academic art history, which, like museums themselves, still largely revolves around major artists and movements. Within the job market, postgraduate students who wander too far from art objects in their choice of dissertation topic arouse suspicion.

One final development to ponder is the recent explosion of Museum Studies courses on both sides of the Atlantic. As the ranks of art history majors/concentrators rise, spurred on by the success of museums and the popular media (Sister Wendy Beckett, *The Da Vinci Code*, etc), so has the number of graduates wondering what to do with an art history degree. Museum work is an obvious and attractive option, and Museum Studies programmes have grown as a conduit to the profession. But how many programmes can the market support? Are programmes multiplying in response to the museum's need for qualified graduates or the university's need for income-generating postgraduate programmes?

Notes

1 Donald Preziosi and Claire Farago, eds, *Grasping the World: The Idea of the Museum*, Aldershot, 2004; Bettina Messias Carbonell, ed., *Museum Studies: An Anthology of Contexts*, Oxford, 2004; and Sharon Macdonald, ed., *A Companion to Museum Studies*, Oxford, 2006. A fourth anthology, Gail Anderson, ed., *Reinventing the Museum: Historical and Contemporary Perspectives on the Paradigm Shift*, Lanham, MD, 2004, offers an alternative selection of thirty-four articles (400 pages), mostly by museum professionals, in which references to Foucault, Bourdieu, etc. are conspicuously absent.

2 See Andreas Huyssen, *Twilight Memories: Marking Time in a Culture of Amnesia*, New York and London, 1995, 13–35.

3 See Pierre Bourdieu and Alain Darbel, *The Love of Art*, trans. Caroline Beatty and Nick Merriman, Stanford, 1990 (first published in French in 1969).

4 Quoted in John Tagliabue, 'Louvre Gets $20 Million for New Islamic Wing', *New York Times*, 28 July 2005, E1. Prince Alwaleed Bin Talal Bin Abdulaziz AlSaud also hopes that the new Islamic wing 'will assist in the true understanding of the true meaning of Islam, a religion of humanity, forgiveness and acceptance of other cultures.' *New York Times*, 3 August 2005, A13. In 2006 a new Islamic wing, funded by another Saudi, Mohammed Jameel, opened at London's Victoria and Albert Museum. Alan Riding's review of it concluded: 'The Prophet [Muhammad] himself is quoted as saying: "God is beautiful, and he loves beauty." In these ugly times, this too may be worth remembering.' *New York Times*, 9 August 2006, E3.

5 For the Declaration, see http://icom.museum/universal.html.

6 For other responses to the declaration, see *ICOM News*, 57:1, 2004; http://icom.museum/universal.html.

8

THE LOGIC OF SPECTACLE c. 1970

ANGUS LOCKYER

At about 5.20 in the afternoon of 26 April 1970, Satō Hideo, twenty-five years old, climbed into the right eye of the golden face of the Tower of the Sun and shut the door behind him. He masked his face with a towel, put on a red helmet emblazoned with the characters for 'Red Army', and 'started agitating' (plate 8.1). Satō had been involved in the anti-war movement for some time and had participated in an occupation of Hiroshima University the previous year. Now he encouraged his audience to 'crush the Expo'. A crowd of 2,000–3,000 soon gathered and 170 police were dispatched to control the situation.[1]

The Tower was the main element in the 'theme exhibit' of the Osaka Expo, intended by the authorities as the embodiment of the theme 'Progress and Harmony for Mankind' and 'produced' by fifty-nine-year-old artist Okamoto Tarō as an attempt to shock his audience out of the anomie that he saw as characterizing contemporary experience. The Tower itself took the form of a tapering white column with outstretched arms, adorned by two faces, white and black, front and back, at its midpoint, and surmounted by a concave golden face in which Satō was now installed. Inside the Tower, Okamoto had designed an immersive experience, taking the visitor from a subterranean depiction of the origins of life to a world of the future suspended in mid-air.[2]

To announce his intention, of disrupting the smooth, soulless routine of the everyday, Okamoto had designed the Tower deliberately to poke its head through the floating roof of the Festival Plaza, the main concourse of the Expo (plate 8.2). The Plaza had been designed by thirty-nine-year-old Isozaki Arata, one of a number of young architects working under the direction of sixty-seven-year-old Tange Kenzō, who was responsible for the master plan for the Expo. The site sprawled over some 330 hectares, or over 800 acres. It was bisected by an expressway, with administration facilities and an amusement park consigned to the smaller southern half, while a kaleidoscope of national, NGO and corporate pavilions radiated from the Plaza to occupy the main, northern part of the site, which was capped by an extensive Japanese garden (plate 8.3).[3]

Both Satō and Okamoto sought to turn the Expo to transformative ends. They wanted to capture the attention of the visitor, to convince him or her of the need for and truth of an alternative way of seeing and being in the world, and thereby to effect a change in the relationship between the individual and his or her time. In so doing, they illustrate one possible and frequent understanding of spectacle and its uses: the monopolization of a space of representation so as to effect the work of ideology or its critique. Much of our work on the spaces and institutions

8.1 Satō Hideo during his occupation of the golden face of the Tower of the Sun. The characters on his helmet read 'Red Army'. *Okamoto Tarō: Expo 70: Taiyō no tō kara no messeeji,* 2000, Kawasaki, Kawasaki-shi Okamoto Tarō Bijutsukan. Photo courtesy of Commemorative Organization for the Japan World Exposition '70.

of visual culture adopts this view. We linger on what is displayed. We read its message. And we assume that it is motivated; that the producer wants the visitor to go away thinking something in particular; that the objects on display are effectively subordinated to this end; and that the visitors get the point. Nor are we entirely wrong. There are few occasions where anything goes: the minimal demand of coherence requires some parameters, not least of ideology, within which site and event can be coordinated. Thus in Osaka, the rubric was progress, albeit interpreted variously and even challenged explicitly (not least by Satō).

In what follows, however, I want to argue that the significance of spectacle as communication can only be understood in the context of spectacle as system. Expos have to accommodate multiple interests and investments, numerous

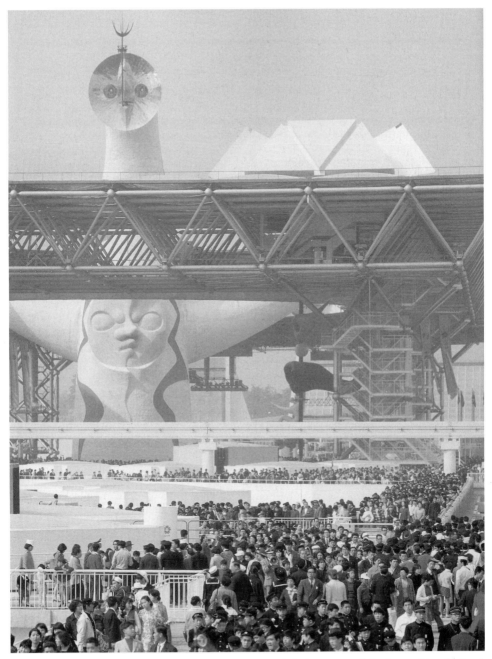

8.2 The view over the main gate to the Symbol Zone, with the Tower of the Sun poking its head through the floating roof of the Festival Plaza. *Okamotō Tarō: Expo 70: Taiyō no tō kara no messeeji,* 2000. Kawasaki, Kawasaki-shi Okamoto Tarō Bijutsukan. Photo courtesy of Commemorative Organization for the Japan World Exposition '70.

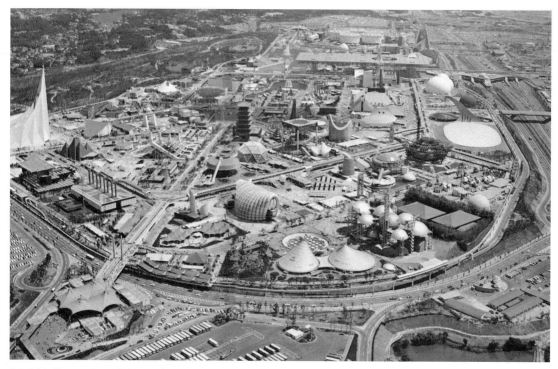

8.3 A bird's-eye view of the Osaka Expo, from the west. The white vertical of the Soviet pavilion on the far left looks across at the low-slung white mass of the US pavilion, with other countries and corporations arranged between. The floating roof of the Festival Plaza is visible in the middle of the site, with the Japanese garden to its left and the five circular structures comprising the Japanese government pavilion at the far end of the site. *Nihon Bankoku Hakurankai Kōshiki Kiroku Shashinshū*, 1971, Osaka, Nihon Bankoku Hakurankai Kinen Kyōkai. Photo: courtesy of Commemorative Organization for the Japan World Exposition '70.

exhibitors, exhibits and visitors. What is striking about them is the diversity of intention that can be accommodated within their parameters, the cacophony of the display itself, and the variety of the response. In order to do so, the work of Isozaki and Tange suggests, expos need not provide a particular account of the world, but account for contingency, for whatever might be put or happen in the space in question. Osaka was the most visited and therefore most successful expo in history not least because it could afford to be somewhat indifferent to what was put on display.

A CENTURY OF EXPOSITION

The publicity for the Osaka Expo described it as the culmination of a century-long dream.[4] By 1970 Japan indeed had over a hundred years of experience of expos, but the claim was somewhat disingenuous. The archipelago first appeared at international exhibitions in the 1860s, in the midst of a tumultuous decade. The Paris Exposition Universelle of 1867, its second outing, was succeeded the following year by the collapse of Tokugawa military government and the installation of a new administration, operating in the name of the Meiji emperor and dedicated to the creation of a centralized state with which to pursue industry and

empire. The new government seized on expos as a central plank in its policy of industrial promotion, for their didactic and therefore economic potential. They promised a controlled environment and captive audiences, within and to which bureaucrats could provide particular accounts of the world (at home) and of Japan (abroad). The revelation of their backwardness when compared to both foreign models and domestic competitors would encourage Japanese producers to new efforts. Overseas, foreign audiences would be captivated by the excellence of Japanese agriculture and industry (initially in the form of raw silk and what we now know as export art), thus creating demand and providing capital with which to spur Japanese industry to new heights.

The policy worked, in part. Foreign audiences were wowed, creating the waves of enthusiasm we know as japonisme and cementing a cultural complex we still see as quintessentially Japanese: ceramics and equally decorative arts; wooden architecture set in manicured if restrained gardens; traditional costume, femininity, tea. And domestic producers did respond. Indeed, the government was able to get out of the exhibition business soon after the turn of the century, at least at home. Agricultural and industrial associations held their own exhibitions, fostering professional development, while local governments began to use such events as celebrations of and justifications for municipal improvement and pride, both diminishing the need for the state to coordinate the initiative. In time, demand was such that the planning of exhibitions itself became a professional pursuit, creating the germ for what is still today a burgeoning industry. Abroad too, the rationale for participation remained. Given the usefulness of expos as cultural diplomacy and media events, it is not surprising that Japan continued to be assiduous in its participation and preparations for such opportunities to prove why a small Asian power might belong in a world of white industry and empire. But there was no compelling reason to hold such an event within Japan. There were attempts to stage an international exhibition in Tokyo in 1890, 1912 and again in 1940, but these repeatedly foundered, as more pressing concerns, most often military, demanded that the necessary funds be directed elsewhere.

The Osaka Expo emerged instead from the new constellation of circumstances and imperatives that marked the postwar era.[5] Following the catastrophe of defeat, expos again became a medium for domestic reconstruction on the part of local governments and cultural diplomacy by the state. Brussels in 1958 and Seattle, New York and Montreal during the 1960s saw a sustained attempt by the government to gain acceptance by the 'international community' that was the contemporary code for the capitalist West. By the middle of the 1960s the diplomatic rationale was supplemented by domestic considerations, which suggested the usefulness, finally, of holding such an expo in Japan. Reconstruction had been succeeded by rapid economic growth in the 1950s and 1960s, but growth brought consequences. It would take time before the government acknowledged the need to balance its attention to production with an awareness of distribution, its focus on the economy with some protection for the environment. But already, in the early 1960s, bureaucrats and politicians saw a need for planning. The existing infrastructure was proving inadequate for the needs of an economy more than doubling its output every decade; the cutting edge of the economy was beginning to shift from heavy industry to electronics and information technology, requiring an upgraded transport and communication

structure; and the concentration of economic activity in the Tokyo metropolitan area threatened to clog up the arteries of the economy, leaving peripheries behind.

Planning was possible, but it was 'big events' that promised to realize the bureaucratic vision.[6] If the world were to come to Japan, the government would be justified in investing the money required to put on the necessary show and provide the infrastructure through which the economy might be managed. The first of these was the Olympics in 1964, which provided the main road network with which the capital could again begin to move, but also the bullet train which linked it to the Kansai region and the second cities of Kyoto and Osaka. Already, before the opening ceremony, plans were afoot for a second instalment, wherein an expo in the Kansai region itself would upgrade infrastructure, rebalance economic activity between the capital and the regions, and encourage people to use the trains. After some inevitable jousting within the region, the Senri hills, in northern Osaka, emerged as the chosen site for the expo, the hub for new rail and road networks, and an opportunity for suburban development.

PROTEST: HAPPENING

Postwar economic growth, however, had not been accompanied by smooth political sailing. The decade before 1970 was an eventful one. It had started with massive protests in 1960 at the renewal of the US–Japan Security Treaty, coinciding with, and in part powered by, the emergence of an autonomous and radicalized student movement.[7] It was in the wake of these that Prime Minister Ikeda Hayato implored the nation to devote itself instead to economic matters, promising that if it did so income would double over the decade. It was a safe bet, given the magic of past performance and compound interest, and indeed the next few years saw an absence of overt political conflict and a fragmenting of the opposition coalition. In 1967 and 1968, however, came a new wave of student activism across a broad front, motivated on the streets by outrage at Japan's geopolitical subordination to the US, manifest in both the ongoing American occupation of Okinawa and Japanese involvement in the Vietnam War, but also on campuses at the conservatism and corruption of their own university administrations. Unlike their predecessors, moreover, these protesters were prepared to resort to violence. The most spectacular incident came with a 30-hour battle between 8,000 riot police and the few hundred student diehards occupying the Yasuda Amphitheatre at the centre of the Tokyo University campus.[8] The end of the occupation did not mean the end of activity, however.[9] The security treaty was up for renewal again in 1970. And soon enough a movement mobilized against the Expo itself, seen as state propaganda and an attempt to provide distraction in what otherwise threatened to be a tumultuous year.

Given this background, the authorities were nervous as 1970 dawned.[10] Nor were fears assuaged, two weeks after the opening of the Expo, when the terrorist group the Japanese Red Army inaugurated their activities by hijacking an airliner at Tokyo international airport, forcing the crew to fly them first to South Korea, where they released the passengers, and then North Korea, where they abandoned the plane.[11] The appearance of Satō in mid-air, less than one month after this incident, wearing a helmet that branded him as a member of this group, must have prompted concerns such that the despatch of 170 police can only have

been seen as a proportionate response; the incident soon became something else.[12]

Satō-kun had chosen his perch well. The passageway leading to the eye was narrow and access was difficult. The police and the Expo Association quickly decided to resort to persuasion rather than frontal assault. By seven in the evening, a banner had been laid out on the ground, urging Satō to come down. At nine, two employees of the Expo Association appeared at a window, reiterating their concern and offering a blanket and some food. But it was too early for compromise. The two sides settled in, Satō waiting for the authorities to close the Expo, and the authorities for him to tire. They also decided not to switch on the 50-kilowatt floodlight in front of which he was sitting. Usually, this illuminated the night skies, but now it threatened to burn their squatter to death.[13] An unanticipated protest may have been manageable. A murdered protestor was clearly not.

The following morning brought audience participation and media frenzy. A group of elementary school children, waiting in line, shouted encouragement. 'Do your best, Red Army! Stick to it!' 'I'll do my best.' He waved, and they waved back. The producer also got in on the act. Around noon, a gentleman in a dark suit appeared among the crowd of reporters on the ground. At two, Satō listened to his radio as Okamoto's comments were reported on the national news. 'I think it's wonderful. It's a festival, so this is fine. [...] He seems to be shouting crush the Expo, but this kind of happening only pleases the visitors, doesn't it?' For Okamoto, Satō was part of the show, but Satō had other ideas.

> If I come down alive, it may only be a happening, but if this ends in my death [...] [i]t will become clear how a human sensibility is lacking in the commotion of the festival. ... This Expo, which preaches progress and harmony, is really just a self-promoting show of state power. And Okamoto has served to disguise its true nature and hide its money-making.

On the evening news, the day's events were rehearsed. 'The man faces the people and waves, as if he were a hero.' 'That's the mass media for you,' commented Satō.

By late April the Expo had been open for six weeks, and the newspapers had already documented the four years of preparation, opening ceremonies, initial reactions, teething problems and critical reviews. Saturation coverage was the order of the day: this was, after all, the first international exhibition ever to be held in Asia, a consummation devoutly wished for over the course of a century, more or less. But there were four months left to fill, and the newsworthy was already in short supply: staged events, statistical titbits and unanticipated contingencies were thin gruel, given the scale of operation and expectation. In the wake of inadequate refrigeration and food poisoning,[14] the 'guy in the eye' was, initially at least, a tailor-made media event.[15]

The second full day brought more of the same, with crowd reactions and news bulletins, but by the third morning the situation had normalized. Satō showed no signs of tiring, but media and visitors had begun to look elsewhere. Negotiations began. The authorities promised to reward capitulation with a deal, but Satō wanted some food before he would descend and a meeting with the press once on the ground. Neither was prepared to back down. The standoff continued on day four, but by May Day Satō was beginning to suffer and the riot police to advance.

They took their time, however, and it was day six that saw the balance of power begin to shift. A policeman emerged from the hatch, secured by red climbing ropes, blinded by the prospect of fame. 'Even if you do stupid things in your organization, you get promoted.' He backed down, but Satō began to question his motivation. 'If the Expo's an illusion, then so is anti-Expo.' Satō realized that he didn't want to die. He was showing off, not even to the visitors, but to the riot police. At seven in the evening, he agreed to descend the following day. At nine, some students appeared beneath the tower and sang the Internationale. Satō felt a bit guilty.

The next morning Satō surrendered his perch, just as the question of his endurance made him the object of renewed attention in the press.[16] At the round window, his belongings were inspected. They included both the 'Manyōshu', a collection of ancient Japanese poetry, and 'Hagakure', an eighteenth-century codification of prescriptions for samurai. Satō and his escort descended in the elevator and were met by five or six police dignitaries, weighed down with gold braid. There was no interview. At the local police station, the interrogation began. 'Why come down after seven days? Why not ten?' 'Aren't you Korean?' 'Why didn't you die? If you had died, it would have caused a bit of a stir.' Despite the helmet, there seemed to be no direct connection with the Red Army. Thus the curtain came down on what the *Asahi* newspaper finally characterized as an 'eye-jacking drama'.[17] In November, with his client still in custody, Satō's lawyer arranged for his own account of the event to be published in one of the leading monthly magazines.[18] Otherwise his efforts were subsumed as one incident among many in the flood of reports and retrospectives, which concluded the summer.[19] Perhaps most telling, the Osaka Prefectural Police, in their own commemorative volume, noted the protest as part of the official report, but also gave it pride of place with a full-page spread in the photographic record of what the editors chose to classify as 'happenings'.[20]

To leave Satō here is not to insist that his protest be understood as nothing more than an incident in a police jotter. What is striking, though, after the nervous confrontations at the top of the Tower, was the ease with which his actions were accommodated by the Expo, indeed became part of the show. The police were not indifferent to Satō, whose occupation prompted them to action. Their concern, however, was not so much with his message. Preparations for the Expo had been dogged by repeated protests along identical lines. Rather, Satō's achievement lay in being where he shouldn't be, occupying an inappropriate space and disturbing the daily routine of the Expo site. It was his seizing of the spectacular potential of the Tower that prompted a well-rehearsed police operation. In the end, however, the operation succeeded: the police were able to account for Satō's actions, which could then become part of the official account of the Expo itself.

ART: BRAND

What did Okamoto Tarō mean by endorsing Satō's occupation of his Tower of the Sun? By 1970 the former should have emerged as the avuncular chair, if not yet the grand old man, of the Japanese avant garde. At the end of the 1920s he had followed a well-trodden path to Paris, where Picasso and others had inspired him to pursue abstraction. At the same time, he was studying anthropology with

Marcel Mauss, prompting an interest in magical and religious symbolism. By the second half of the decade, Okamoto was associating with the surrealist group, not least Georges Bataille, who became an enduring influence, and he exhibited in the Exposition Internationale du Surrealisme in 1938. Returning to Japan in 1940 he won a prize for his European work from the Nika-kai, a leading avant-garde artist association, and following military service in the war he quickly became a prominent figure in the postwar avant garde, representing Japan at the 1954 Venice Biennale.[21]

From the late 1940s Okamoto began to inveigh against the 'heavy shell of the past' that imprisoned Japanese art and people.[22] This shell rendered tradition a remote, elite and 'antiquated reality', thereby denying people the resources they needed with which to confront the concerns of the present.[23] One way out was a principle he designated as 'bipolar oppositionalism'. The artist's responsibility was to represent 'all possible methodological dichotomies such as rationality/irrationality, figuration/abstraction, realism/surrealism, and reality/fantasy, as they are – torn – instead of unifying them'.[24] At the same time, Okamoto was also beginning to apply his ethnological training in research and writing on the prehistoric Jōmon period and in Okinawa, the southernmost islands of the archipelago, then under American administration. Here he found models for practice, notably in the 'dynamic and popular' styles that characterized Jōmon earthenware, in contrast to the refinement of the later 'static and aristocratic' forms that came to define the archipelago.[25] Returning to such sources, he believed, one could discover a way to hold such opposites in creative tension, thereby overcoming both the ossification of traditional Japanese art and the fragmentation of modern experience. Jōmon figurines and Okinawan masks quickly became recurrent motifs in Okamoto's own painting and sculpture, the 'black holes' of the eyes punctuating the surface of the face and leading the observer beyond the mask, not least in the three faces of the Tower of the Sun in the Expo of 1970.[26]

For many, given his avant-garde credentials, it was a shock that Okamoto agreed to participate in what came under heavy attack from artist as well as student groups in the run-up to the Expo, some comparing the event to wartime propaganda painting.[27] Okamoto justified his official role as producer, perhaps not least to himself, as the continuation of his earlier radicalism, underlining this by the repeated use of two key terms. The Expo itself he saw as a 'festival', not the 'strangely sober', sacred practice that characterized what went under the name in contemporary Japan, but rather an opportunity for 'massive consumption', getting drunk and going broke. Like a potlatch, the Expo promised a place where the surplus that had been produced through postwar economic growth could be consumed, where old ideas could be discarded and new worlds emerge. The Olympics had reduced the masses to spectators, the Expo promised participation. In order to realize this, Okamoto's role was to produce something 'monstrous', which would shock visitors out of the complacency and anomie of everyday life, coming into contact with their core humanity and each other. For Okamoto, then, he could stand against the progress and harmony that was the official theme by fracturing the smooth façade that they imposed on existence and revealing a more authentic life within.[28]

To do so, he created an immersive experience, beginning underground, before moving through the Tower itself, to a mid-air exhibit, and finally returning to

ground level: following the tour took the visitor from the origins of the world to ascend a tree of life, which culminated in the contemporary progress that would lead to the future, before coming back to the harmony that characterized the present.[29] Descending underground, one was plunged into darkness, from which emerged hugely magnified models of DNA and other basic building blocks of life. The 'world of life' was succeeded by the 'world of humans', first seen in early human communities, engaged in a struggle with nature. Human activity then evolved into spaces of 'wisdom' (chie), represented by a 'forest of tools'; 'prayer' (inori), by numerous masks hanging from the ceiling and by yet another, 'subterranean sun', designed by Okamoto; and finally 'encounter' (deai), by various human figures and forms.

Leaving the past behind, one entered the Tower of the Sun itself, within which a 'Tree of Life' soared skywards (plate 8.4). Stairs and escalators took one past simple marine forms, then dinosaurs, to mammals and finally humans. Emerging from darkness into mid-air light, the roof held visions of the future: satellites illustrated the possibilities of 'space', diagrams of the brain the potential of 'humanity'; the 'world' was depicted with photo-collages of both dangers (Hiroshima, environmental pollution) and possibilities (ethnic diversity suggesting the possibility of mutual understanding); finally, architect-designed capsules provided glimpses of a variety of urban 'lifestyles' (many housing young women as model residents). Descending from the sky, an escalator led one through a second, low-lying Tower of the Mother, balanced on the other side of the Plaza by a Tower of the Child, which was a simple pole along which were strung the abstract forms of a fish, ghost, human and aircraft. In the middle of the Plaza, linking the three towers, 619 photographs unfurled, illustrating the 'nameless people who support the world' and thereby the harmony within diversity of the present.

To what extent did this 'monstrosity' produce the 'festival' that Okamoto wanted? Recently, both Expo and Okamoto have begun to be revisited and re-evaluated, in terms that the latter would have endorsed. Satō himself in a recent interview also recognizes Okamoto's anarchist credentials and the significance of his call for everyone to 'liberate themselves' on the Festival Plaza.[30] Meanwhile, the dawn of the new millennium and the thirtieth anniversary of the Expo provided the opportunity for a major exhibition exploring 'The Message from Tower of the Sun', jointly organized by the National Museum of Art in Osaka, the Okamoto Tarō Museum of Art in Kawasaki, and the Expo Commemorative Association, together with appropriate media partners.[31] The exhibition encouraged the leading monthly arts magazine to devote a feature to Okamoto and Expo, including the former's ruminations on the Jōmon and an evocative on-site exploration of the now empty Tower of the Sun by Sawaragi Noi, a leading contemporary art critic.[32] Finally, Sawaragi's identification with Okamoto has resulted in an extensive, recuperative monograph, in which he seeks to refurbish Okamoto's message for a society that has forgotten him.[33]

It is worth pausing, though, before allowing Okamoto and his advocates the last word on the significance of his work. Nowadays, the Tower stands empty and alone in the midst of the Expo Commemorative Park. In 1970, however, it was surrounded by a crowd of pavilions, one of many trying to capture the distracted gaze of an exhausted visitor. In these circumstances, it is hard to imagine the

8.4 The Tree of Life inside the Tower of the Sun. *Okamoto Tarō: Expo 70: Taiyō no tō kara no messeeji*, 2000. Kawasaki, Kawasaki-shi Okamoto Tarō Bijutsukan. Photo courtesy of Commemorative Organization for the Japan World Exposition '70.

theme exhibit being seen as a radical disjuncture, or providing the participatory, transformative experience that Okamoto desired. The exhibition, however abrupt the transition to subterranean darkness, thereafter reaffirmed the normative assumptions of evolutionary progress, culminating in an expansive, imagined future, albeit one hedged with the necessary warnings of apocalypse. The experience may have been immersive, but it was also quite typical, confronting a somnambulatory visitor with immobile exhibits, perhaps paling in comparison to the cinematic immersions that were commonplace in the corporate pavilions. Anecdotal evidence suggests that many of those for whom the Expo still provides

107

a talismanic memory of childhood were captivated elsewhere on site, intrigued by the Tower itself, but left cold by the core exhibit.[34] At the time, it was a rock from the moon, displayed in the US pavilion, which attracted the longest queues.[35] The Tower was unavoidable, certainly striking, even monstrous, but over time, like Okamoto himself, it became a figure of fond recollection, even fun. By 1981 Okamoto's radicalism had culminated in a catchphrase, 'Art is explosion', immortalized in a television commercial. Similarly, the Tower today functions as a familiar sight in the Kansai landscape, giving bus tour guides an opportunity to fill their commentary, reminding a middle-aged audience of its youth, captive schoolchildren of a past before they were born, before speeding on to the more significant sites of Kyoto to the east or Himeji castle to the west.

ARCHITECTURE: SYSTEM

The Expo produced a number of icons, but the Expo itself was the product of a complex bureaucracy, in the form of the Japan Association for the 1970 World Exposition.[36] This was in large part the creation of the government, but operated autonomously and brought together individuals from a wide range of public and private organizations. Throughout the planning of the Expo, the Association's main role was one of coordination, raising funds and refereeing disputes between competing interests, visions and projects. This did not render it immune from official interference: some exhibits were censored, most notoriously a collection of Hiroshima photographs, deemed 'too graphic'.[37] Nor did the Association garner a reputation for Solomonic judgement: a number of participants complained of bureaucratic inertia, dimwittedness and meddling.[38] In order to mount the Expo, however, the government and the Association were both compelled to subcontract responsibility for the content of the Expo to a huge range of committees, professionals and intellectuals. It was the latter who came up with the theme that the Expo was supposed to represent, the symbols through which it would be identified, and most importantly the site within which the pavilions, exhibits and visitors would be accommodated. Similarly, companies and corporations availed themselves of the professional services of architects and designers to give form and content to their own presence on site.[39]

Architects had long been involved in the planning and design of expos. By the middle of the twentieth century, however, a number of developments had combined to foreground their importance. International exhibitions had begun in the mid-nineteenth century as a comprehensive account of art and industry, with nation-states as the category through which one might compare the world under one roof. Already by the end of the century, however, expos had become a capacious site for multiple pavilions and popular distractions, with nation-states gradually ceding ground to corporations and entertainment.[40] While these disaggregated sites still used classical models to legitimate their claims of universal significance, from the 1920s and 1930s authorities began to turn to modernist forms to declare their authority on the fast-moving present and so the uncertain future.[41] Similarly, while non-Western countries, not least Japan, had earlier been provided with, or asked for, replicas of indigenous architecture within which to stage their cultural distinction, by mid-century they too had begun to ask architects to demonstrate the contemporaneity of their cultural credentials. Paris in 1937 thus saw a modernist Japanese pavilion by Sakakura Junzō, even if New

York in 1939 saw a reversion to a more traditionalist form.[42] By Brussels in 1958, the pavilions had become as significant as the exhibits they housed. Expos were architectural concours, opportunities for architects to experiment with solutions that would be too radical for more permanent commissions.

Osaka similarly became a venue for cutting-edge architectural practice and criticism.[43] One of the most prominent and visible influences on site was that of Metabolism, which had emerged a decade earlier among a group of young architects, including Kikutake Kiyonori and Kurokawa Kishō, who published the group's manifesto in 1960, with the subtitle 'proposals for a new urbanism'.[44] Isozaki was also caught up in the excitement, emerging into prominence at the same time with plans for a 'City in the Air'.[45] Metabolism sought to move beyond the marriage of form and function prescribed by international modernism. The fixed structures that this generated were now revealed as incapable of responding to ever-increasing demands on the urban environment. Instead, buildings should be conceived as a system of interchangeable parts that could be replaced at different rates and as circumstances demanded. The theory proved easier than the practice. Over the next decade designs for 'mega-structures' proliferated, but few made their way from drawing board to city street. In some ways, therefore, the Expo was Metabolism's swan song. Kurokawa and Kikutake were both well represented on site, the former most spectacularly with the Takara Beautilion, a 'tree structure' with the 'potential to extend, or replicate horizontally and vertically depending on necessity' (but here housing, incidentally, an exhibit devoted to the 'Joy of Being Beautiful').[46] Isozaki, meanwhile, had been delegated by Tange to work on the Festival Plaza, whose modular construction and multiple functions both drew on Metabolist insights (plate 8.2).

In retrospect, Isozaki ruefully admitted that the Expo did not work out quite as he had imagined, in large part because of Okamoto's efforts to represent a suppressed tradition. At the Expo, Tarō had smuggled 'things you really didn't want to see' into the avant-garde site. Subsequently, the Tower had survived, while the brave new architecture had vanished. And so, Isozaki averred, 'my first impression ... [was,] I've lost!', prompting a personal turn towards questions of representation and identity.[47] But hindsight is misleading here, in describing the situation at the time as a confrontation between modernism and tradition. It would also be wrong to suggest that the only architectural shape of things to come was a retreat from the Metabolist emphasis on structure to a preoccupation with the Japanese qualities of space. A better guide is an essay written in 1966 on the 'invisible city', which marked Isozaki's own departure from Metabolism. Just as the structuralist turn of his Metabolist colleagues had subsumed the functionalist emphasis of the Congrès international d'architecture moderne, so the time had come, he argued, to incorporate the earlier insights in a cybernetic understanding of the city: 'the elements comprising the city should not be understood only in terms of their external form, but rather as a complex of various invisible systems.'[48]

Nor was Isozaki alone in his turn towards system thinking. For many intellectuals, Japan was moving towards a post-industrial, information society.[49] The cities of the future had to be conceived in the first instance as nodes in a transport and communication network, modelled as solutions to problems of coordination and designed through collaborative endeavour. At the Expo, as a model for such a

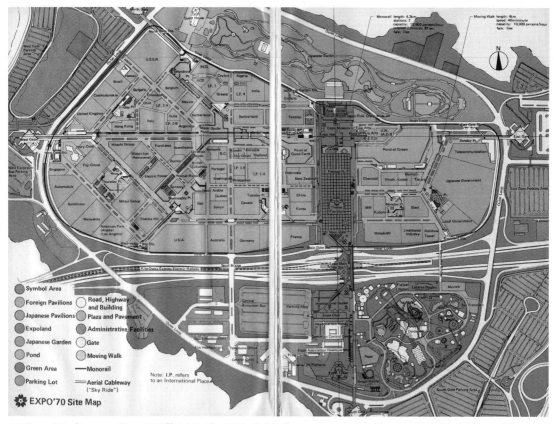

8.5 Expo '70 site map. *Expo '70 Official Guide*, 1970. Suita, Japan Association for the 1970 World Exposition. Photo courtesy of Dentsu.

city, the collaboration was overseen by Tange Kenzō. Tange had first emerged as a prominent figure with his design for the Hiroshima Peace Memorial Museum, opened in 1955. Already by 1960, with a young Isozaki working in his office, he had moved from individual buildings to urban development, with a plan for the capital which proposed spanning Tokyo Bay in order to provide a new infrastructure, facilities and housing for a city of ten million inhabitants. Postwar Japanese development afforded little possibility for a full-scale implementation of these ideas on a permanent basis, but the Expo afforded him an opportunity to begin with a clean slate.[50]

The planning process was not an untroubled one. In its early stages, Tange shared responsibility with Nishiyama Uzō, an architect based at Kyoto University.[51] Nishiyama was insistent that there had to be some kind of relationship between the Expo as a site, 'providing transport and other services, smoothly regulating the whole', and the contents of the exhibits. Moreover the Expo as a whole had to reflect the domestic and international conditions of the time. For Nishiyama, 'progress and harmony' were disingenuous given the Cold War, but if the Expo were indeed serious about these claims, it would have to give them substance in the form of a 'Symbol Zone' anchored on the Festival Plaza.[52] Tange agreed and both became core elements of the site. Repeatedly, he supported

Nishiyama and echoed Okamoto by characterizing the Expo as a festival (albeit with a rather different gloss: an opportunity not to consume surplus, but to foster exchange). Nor was Tange immune to the more general problem of representation, the question of what the Expo might mean. Eventually, the site as a whole could be read as a symbol. 'In the [final] plan ... a metaphoric structure involving botanical trunk, branches, and flowers was employed; but the trunk of the structure was deliberately referred to as the Symbol Zone.'[53]

For Tange, however, the relationship between symbol and structure was a particular one. Two points are key here. First, the importance of a space for the message of the Expo was clear, but the content of that message could remain indeterminate. Making meaning was one among a number of systems which the structure of the site needed to accommodate in order for the Expo to function. Second, the structure of the site, and so its metaphoric significance, could not be determined *ab initio*, but rather had to emerge as technical solutions during the process of design. That process was one governed not by questions of meaning but by problems of numbers. Nishiyama and his colleagues had already produced what became the first draft of the final plan. Tange emphasized, however, that this was no more than an 'image plan'.[54] Only with visitor estimates and some sense of transport infrastructure, could the site begin to take concrete form. The Association liked what it was hearing. As the estimates were refined, during the work for the third draft, initiative passed from Nishiyama to Tange, allowing the latter to be credited with the master plan. It became clear that a single main gate would produce an unacceptable amount of congestion. With four sub-gates came the opportunity to add 'four branches to the trunk of the symbol zone', equipped with moving walkways, thus creating 'arteries for moving visitors'.[55] And with this, the final solution took shape (plate 8.5).

The master plan provided the basic facilities: the trunk in the form of the Symbol Zone; the branches, comprising the 'Moving Pedestrian Way', the seven sub-plazas, and the sub-gates, and the utilities and other services necessary to ensure the smooth running of the whole. The branches were in turn 'connected to each of the pavilions which could be compared to flowers, in order to provide a smooth flow of spectators [sic]'.[56] Given the unifying structure, there was no need to exercise any control over the pavilions themselves: '[we] let each pavilion be absolutely free.'[57] In order to ensure that the population could move, the attractions had to be dispersed. The pavilions of the United States, USSR and Japan were placed strategically around the edge of the site. Subsidized space for developing nations was provided in shared structures towards the centre. Nor was Tange uninterested in what was done with the spaces provided by his plan. Coordination with Okamoto's group went well. 'Okamoto inserted a theme space within the basic three-dimensional space we had thought up. ... The first time I saw the plans I was delighted. Within the mechanical realization of the site as a whole, [here was] something human'[58] But content was someone else's responsibility, architectural solutions could be delegated. Tange could confine his own attention to the core structures and invisible systems that would enable Okamoto and the rest to do their thing, whatever that might be.

To claim that Tange could afford to be indifferent to what was put on display is not to condemn the latter to insignificance. The success of the Expo was

measured, baldly, by the number of visitors who passed through its turnstiles. In order to get them to do so, it needed headliners and headlines. Okamoto was the former; Satō provided the latter. But they were only two of many who sought to turn the space provided at the Expo to their own communicative ends. The messages emanating from the site, not least the stories documenting the scale of preparation, were coordinated in a vast publicity campaign, to ensure ongoing media coverage and public awareness. Publicity was coordinated in turn with numerous other sub-systems, both within the Expo and beyond, in order to ensure that exhibits and visitors could get to and from the site and that both could be accommodated when they got there. Perhaps the proudest boast of the *Official Report* was the information system that allowed the authorities to integrate these sub-systems, to monitor activity throughout the site, and thereby to co-ordinate any necessary response. Equally, it was only when a system failed and the movement stopped that the Expo as a whole threatened to grind to a halt: on 5 September 835,832 people descended on a site designed to hold a maximum of 600,000, overwhelming both transport and site capacity. (Soon enough, predictably, excess became success: the failure to predict such a number was itself rendered into the spectacle of front-page news. There was some consolation in the fact that the number in question comfortably exceeded the previous daily record of 703,664 at the Brussels Expo of 1958.)[59]

The Expo was designed to give an account of the world in terms of 'progress and harmony'. The theme itself was up for debate, however: there was space both for technocratic solution and dystopian future. The Expo could accommodate both. More critically, in order to stage such a spectacle, the authorities had to plan for the predictable, but account for contingency. In similar fashion, if we are to understand the Expo, and the logic of spectacle that it embodied, we need to account for both medium and message, to acknowledge the possibility both of motivated display and indifferent system. To characterize the Expo as a whole in terms of indifference, however, is not to dismiss the ideological nature of the work that it did. Interpellation does not require an apparatus to make its subjects believe something in particular about what he or she sees in front of him or her. Yoked to spectacle, the job is rather to get the subject to perform adequately as, for example, expo visitor: to get him or her on to the train and into the site and to police the boundaries of behaviour once there. Osaka garnered larger visitor numbers than any other expo in history. As importantly, it catalysed a boom in domestic tourism that has continued down to the present, reinforcing a shift from industrial production to individual consumption as the engine of economic growth.[60] As far as the state was concerned, the Expo and its visitors performed more than adequately.

Finally, to claim that Expo '70 could afford to be indifferent to questions of representation is not to suggest that the same is true of spectacle in other times and places. It may well be the case that their universal aspirations and accessibility make expos somewhat different from the more controlled display environments of museums and commemorations, the choreographed displays of Disneyland and Nuremberg. The latter two examples suggest a greater coincidence between medium and message (and behaviour) than is ever possible at a world fair. Even here, however, it may be useful to examine how such motivated displays can discipline the complexity inherent in sites of such size. It would

seem to be the case, moreover, that the trend towards indifference is one that has increased over time. In the nineteenth century, expos also exhibited a concern with questions of meaning: unsuitable exhibits, proper classification and appropriate deportment were ongoing headaches for exhibition authorities. Over time, however, the emphasis shifted from regulation to accommodation. Perhaps expos were simply ahead of the curve. By 1970 artists, too, had realized that the rules of the game were changing. Investigation was shifting from the spectacular potential of protest and happening to the systems within which such events could be accommodated.[61] Such an investigation continues to be important in the present. Not least, it might shed some light on why a museum founded in 1852 to support and encourage excellence in art and design could provide space in 2007 to explore the 'evolving image' of an Australian pop icon.[62] The simple answer, as at the Osaka Expo, is numbers, but this in turn only raises the question of whether the indifference between medium and message is now absolute.

Notes

Thanks to Deborah Cherry and Fintan Cullen for their invitation, encouragement and patience; to the other participants at the conference for their warm reception and hard questions; and to Stanford and Wake Forest Universities, the School of Oriental and African Studies, London, and the Japan Society for the Promotion of Science for the financial and other resources without which this work would have been impossible.

1 *Asahi Shinbun*, 27 April 1970, 15. See also Satō Hideo, 'Taiyō no tō o senkyo shite kara: banpaku o mioroshite kangaeta koto', *Chūō Kōron*, November, 1970, 188–96.

2 The best introduction to Okamoto's work at the Expo is the catalogue of a recent retrospective exhibition. Kawasaki-shi Okamoto Tarō Bijutsukan, ed., *Okamoto Tarō: Expo 70: Taiyō no tō kara no messeeji*, Kawasaki, 2000.

3 For the master plan, see Commemorative Association for the Japan World Exposition, *Japan World Exposition, Osaka, 1970: Official Report*, Suita, 1970, vol. 3, 158–73. For an overview of the site, see Japan Association for the 1970 World Exposition, *Expo '70 Official Guide*, Suita, 1970.

4 For the general history of Japan at the exhibition, on which the following is based, see Yoshida Mitsukuni, *Bankoku Hakurankai: Gijutsu Bunmeishiteki ni*, Tokyo, 1985; Yoshimi Shun'ya, *Hakurankai no Seijigaku: Manazashi no Kindai*, Tokyo, 1992; and Yoshimi Shun'ya, *Banpaku Gensō: Sengo Seiji no Jubaku*, Tokyo, 2005. In English, Ellen P. Conant, 'Refractions of the rising sun: Japan's participation in international exhibitions, 1862–1910', in Tomoko Sato and Toshio Watanabe, eds, *Japan and Britain: An Aesthetic Dialogue 1850–1930*, London, 1991, and Angus Lockyer, 'Japan at the Exhibition, 1867–1970', PhD diss., Stanford University, 2000.

5 For an introduction to the various aspects of postwar Japanese history, see Andrew Gordon, ed., *Postwar Japan as History*, Berkeley, 1993.

6 For the relationship between planning and 'big events', focusing on the 1975 Okinawa Expo, see Tada Osamu, *Okinawa Imeeji no Tanjō: Aoi Umi no Karuchuraru Sutadīzu*, Tokyo, 2004. For a critical analysis of postwar expos in Japan, see Yoshimi, *Banpaku Gensō*.

7 See Kazuko Tsurumi, 'Some Comments on the Japanese Student Movement in the Sixties', *Journal of Contemporary History*, 5:1, 1970, 104.

8 Henry DeWitt Smith, 'The Origins of Student Radicalism', *Journal of Contemporary History*, 5:1, 1970, 87.

9 Tsurumi, 'Some Comments', 107–109. For a more extensive contemporary analysis of the movement, exploring the multiple factions and mindsets, see Ichiro Sunada, 'The Thought and Behavior of Zengakuren: Trends in the Japanese Student Movement', *Asian Survey*, 9:6, 1969, 457–74, and Gavan McCormack, 'The Student Left in Japan', *New Left Review*, 65, 1971, 37–53. For a different backdrop and snapshot of the state of things just prior to the opening of the Expo, see Lawrence W. Beer, 'Japan, 1969: "My Homeism" and Political Struggle', *Asian Survey*, 10:1, 1970, 43–55.

10 Tsurumi, 'Some Comments', 111.

11 McCormack, 'The Student Left', 45–7. See also Patricia Steinhoff, 'Hijackers, Bombers, and Bank Robbers: Managerial Style in the Japanese Red Army', *Journal of Asian Studies*, 48:4, November 1989, 724–40.

12 Except where otherwise noted, the following is drawn from Satō's own account of his occupation of the Tower, 'Taiyō no tō'.

13 *Asahi Shinbun*, 27 April 1970, 15.

14 *Asahi Shinbun*, 16 April 1970, evening edition, 10.

15 *Medama no otoko*. This was one of a number of labels affixed to Satō over the course of his stay.

16 *Asahi Shinbun*, 3 May 1970, 15. After the initial shock of his appearance, there was little to report until they could begin to discuss the prospects for his imminent surrender or demise. The article notes that despite Satō's protestations, medical opinion suggests that after 140 hours he will reach his physical limits.

17 'Medama noritori geki, isshukan maku', *Asahi Shinbun*, 4, May 1970, 15.

18 Satō, 'Taiyō no tō'.

19 See, for example, the official photograph album. Nihon Bankoku Hakurankai Kinen Kyōkai, *Nihon Bankoku Hakurankai kōshiki kiroku shashinshū*, Suita, 1971, 453.

20 Osaka-fu Keisatsu Bankokuhaku Kiroku Henshu Iinkai, ed., *Nihon Bankoku Hakurankai no Keisatsu Kiroku*, Osaka, 1971, n.p.

21 Alexandra Munroe, 'Morphology of Revenge: The Yomiuri Indépendant Artists and social protest tendencies in the 1960s', in Alexandra Munroe, ed., *Japanese art after 1945: scream against the sky*, New York, 1994, 160. See Sawaragi Noi, *Kuroi taiyō to akai kani: Okamoto Tarō no Nihon*, Tokyo, 2003, for a complete account of Okamoto's life and work.

22 Okamoto Tarō, *Konnichi no geijutsu*, 1954, cited in Munroe, 'Morphology of Revenge', 154.

23 Okamoto, 'Dentō to wa nanika?', in *Watashi no gendai bijutsu*, Tokyo, 1963, cited in Alexandra Munroe, 'Circle: Modernism and Tradition', in Munroe, *Japanese art after 1945*, 128, 133.

24 Isozaki Arata, 'As witness to postwar Japanese art', in Munroe, *Japanese art after 1945*, 28.

25 'Jōmon earthenware exudes the smell of Japanese soil and groans under its weight. So robust and relentless – it is tense because it is holding back its explosive energy. Its beauty is almost terrifying – I sense the resonance of an extraordinarily vital rhythm that echoes in the bottom of my stomach. I feel that I can finally stretch my legs, excited with my discovery of the hidden pulse of the nation. This is what I was looking for.' Okamoto, 'What is tradition?', in Munroe, *Japanese art after 1945*, 382.

26 Sawaragi uses the 'black holes' as the starting point for his own re-evaluation of Okamoto. *Kuroi taiyō*.

27 Alexandra Munroe, 'The laws of situation: Mono-ha and beyond the sculptural paradigm', in Munroe, *Japanese art after 1945*, 259.

28 'Festival' is *matsuri*, 'monstrous' is *berabō*. For example, 'Bankokuhaku e no kitai to fuan' [Hopes and concerns for the Expo], *Asahi Jaanaru*, 22 October 1967; Okamoto Tarō, 'Bankokuhaku ni kaketa mono' [What I've staked on the Expo], in *Nihon Bankokuhaku: Kenchiku, Zōkei*, 1971, reprinted in Kawasaki-shi Okamoto Tarō Bijutsukan, *Okamoto Tarō*, 6–9. For an extended analysis of what Okamoto meant by these terms, see Sawaragi, *Kuroi Taiyō*. For *matsuri*, 208–226, and for *berabō*, 189–207.

29 The most useful overview of the project is Kawasaki-shi Okamoto Tarō Bijutsukan, *Okamoto Tarō*. In English, see *Official Report*, vol. 1, 477–95. Sawaragi also provides a tour of the exhibition, but ends it inside the Tower, before the emergence into mid-air and the future. *Kuroi Taiyō*, 170–88.

30 The interviewer, Yanobe Kenji, has made his artistic career in large part through the exploration of the Expo as providing not a city but the ruins of the future, not least in a recent recreation of Satō's performance of resistance inside the Tower of the Sun. Gunhild Borggreen, 'Ruins of the Future: Yanobe Kenji Revisits Expo '70', *Performance Paradigm* 2, March 2006, 125.

31 Kawasaki-shi Okamoto Tarō Bijutsukan, *Okamoto Tarō*.

32 *Bijutsu Techō*, 52.794, October 2000.

33 Sawaragi, *Kuroi Taiyō*. Okamoto is also beginning to reappear on the Western radar. Bert Winther-Tamaki suggests that Okamoto's Tower might also be understood in terms of Michael Hardt and Antonio Negri's work on globalization, as 'ritualistically digesting and rejuventating the multitudes, symbolically unleashing biopower unyoked from the hegemony of the bipolar framework of the Cold War'. 'Idol to Globalization: Okamoto Tarō's Tower of the Sun, 1970', paper delivered at 'Rajikaru! Experimentations in Japanese Art 1950–1975', conference at Getty Center, 27–29 April 2007. Abstract at: http://www.ponja-genkon.net/pdf/28_Sympo_Abstract_Bio_2.pdf (accessed 14 April 2007).

34 Kushima Tsutomu, a self-described 'Sunday researcher', has recently produced a celebration of the Expo, combining the author's memories and souvenirs from the time with a number of interviews. For one respondent, who would have been seven during the Expo, 'the inside [of the Tower] was empty'. *Maboroshi Bankoku Hakurankai*, Tokyo, 2005, 188–90.

35 For the official statistics on visitor behaviour, including queuing, see *Official Report*, vol. 2, 371–2. For media comment, *Asahi Shinbun*, 9 September 1970, evening edn, 15.

36 For the Association's own account, see *Official Report*, vol. 1, 43–57 and *passim*.

37 *Asahi Shinbun*, 6 February 1970, 10.

38 For example, Komatsu Sakyō, 'Nippon, 70 nendai zengo. Dokyumento: orinpikku kara bankoku-haku e', *Bungei Shunjū*, 49:2, 220–70.

39 One of the contemporary criticisms and retrospective puzzles of the Expo was the extent to which leading intellectuals, artists and architects, who had been associated with progressive causes during the 1950s and 1960s, were willing to participate in what some identified as a state apparatus. See Yoshimi, *Hakurankai no Seijigaku*, 222–6.

40 The Crystal Palace for London 1851 and the massive oval exhibition hall for Paris 1867 are examples of the former, Chicago 1893 and St Louis 1904 of the latter. See Paul Greenhalgh, *Ephemeral Vistas: The Expositions Universelles, Great Exhibitions and World's Fairs, 1851–1939*, Manchester, 1988, and Robert Rydell, *All the World's a Fair: Visions of Empire at American International Expositions, 1876–1916*, Chicago, 1984, for general accounts.

41 See Greenhalgh, *Ephemeral Vistas*, and Robert Rydell, *World of Fairs: The Century-of-Progress Expositions*, Chicago, 1993.

42 Inoue Shōichi, 'Pari bankoku hakurankai Nihonkan, 1937: Japonizumu, modanizumu, posutomodanizumu', in Yoshida Mitsukuni, ed., *Bankoku Hakurankai no Kenkyû*, Kyoto, 1986, 133–56.

43 See the numerous special issues of leading architectural journals dedicated to the Expo: *Kenchiku Zasshi*, 85 (1021), March 1970; *Kenchiku Bunka*, 28:4, April 1970; *Shin Kenchiku*, 45 (5), May 1970.

44 For a brief introduction to Metabolism, see David B. Stewart, *The Making of a Modern Japanese Architecture*, Tokyo, 1987, 177–85. See also Kurokawa Kishō, *Metabolism in Architecture*, Boulder, 1977.

45 Stewart, *The Making*, 219–22.

46 Kurokawa was also responsible for the Toshiba IHI Pavilion, composed of four 'structurally independent parts' but constructed for the most part from a single structural element; and a capsule house suspended from the roof of the Theme Pavilion. Kisho Kurokawa, 'Works and Projects: 1970s', http://www.kisho.co.jp/page.php/211 (accessed 14 April 2007). Kikutake had built the Expo Tower, standing at the southernmost edge of the site and facing the Tower of the Sun, confronting the latter's human form with a steel lattice, from which geodesic spheres were suspended, to provide observation platforms and a wireless relay station.

47 Sawaragi, 'Nihon toiu "warui basho"', cited in Sawaragi, *Kuroi Taiyō*, 199.

48 Cited in Sawaragi, *Kuroi Taiyō*, 195. For an introduction to Isozaki, see Stewart, *The Making*, 219–67.

49 For one example, see the sixteen-volume series, Usui Yoshimi, ed., *Gendai no Kyōyō*, Tokyo, 1966–8.

50 For Tange's career until the mid-1960s, see Stewart, *The Making*, 164–85. Also Zhongjie Lin, 'City as process: Tange Kenzo and the Japanese urban utopias, 1959–1970', PhD diss., University of Pennsylvania, 2006.

51 Both published their own accounts of the process: Nishiyama Uzō, 'Bankokuhaku kaijō keikaku: chōsa kara kikaku e', *Kenchiku Zasshi*, 85 (1021), March 1970, 193–9. Tange Kenzo, 'Bankokuhaku no keikaku to mirai toshi', *Kenchiku Bunka*, 282:4, April 1970, 71–6.

52 Nishiyama, 'Bankokuhaku kaijō keikaku', 194–8.

53 Kenzo Tange, 'My Experiences,' *SD*, 184, January 1980, 187. See also Mainichi Shinbunsha, *Here Comes EXPO '70*, Tokyo, 1968, 17.

54 Tange, 'Bankokuhaku no keikaku', 71.

55 Tange, 'Bankokuhaku no keikaku', 71–2.

56 'Master plan for EXPO '70 and master design of trunk facilities', *SD*, 184, 60.

57 Tange, 'Bankokuhaku no keikaku', 72.

58 Tange, 'Bankokuhaku no keikaku', 75.

59 *Asahi Shinbun*, 6 September 1970, 1. For the official account of visitor numbers, see *Official Report*, vol. 2, 362–70.

60 See Marilyn Ivy, 'Itineraries of Knowledge: Transfiguring Japan', in *Discourses of the Vanishing: Modernity, Phantasm, Japan*, Chicago, 1995.

61 Donna de Salvo, ed., *Open Systems: Rethinking Art c. 1970*, London, 2005.

62 Victoria & Albert Museum, 'Kylie – The Exhibition', http://www.vam.ac.uk/collections/fashion/kylie/index.html (accessed 1 April 2007).

9

DISPLAY AT THE NATIONAL PORTRAIT GALLERY, LONDON, 1968–1975

PETER FUNNELL

On Tuesday 2 July 1968, a set of four newly displayed rooms at the National Portrait Gallery, London, covering the period from the Napoleonic Wars to the death of Queen Victoria, was opened by the Minister for the Arts, Jennie Lee. A sense of the importance attached to the new displays by the gallery, and of the unusual nature of the opening event, is conveyed in the letter of invitation sent to Lee in April by the chairman of the trustees, Lord Kenyon, but presumably written by the Gallery's new, young director, Roy Strong:

> This will be the first series of rooms in the Gallery to be decorated in such a way aiming at evocative educational story-telling by mingling portraits with caricatures, furniture, captions, sculpture, weapons, photographs, etc. It is a blue-print for the redecoration of the whole Gallery. To the private view we are asking only history teachers from schools in the area and children between the ages of 14 and 18. We feel very strongly that the Gallery should be playing a vital part in the teaching of English history in London schools.[1]

The idea of a child-focused private view was presumably influenced by the success of the first Sunday-morning opening of the Victoria & Albert Museum in London early that April which Lee also attended and which had been carefully orchestrated by the V&A's Director, John Pope-Hennessy. Pope-Hennessy recalls 'ringing up any friend who had a child, begging them to come along to the museum that Sunday'.[2] Making museums and the arts in general more attractive to children and young people had become a significant strand in Lee's policy since she became Britain's first Minister for the Arts after Labour's election victory in 1964. In the event the age range invited to the Portrait Gallery opening was adjusted to 9 to 15 years with the proviso, printed on the crisply designed invitation card: 'No adult admitted without a child' (plate 9.2). The children were 'given a huge tea in the Tudor Room', Strong wrote to his friend Jan van Dorsten, 'little lecture tours and a dramatic reading'.[3] This was followed by speeches by Kenyon and Lee, Lee's speech sailing 'near the wind' politically, according to the biographer and trustee, Elizabeth Longford.[4] 'We dined with Miss Lee after', Strong wrote to van Dorsten ' – valuable – the whole a ploy to get her into the Gallery and I knew she *loved* children'.[5]

'Not Just Old Fossils', a headline proclaimed on 12 July 1968 above an account of the event in the unlikely setting of the *Railway Review*: 'Do you think of

museums as rows of old fossils staffed by old fossils? If you do then you are not with it, for the people who run our museums are certainly not past it.' This had also been a theme of Lee's speech: 'Miss Lee said our museums were casting off the image of static display institutions and becoming lively centres of activity. Ingenuity and enthusiasm were evident.'[6] In the following months a wave of press coverage celebrated the reforms that Strong was achieving at the Portrait Gallery and was to propel him into the forefront of public attention.

This essay will examine the creation of the sequence of displays that begins with those opened by Jennie Lee on 2 July 1968, dedicated to the years 1793–1901, and that continued in two further phases under Strong's directorship, covering the seventeenth and eighteenth centuries. They were described as 'a totally new historical concept of display' and 'the major internal achievement' of Strong's years by his successor, John Hayes, in the

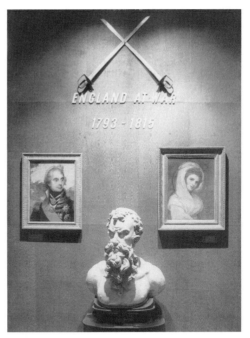

9.1 Detail featuring Lord Nelson, Emma Hamilton and figurehead, from installation shot of the new Regency and Victorian displays: the entrance to Room 12: 'England at War', National Portrait Gallery, London. © National Portrait Gallery, London, gallery records.

Gallery's *Report* covering the years 1967 to 1975.[7] The *Report* neatly summarizes the strategy of the displays. The sequence of rooms is chronological so as to 'provide a visual history of Britain, from the Tudor period onwards'. 'Within each room a theme or mood is established' and 'additional material, in the form of prints, furniture and objects, is employed to create a stimulating and imaginative effect.' 'The aim is to provide a revealing historical background to the portraits and to set them firmly in the context of their time.'[8] The true radicalism of the change in the gallery's displays that Hayes coolly describes is only fully revealed by comparative plates reproduced in the *Report* (plate 9.3). This shows 'before' and 'after' shots of the gallery's Civil War displays. In the one, portraits are neatly

9.2 Invitation card for the opening of the new Regency and Victorian displays at the National Portrait Gallery, London, Tuesday 2 July 1968. © National Portrait Gallery, London, gallery records.

117

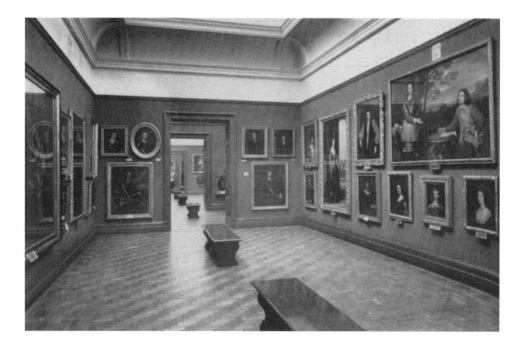

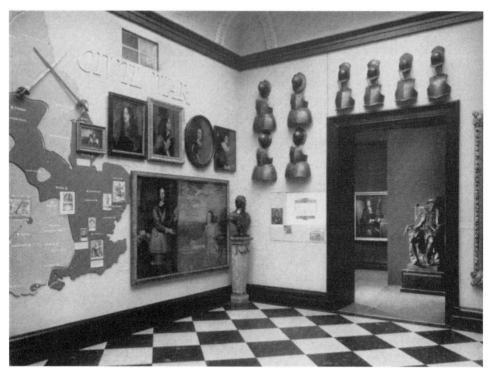

9.3 'Portraits covering the years of the Civil War, before and after the new display of 1969', plates 6 and 7 in National Portrait Gallery, *Report of the Trustees 1967–75*, London, 1975. © National Portrait Gallery, London, gallery records.

ranked on the walls with the only interpretation being supplied by labels, or 'tablets', on the frames providing details of sitter and artist. In the second photograph, showing the displays post 1969, giant letters proclaim 'CIVIL WAR', an equally giant map can be glimpsed to the left, portraits are irregularly placed, and suits of armour have been introduced on to the adjacent wall which also holds an explanatory graphic with reproductions.

I shall describe the radical changes in the permanent displays at the Portrait Gallery in the late 1960s and early 1970s shortly. As Hayes's comments suggest, at the time they were regarded as highly innovatory and, although relatively short-lived, this approach to display helps to elucidate broader issues or contexts that are the main focus of this essay. The first of these will require a brief account of display at the Portrait Gallery in the fifty or so years before Strong's directorship, with a view to examining how this reflected varying degrees of public engagement. This leads to an exploration of the place of the displays within the broader cultural politics of the later 1960s, notably their relationship, as much in tone and style as in substance I argue, to Jennie Lee's groundbreaking White Paper of February 1965, *A Policy for the Arts, The First Steps*. The final context will be the development of a popular consciousness of history during the period, a phenomenon in which the visualization of history played a crucial role.

THE DISPLAYS

By the time of Strong's departure to become director of the V&A at the end of 1973, he and his small, young team had transformed the entire top floor of the gallery, then its principal display area. The displays opened by Lee in 1968 occupied the four rooms of the extension of 1933 funded by Lord Duveen. On entering the first of the new, themed rooms, the visitor would have been confronted by a screen on which hung portraits of Nelson and Emma Hamilton (plate 9.4). Above them are crossed sabres and between them a massive figurehead of Neptune on loan from the National Maritime Museum. Two aspects of this can be said to apply to all the displays. The first, as Strong wrote at the time, is a 'new spirit of cooperation between the museums and galleries of London' that enabled the loan of non-portrait items from other collections, a precondition for the new display policy. The second concerns the type of popular history told in the displays, not shying from beginning with one of the more romantic stories of the Napoleonic period. This did not go without criticism. In an otherwise enthusiastic review, Gregory Martin, writing in the *Listener*, felt that 'to introduce the war with the French in terms of the love affair of Nelson and Lady Hamilton sacrifices a sense of history for gossip.'[9]

Beyond the introductory screen, the visitor would have come upon Karl Anton Hickel's large canvas *Pitt addressing the House of Commons* and a display tracing the course of the war with France through a type of pictorial timeline (or 'montage' in the word of the press release for the displays) that extends along the lower part of the walls (plate 9.5). This contains text, battle scenes in the form of engravings, and an oil painting, also on loan from the National Maritime Museum, which is hung tightly beside the gallery's own portrait of Admiral Duncan by Henri Pierre Danloux. Above are portraits of more military figures interspersed by an arrangement of bayonets. As Martin commented of the

displays, 'the portraits are no longer hung in serried rows, but are grouped according to the historical context of the sitters':

> Balance and symmetry – the time-honoured principles for the display of permanent picture collections – have for the most part been abandoned in favour of differently shaped and arranged chapters.[10]

Irregular hanging in fact became a key element in Strong's increasingly forceful outpourings against what he called the 'cobweb school' of museum curators. The next element of the display focused on the period from 1811 to 1830 of George, Prince of Wales' regency during the illness of his father and subsequent reign.

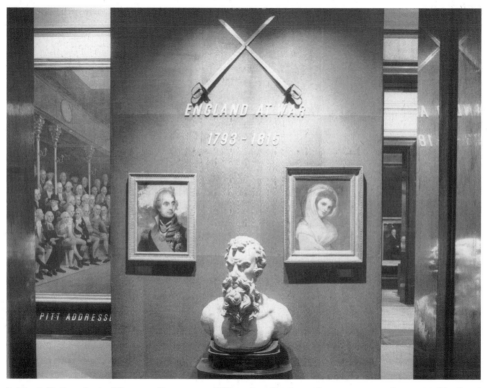

9.4 Installation shot of the new Regency and Victorian displays: the entrance to Room 12: 'England at War', National Portrait Gallery, London. © National Portrait Gallery, London, gallery records.

This display can be seen clearly in another installation shot of the time (plate 9.6). Here the Regency is epitomized by Thomas Lawrence's portrait of George IV (c. 1814), a piece of period furniture, a James Gillray caricature, and an aquatint of the orientalist pavilion that George had built at the seaside resort of Brighton. The room, also containing George Hayter's large painting *The Trial of Queen Caroline*, was papered in yellow and grey stripes.

Next was a room boldly headed REFORM. As the press release explained: 'The clouds of political, social, educational and moral reform gathered thickly in the opening years of the nineteenth century, contrasting sharply with the luxury of

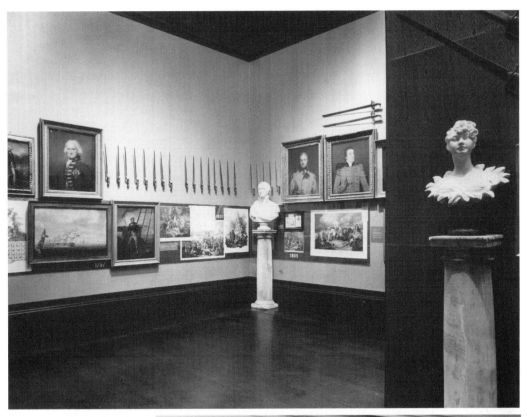

9.5 (above) Installation shot of the new Regency and Victorian displays: the left-hand walls of Room 12: 'England at War', National Portrait Gallery, London. © National Portrait Gallery, London, gallery records.
9.6 (right) Installation shot of the new Regency and Victorian displays: George IV wall in Room 13: 'The Regency', National Portrait Gallery, London. © National Portrait Gallery, London, gallery records.

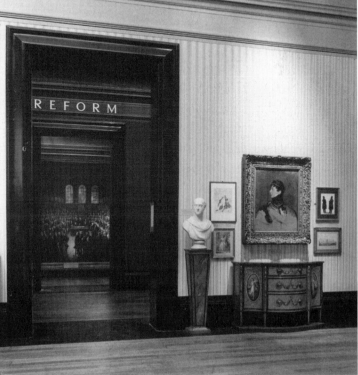

the Regent's rule.'[11] No photographs survive of this or of the next room that took the displays through to the end of Victoria's reign with strong emphases on the broadening of the political franchise and imperial expansion. But we know from an interview Strong gave to *Time & Tide* that the Reform room was subject to further experimentation:

> I have taken the frames off so you get the feeling of earnest men and women tackling great social problems more than you would if they were all sitting in gilt frames. The walls have been painted in dark olive green and quotations from Bentham in big gold letters decorate two of them.[12]

Hayter's enormous painting of The Reformed House of Commons can be seen hanging on a specially erected screen at the entrance to the final gallery on the other side of which were portraits of Victoria and Albert introducing the Victorian displays. In this room, the ceiling is 'dark crimson, and a Morris type wallpaper in yellow and purple is the background.'[13] Striking, quasi-period finishes and physical interventions into the internal fabric of the gallery building were further key elements in the new displays, the latter essential in order to articulate the discrete themes and tight historical narratives that they conveyed.

Energy, and a pragmatic ability to achieve effects simply and relatively cheaply, contributed to the speed with which Strong, working with two young members of staff – the designer Caroline Brown and assistant keeper Richard Ormond – was able to achieve his transformation of the gallery's permanent displays. In just over a year from the opening of the nineteenth-century displays, a further set of rooms was unveiled (plate 9.7), tracing British history from the accession of James I to the death of Queen Anne, 1603–1714. These are described in the 1967–75 *Report* as having 'a rather more elaborate treatment' than the rooms dedicated to the nineteenth century. They traced seventeenth-century history through the Jacobean court, the Civil War, the development of scientific and philosophical thought, the Restoration and the reign of Queen Anne.[14] As before, 'projecting screens' were used to divide the galleries and a range of evocative 'period' finishes was introduced. In the case of the Civil War room the chequered floor was in fact composed of black and stone-coloured linoleum tiles. This room also made use of a giant map (plate 9.8). Flanked by a bust of Oliver Cromwell and surmounted by more crossed swords, the map acts as a simple and direct way of conveying a narrative of the war, forming the background for engravings of portraits and events positioned next to the locations where battles or other incidents took place. The use of the gallery's extensive reserve collection of engravings was essential to the storytelling in both this and the previous set of displays. It was also, significantly, an issue over which Strong records the oppo-sition of his more conservative trustees. This came at the trustees meeting of October 1969, initially from Lord Euston but followed up by field marshall Sir Gerald Templar whom Strong regarded as an especially reactionary presence on the board and who, in an earlier incident, had told him and Ormond to get their hair cut.[15] On this occasion, Strong recorded in his diary, Euston had raised the question of the trustees approving all schemes of redecoration in the gallery:

9.7 (left) Invitation card for the opening of the new seventeenth-century displays at the National Portrait Gallery, London, Tuesday 16 September 1969. © National Portrait Gallery, London, gallery records.
9.8 (right) Installation shot of the new seventeenth-century displays: graphic in the Civil War room, National Portrait Gallery, London. © National Portrait Gallery, London, gallery records.

> That swipe boded ill and was followed by the Field Marshall [Templar] who demanded whether or not on principle engravings should even be included in the display. This was a frontline attack on the newly opened Regency rooms ... I was saved by Elizabeth Longford, who said decoration by committee was decoration by the lowest common denominator.[16]

With the exception of work on the Tudor room, the final phase of Strong's transformation of the gallery's displays was to be the set of rooms on the south side and central enfilade of the floor containing eighteenth-century portraits. Completed at the end of 1971, these seem to some extent more conventionally arranged than the earlier sets of displays. None the less, sections on the War of American Independence and colonial expansion saw a return to tried and tested methods with the introduction of another giant map dotted with engravings and loans of drawings from the Royal Institute of British Architects, a ship's model from the Maritime Museum, and botanical specimens from one of Cook's voyages (plates 9.9 and 9.10). Although this chapter confines itself to the period of Strong's directorship, this approach to display continued for some years after his departure. Richard Ormond advanced an extremely ambitious scheme for the gallery's first floor, recasting the Victorian displays and tracing British history up to 1914. Subject to delay, and never fully implemented, the first phase opened in 1975–6 and survived in part until the early 1990s (plate 9.11).

Revolutionizing the permanent displays was at the heart of the transformation of the gallery under Strong's directorship but there were many other innovations. The most important of these was the introduction of an ambitious and popular temporary exhibition programme beginning with *Beaton Portraits*.

123

9.9 Installation shot of the new eighteenth-century galleries taken before their refurbishment in 1987: Sir Joseph Banks on the left flanked by a botanical sample, National Portrait Gallery, London. © National Portrait Gallery, London, gallery records.

Opened shortly after the first set of permanent displays, with a highly theatrical set designed by Richard Buckle, it attracted some 80,000 visitors.[17] As Strong wrote a few years later, there was an interdependence between temporary and permanent displays:

> Exhibitions form a crucial part of any Gallery's policy. Indeed they might also be said to be statements of policy of an experimental nature, ideas and features of which will be taken up and used in the revamping of the public collection.[18]

There were other initiatives. Coinciding with the opening of the Regency displays, he produced a set of popular introductory publications to the collection.[19] Likewise, a series of leaflets entitled *Six Famous Portraits in Fifteen Minutes* was issued in August 1968 in acknowledgement that many visitors would welcome a simple, directed guide to the gallery's highlights. Experiments in public programming followed. Lunchtime readings by famous actors such as Dame Flora Robson (on Elizabeth I) and Dame Sybil Thorndyke (on Ellen Terry) in the 'People Past and Present Series' attracted capacity audiences. 'These occasions give point to the paintings. They are sell outs,' reported Quentin Crewe in a profile of Strong in the *Sunday Mirror* of 3 November 1968 headed 'He's Giving History a Facelift' that also warmly welcomed the new nineteenth-century displays.[20] Strong also

124

9.10 Installation shot of the new eighteenth-century galleries taken before their refurbishment in 1987: 'The Struggle for America', National Portrait Gallery, London. © National Portrait Gallery, London, gallery records.

9.11 Installation shot of the new first-floor Victorian galleries: 'Early Victorians', National Portrait Gallery, London, 1975. © National Portrait Gallery, London, gallery records.

introduced internal reforms that had important longer-term effects. These included abolition of the rule that barred the acquisition of portraits of living sitters, and a new emphasis on collecting and displaying photographic portraiture. Equally long term in its impact, and fulfilling the commitment to Jennie Lee to play 'a vital part in the teaching of history in London schools', was the establishment in September 1970 of a fledgling education department.

GALLERY DISPLAYS BEFORE 1968

Looking back in 1997 on his years at the Portrait Gallery, which he had joined as an assistant keeper in 1959, Strong reflected that

> it was a great institution that had gone to sleep ... None of the waves of innovation which stemmed from the United States had yet reached it, although they had already transformed, for instance, the Victoria and Albert Museum under the aegis of Leigh Ashton.[21]

Central to Strong's approach to the gallery's permanent displays was a fundamental shift in attitude to what was expected of museums and galleries, a change from the belief that their prime function was one of classification and preservation to the view that they should respond far more to the needs of the ordinary visitor. 'The day when a gallery could rest securely on the laurels of its great treasures is gone,' he wrote in 1968, 'Gallery directors in the mid-twentieth century have to be outward looking, deep in the knowledge of the artefacts of the past which they curate but part of the present in which they live.'[22] The model he refers to in 1997 – that of Leigh Ashton's transformation of the V&A's displays in the postwar period – would also have been the obvious precedent in Britain for any museum modernizer in the later 1960s. Dividing the displays between 'Primary Galleries' in which objects were sparingly and attractively arranged by period, and 'Secondary Galleries', arranged by material and aimed more at the specialist, Ashton had resolved issues of display specific to the V&A and had given the whole museum greater appeal and accessibility.[23] As such, Ashton's work represents an important moment in the twentieth-century history of museums in Britain and changing attitudes towards their publics.

Where had the National Portrait Gallery stood in this respect in the decades leading up to Strong's directorship? A view of the NPG's wider public function can be found in the early years of the century and the approach of its director from 1909 to 1916, C.J. Holmes. In words that anticipate Strong's approach, Holmes wrote of how 'the potentialities of the Gallery as a vivid illustration of our national history had always appealed to me'[24] and how it should be 'an essential feature in our national education'.[25] In order to fulfil this potential, Holmes set about making the gallery's displays more attractive and, in so doing, put into practice the most advanced approach to museum display of the period, that of 'dual arrangement'. This had first been applied to an art museum a few years earlier at the Boston Museum of Fine Arts under Benjamin Ives Gilman and anticipated the approach Ashton was to take at the V&A.[26] At Boston everything was done to aid contemplation by the general visitor: 'installation has been carefully studied to help the visitor to see and enjoy each object for its own full value,' the MFA's *Bulletin* stated in 1909.[27] Holmes had advocated the 'Boston system' as co-editor of the *Burlington Magazine*.[28] On becoming director of the

Portrait Gallery, he was able to put these new ideas into practice so that his rearrangement of the displays saw 'the proper exhibition of the best portraits' in a much less crowded hang in 'the galleries which had a good light', and 'the relegation of the unimportant to ordered obscurity'.[29]

The gallery appears to have grown more inward-looking under Holmes's successors, James Milner and Sir Henry Hake, the latter dominating the institution in the interwar years and the early 1950s. Partly there were other preoccupations. These were firstly that of simply finding more space for an ever-growing collection, something achieved with the opening of the Duveen Wing in 1933, and secondly the extraordinarily protracted process of postwar reconstruction.[30] As Strong acknowledged in 1970, his work would not have been possible 'without the labours of one's predecessors who reconstituted the collection after the war. This must have been a truly appalling task.'[31] Yet the display policy, and the attitude to the gallery's public during these years, was a highly conservative one. In this, however, it shared many of the attitudes that dominated most national museums in Britain in the interwar years and 1950s, a period that witnessed a tendency for museums to regard their principal users as connoisseurs and collectors who shared the same interests and preoccupations as those who staffed them. In Britain, this tendency was remarked upon in two reports on the state of museums commissioned by the Carnegie Foundation. That by S.F. Markham in 1938 stated:

> At present two cultural peoples exist side by side in this country. There is the world of the scholar and the connoisseur ... [associated with] our great national institutions [...]; and beneath it and all around it is a great body of Englishmen and Englishwomen who have had little opportunity of any definite education since they left school.[32]

Just after the 1939–45 war, a report published by the Dartington Hall trustees likewise attributed the decline in visitors to national museums during the interwar years to their attending to the 'specialist needs of students and connoisseurs' as opposed to 'the public at large'.[33] As David Piper, Strong's predecessor as director, recorded, this is very much how things were when he started at the gallery in 1946 under Hake. The 'daily business' of the place was punctuated by 'the coming and going of professional habitués, historians, antiquaries, curators' while 'the scale of activity, as far as relationship with the general public was concerned, was extraordinarily limited compared with what it has become since, as is the case in all museums and galleries.' Enquiries from the public 'would be met with courtesy if not warm enthusiasm.'[34] A slight thawing of attitudes occurred under Hake's successor, Kingsley Adams. As Adams wrote in the 1955–6 *Report*, 'it is planned – the public economy permitting – to provide a setting for the portraits somewhat less austere than has for long prevailed in this Gallery.' Allowing that this will be 'a very slow process', he was able to record that one of the Victorian rooms was 'now hung with a William Morris wall-paper'[35] and, over the years, further modest changes occurred. Temporary exhibitions such as *The Winter Queen* of 1963, curated by Strong and an early precedent for his approach to display, also began under Adams and there is a suggestion of a more generous attitude to the gallery's public. In spite of this, the permanent displays remained formal and virtually lacking in any form of interpretation, suggesting that it was

considered the gallery's primary duty to display as much of the collection as possible in an orderly fashion, aimed at those with sufficient knowledge to appreciate it (plate 9.12).

A sea change occurred under Adams's successor, David Piper, announced by the appearance of the 1964–5 *Annual Report* on the cover of which the old-fashioned typeface of previous years was replaced by a bold *sans serif*. Inside, the trustees welcomed the new Labour government's initiative to place national museums and galleries under the Department of Education and Science instead of the Treasury and expressed the hope for greater financial support.[36] The *Report* goes on to survey the current state of affairs at the gallery and its future prospects with an unprecedented expansiveness. It boldly asserts the gallery's place in national life – 'as integral in the living, ever continuing, texture of the history of Britain'[37] – and announces plans for the future, particularly with regard to the permanent displays:

> three methods of display are at present envisaged; first, the traditional form of picture gallery; secondly, allied to this and possibly in some cases built in with it, a series of thematic, story-telling, and changeable displays drawing also on sources other than the primary portraits, such as photographic montages and possibly a limited use of furniture, costume, and actual objects of the period; thirdly, the reference portraits will be shown in areas adjacent to the primary displays and likewise always open to the public.[38]

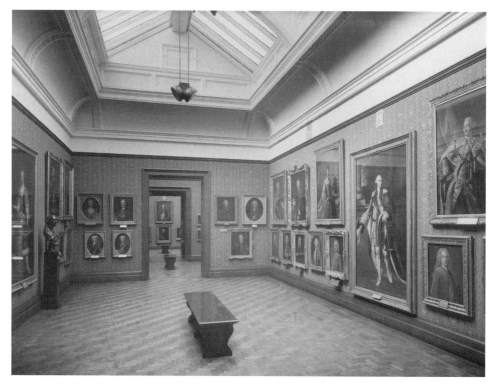

9.12 Installation shot of an eighteenth-century gallery, National Portrait Gallery, London, 1963. © National Portrait Gallery, London, gallery records.

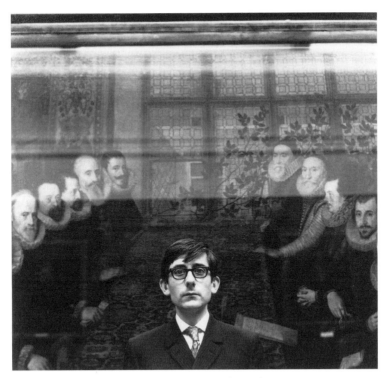

9.13 Sir Cecil Beaton, *Roy Strong*, 1967. Bromide print, 20.8 × 21.1 cm. Photographed for *Vogue*, 1967. By courtesy of The Cecil Beaton Studio Archive, Sotheby's, London.

This plan – with a picture gallery as distinct from areas dedicated to the 'reference portraits' – again echoes the principle of 'dual arrangement'. But of course what is most striking is the way the second category of display anticipates what was to happen in 1968. As this and subsequent reports further revealed, Strong was already working with Caroline Brown on improving the appearance and the organization of the display in a number of areas of the gallery.[39]

Piper's short directorship was an important transition period leading to the changes Strong was to make. That Piper's initiatives have been somewhat overshadowed might be put down both to the radical nature of what Strong implemented as director and the fact that, from the start, the transformation was so closely associated with Strong's own identity and the public persona he projected.[40] The importance of this should not be underestimated since it not only guaranteed the success of Strong's project in terms of public attention but was, I will suggest, in accord with the tone and spirit of Jennie Lee's aspirations for the arts. The image that Strong acquired in the months towards the end of 1968 and early 1969 – the period of the new displays, *Beaton Portraits*, and the other innovations – will be familiar to anyone who has read Strong's *Diaries* or who knows the portraits of him from Cecil Beaton's 1967 *Vogue* session showing him in the gallery (plates 9.13 and 9.14). These photographs also illustrated two major profiles of Strong that appeared in the *Guardian* and *Sunday Mirror* in November 1968 and which constituted a high degree of exposure that Strong himself remarked upon at the time: 'pop idol stuff'.[41] In both articles image and

text reinforce each other: youth and sharpness of dress, wit and intelligence beyond the slightly disengaged expression, and above all, the element that is central to the persona, the combination of scholar and showman. Like the Beaton photographs, both articles begin with accounts of Strong in the context of the gallery – 'he scuttles round the dignified halls of the Portrait Gallery [...] looking like some stray from the pop scene'[42] – playing up the implausibility of man and position, the contrast between old and new. 'Dr Strong is a combination of scholar and showman in equal parts,' *Time & Tide* observed in a further profile published on 5 December 1968, and it was an idea that Strong was himself keen to advance.[43] He was highly conscious of the role that scholarship had played in taking him from his relatively humble suburban upbringing and allowing him, as he says, to 'enter a new world'.[44] Equally, the need to 'take your museum out to the public with a certain amount of showmanship'[45] was a key theme of Strong's polemics at this time and he was adept at matching his own style to suit the journalistic occasion, mingling references to high and low culture and dropping into pop argot for papers like the populist *Sunday Mirror*. Indeed the *Mirror* ends with a hyperbolic passage that draws attention to these apparent contradictions but finds them resolved. 'I suddenly realised that he is a man of the future' the profile concludes, for 'he is what people will be like when education is neither a privilege nor a struggle – when it is universal.'[46] In the context of the *Mirror*, a newspaper with strong Labour sympathies, there are evident political resonances to this.

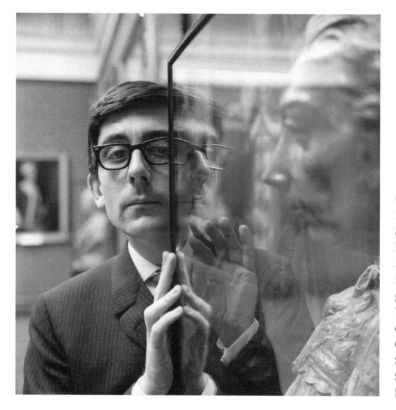

9.14 Sir Cecil Beaton, *Roy Strong*, 1967. Bromide print, 20.8 × 21.1 cm. Photographed for *Vogue*, 1967. By courtesy of The Cecil Beaton Studio Archive, Sotheby's, London.

THE POLITICAL CONTEXT FOR THE NEW DISPLAYS

In recent years Strong has been keen to distance himself from Jennie Lee and her policies. Having solicited his recollections for her 1997 biography of Lee, Patricia Hollis records his 'harsh judgement'. He relates the episode with which this essay begins in less than flattering terms, of how he had shipped in 'a mass of Council children to keep her happy' and how 'one had to play up to her': 'Nothing would lead me to conclude that she knew anything at all about the visual arts ... She was a lovable opinionated champagne Socialist who always popped up at the head of the queue anywhere.'[47] Strong's contemporary account of Lee at the opening of the new Regency galleries, though not without its reservations, was a good deal more sympathetic than his later recollection: 'I was impressed by her, although she is a bit clogged up with *vieux jeux* socialism.'[48]

Whatever Strong's personal views of Lee, there is a very close congruence between what he did and said at the time and the views that are most clearly articulated in Lee's *A Policy for the Arts, The First Steps*. At the heart of the White Paper is a vision of a greatly expanded audience for the arts and an emphasis on the interdependence between the arts and education. In terms reminiscent of the Carnegie Foundation and Dartington Hall reports of the mid-century, the White Paper criticizes 'those of our museums [...] that have failed to move with the times, retaining a cheerless unwelcoming air that alienates all but the specialist and the dedicated'.[49] As Lee put it in an address to the Museums Association in 1966, museums must make 'provision to attract the general public more and more [...] this is the place for the museum of the future.' Museums, she continued, should be 'the living centre of a community'.[50] Central to this aspiration was greater provision for children. 'Almost all the activities described in this White Paper', Lee's policy document states, 'are linked directly or indirectly with education.'[51] Lee was insistent that museums should become both more attractive and welcoming to children[52] and she worked hard to encourage more formal relationships between schools and museums, a 'two-way traffic' with 'museums going to the schools and to the children' and children feeling that the museum was a 'home from home'.[53]

Although it would be inaccurate to view developments at the National Portrait Gallery in the late 1960s as some sort of 'implementation' of government policy, it is clear that Strong's reforms were in tune with Lee's policies. The new permanent displays and associated activities had an educational role at their heart and were part of Strong's mission to open up the gallery to broader audiences. It is, however, as much in tone and spirit as in policy that further similarities between Lee's vision for the arts and Strong's activities at the Portrait Gallery emerge. In one of the key passages in the White Paper, it is asserted that for change to take place 'a new social as well as artistic climate is essential.' It allows that 'many working people' have been conditioned to consider the arts 'outside their reach':

> A younger generation, however, more self-confident than their elders, and beginning to be given some feeling for drama, music and the visual arts in their school years, are more hopeful material. They will want gaiety and colour, informality and experimentation.[54]

An emphasis on 'attractive presentation', on lessons learned from advertising and marketing, is a recurrent theme of the White Paper. Arts venues should be given

'a gay "Come to the Fair" atmosphere';[55] and the arts should contribute towards 'making Britain a gayer and more cultivated country'.[56] Again, the emphasis on 'gaiety and colour, informality and experimentation' is clearly parallel to what Strong put in place at the gallery as well as the image he projected of himself. He also shared with Lee a strong sense that museums should be places of enjoyable recreation and provide the facilities necessary for this. When he addressed the Museums Association in 1970 he, too, put forward a vision of the museum as serving 'the average family person' with facilities for both children – 'a crèche, a games room, a room to paint in' – and their parents: 'Martinis with the Bellinis may sound very shocking but surely this is the future of museums.'[57]

Strong, like Lee, also had a vivid sense of the emergence of a new public for the arts. As he wrote in April 1969:

> I want to see exhibitions reaching out to a wider public, which through television and teaching in our schools is becoming ever more culturally conscious [. . .] it will mean the destruction of the high art aura [. . .] and the broadening out of the exhibition concept to bring in a much wider range of people.[58]

This too draws a comparison with a passage in Lee's White Paper and, in its references to those made 'culturally conscious' through popular media such as television and film, places Strong and his work at the Portrait Gallery within a wider context of contemporary debate about the arts and their public. Turning to the 'diffusion of culture' the White Paper asserts that 'advertisements, buildings, books, motor cars, radio and television, magazines, records, all carry a cultural aspect.' The role of government, it continues, should be that of 'bridging the gap between what have come to be called the "higher" forms of entertainment and the traditional sources – the brass band, the amateur concert party, the entertainer, the music hall and pop group – and to challenge the fact that a gap exists.'[59] This is what Robert Hewison has called the 'long front of culture' and which he defines as 'a new democratic model of culture – the 'long front' – which broke down the old hierarchies of taste, admitted fresh cultural forms like rock music and constructed a new, collage culture from the fragments of the old'.[60] This notion of 'bridging the gap' was central to the White Paper.[61] But it was a view that drew censure from the intellectual Left, most notably from Richard Hoggart. In a searching essay on 'The Arts and State Support' in 1967 Hoggart also noted the expanding audience for the arts, especially among young people, and applauded 'the remarkable step forward' that Lee's White Paper represented. But he was disdainful of 'the new adman's tone' of passages such as that on 'gaiety and colour' and of the 'muddle' of conceiving very different types of artistic expression as essentially the same 'without sufficiently considering what appreciation of the arts really involves'.[62] Elsewhere in the article he deplores the way the arts can be conceived 'as a form of consumption'. 'Such an attitude attracts the world of commercial persuasion and learns its language,' he writes, 'It insists that to enjoy the arts is fun; it has a whizz-kid air.'

POPULAR HISTORY

If Strong's reforms at the National Portrait Gallery were played out against the background of government attempts to broaden the public for the arts and the

debates these stirred, there was a further related phenomenon that has a close bearing on what he and his colleagues did. This is, in Peter Mandler's words, the 'boom in popular historical consciousness'[63] that took place in the 1960s. According to Mandler's account, 'from a very low ebb in the late 1950s, popular engagement with history in a variety of old and new forms burgeoned dramatically over the next few decades.'[64] Old forms included 'a sudden and dramatic growth of interest in history books'[65] while new manifestations of an enthusiasm for history range from a trebling of National Trust visitors to three million per annum during the course of the decade[66] to the exploitation of the subject through popular media such as television.[67] Again there is a sense not just of a widening audience but also a shift into the worlds of recreation and entertainment: 'history began to look less like a burden and more like a funfair.'[68] The varied and multiple forms this new consciousness of the past took are nowhere more richly recorded than in Raphael Samuel's sympathetic excursions into the worlds of what he calls 'unofficial knowledge' in *Theatres of Memory*. Samuel too finds that the 'historicist turn in national life may be dated to the 1960s'[69] citing examples ranging from the boom in family and local history to the passion for collecting even the most ephemeral items from the past. A key feature of the new popular awareness of history that Samuel emphasizes was its strong pictorial element. Strong himself was fully alert to the possibilities this presented, writing in 1969 that this was 'an age when the public are ever more visually conscious of the past'.[70] A prime agent of this trend was the development of illustrated, historical publishing. Samuel, again, has recorded the 'discovery' of old photographs in this period and is keen to celebrate the role of 'the picture researchers': 'a new breed of Cliographers who owe their existence to the photo-litho revolution of the 1960s, so far as popular historical publication is concerned'.[71]

Illustrated historical publications – whether newly created series or illustrated editions of already popular books – offer close parallels to the new permanent displays at the National Portrait Gallery.[72] Strong used the language of the graphic, writing of 'portraits hung as pictorial collage'. Collage is a word he frequently used to describe his method of display and one that has further echoes of the 1960s worlds of art and pop. As with popular illustrated history, this collage approach worked through the lively juxtaposition of a wide range of images in a variety of media – portraits, documents, engravings, maps – providing a similar visual texture. The association between the gallery and the popular publishing industry was also developed during these years when it teamed up with firms such as Jarrold & Sons and Pitkin Pictorials, both publishers of popular illustrated histories and guides to heritage sites, to produce colourful introductions to the collection. And museums and galleries were themselves among the prime repositories supplying the materials for illustrated books and thus part of the network responsible for the production of popular illustrated history.

Further similarities between the new permanent displays and popular illustrated publishing lie in the sort of history they told. Samuel has identified the way that

the visual provides us with our stock figures, our subliminal points of reference, our unspoken point of address. When we think of eighteenth-century politics we see Hogarth's Wilkes. The bubonic plague brings skeletons out to dance. The Crimean War is Florence Nightingale with her lamp.[73]

Telling history at the National Portrait Gallery necessarily worked in this way because portraits and the lives of individuals come to stand for larger episodes. But in Strong's displays this was part of a genuinely popularizing instinct. They were, as Kenyon wrote to Lee, a type of 'evocative educational story-telling'. In this view of things, it is perfectly legitimate to structure an account of British history through emphasizing its 'stock figures'. Despite the *Listener's* reservations about sacrificing a 'sense of history for gossip', it is very much the point that the Napoleonic Wars should be introduced by portraits of Nelson and Emma Hamilton together with the figurehead of Neptune and crossed sabres. And in the map showing the Civil War in the seventeenth-century displays there was no hesitation in including a print of Charles II's oak tree.

Strong's keen appreciation of the possibilities of pictorial history is further demonstrated by his highly original book on Victorian historical genre painting,

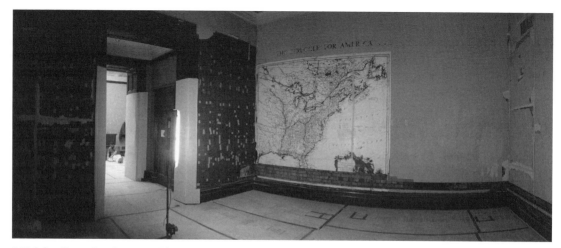

9.15 John Goto, *America*, 1999: The 'Struggle for America' room during refurbishment of the galleries in 1999. © John Goto.

And when did you last see your father?, based on lectures given in 1974. He had always been fascinated by such pictures, he writes in the foreword, 'since they illustrated the history books of my childhood' and presented history as 'a glittering pageant, full of striking and romantic tableaux, peopled by their heroes and heroines'. History as taught at university, he writes, 'with its preoccupation with the administrative, economic and constitutional aspects, came as a terrible shock after this idyll of splendour.'[74] The 'Victorian vision' of history, on the other hand, worked to access the past through familiar episodes and, as in Samuel's formulation, stock figures – 'bluff King Hal, magnificent Elizabeth, innocent Jane Grey' – making the past 'human, living and real'.[75] It was also a version of history that had become widely diffused, he writes, 'through the spread of literacy and the popular reading of national history' in the Victorian period. Strong's deep sympathy for popular and pictorial types of history was fundamental to the creation of new permanent displays during his years as director. But it also gave him an insight into the gallery's founding circumstances and principles, in part a manifestation of popular nationalist history in the 1840s and 1850s.[76]

Strong's clear apprehension of the role of popular history in the foundation of the gallery gave further conviction to the radical changes he made to the permanent displays. These displays were gradually replaced in the 1980s and early 1990s and their approach largely rejected (plate 9.15). A number of factors could be advanced for this, from the difficulties of maintenance, on the practical side, to a shift towards an historicizing approach to hang and decoration common to many museums in the 1980s and a new respect for the gallery's building and the original plan of its rooms. A desire to return the portraits to greater prominence in the displays was another element as was a more questioning approach to the tight narrative of national history that Strong's approach implied. But his transformation of the gallery's displays remains important for its attempt to engage the gallery fully in the telling of history. It also reveals attitudes towards the gallery's public that anticipate much that concerns those who work in museums and galleries today.

Notes

I am grateful to Charlotte Brunskill, Emma Chevalier, Bernard Horrocks, Catharine MacLeod, Sandy Nairne, Richard Ormond and Heather Tilley.

1 Lord Kenyon to Jennie Lee, April 1968, National Portrait Gallery Archive, gallery records, Building, rooms 12–15.

2 Patricia Hollis, *Jennie Lee, A Life*, Oxford, 1997, 273.

3 Strong to Jan van Dorsten, 20 July 1968, in *The Roy Strong Diaries 1967–1987*, London 1997, 22.

4 Elizabeth Longford to Strong, 3 July 1968, National Portrait Gallery Archive, gallery records, Building, rooms 12–15.

5 Strong, *Diaries*, 22.

6 *Railway Review*, 12 July 1968, National Portrait Gallery Archive, gallery records, press cuttings.

7 National Portrait Gallery, *Report of the Trustees 1967–75*, London, 1975, 29. No report had been published under Strong since, he explains, he was 'so busy'; Strong, *Diaries*, 128.

8 National Portrait Gallery, *Report of the Trustees 1967–75*, London, 1975, 29.

9 *Listener*, 25 July 1968, National Portrait Gallery Archive, gallery records, press cuttings.

10 *Listener*, 25 July 1968, National Portrait Gallery Archive, gallery records, press cuttings.

11 Press release entitled 'From Waterloo to Sebastopol, The National Portrait Gallery introduces a historical panorama', National Portrait Gallery Archive, gallery records, Building, rooms 12–15.

12 *Time & Tide*, December 1968, National Portrait Gallery Archive, gallery records, press cuttings.

13 *Listener*, 25 July 1968, National Portrait Gallery Archive, gallery records, press cuttings.

14 National Portrait Gallery, *Report of the Trustees 1967–75*, 30.

15 Strong, *Diaries*, 26.

16 Strong, *Diaries*, 45. It is odd that Strong talks of the newly opened Regency rooms in October 1969: by then both those and the seventeenth-century rooms were open.

17 On *Beaton Portraits*, see Susanna E. Brown, 'Exhibiting Beaton: The Changing Face of the National Portrait Gallery in the 1960s,' MA dissertation, Courtauld Institute of Art, 2005.

18 *Art & Artists*, January 1970, 29, National Portrait Gallery Archive, gallery records, press cuttings.

19 For example, a sixpenny leaflet by Richard Ormond entitled *Seeing history* on the display 'England at War'.

20 *Sunday Mirror*, 3 November 1968, National Portrait Gallery Archive, gallery records, press cuttings.

21 Strong, *Diaries*, 6.

22 Typescript article entitled 'Updating a Victorian Institution', published in *Parade, A News-Review of the Arts*, National Portrait Gallery Archive, gallery records, press cuttings.

23 See Anthony Burton, *Vision & Accident: The Story of the Victoria & Albert Museum*, London, 1999, esp. 195–9.

24 Charles John Holmes, *Self & Partners (Mostly Self)*, London, 1936, 267.

25 Holmes, *Self & Partners*, 291.

26 For the origins of the idea of 'dual arrangement', see Burton, *Vision and Accident*, 161–2, and Andrew McClellan, 'A Brief History of the Art Museum Public', in Andrew McClellan, ed., *Art and its Publics: Museum Studies at the Millennium*, Oxford, 2003, 18–19.

27 Quoted by McClellan, 'A Brief History', 19.

28 For example, see both the Editorial and an article 'Art in America' in the *Burlington Magazine*, 9:37, April 1906.

29 Holmes, *Self & Partners*, 268.

30 See National Portrait Gallery, *Ninety-ninth Annual Report of the Trustees 1955–56*, London, 1956, 18, where it is recorded that reinstallation of the entire collection was not expected until the following year.

31 *Art & Artists*, January 1970, 27, National Portrait Gallery Archive, gallery records, press cuttings.

32 Quoted by Burton, *Vision & Accident*, 185.

33 Quoted by Burton, *Vision & Accident*, 186.

34 David Piper, typescript autobiography, chap. 8, 46, National Portrait Gallery Archive, gallery records, staff. I am grateful to Lady Piper for permission to quote from this document.

35 National Portrait Gallery, *Report of the Trustees 1955–56*, 18.

36 National Portrait Gallery, *Annual Report of Trustees 1964–65*, London, 1965, 5.

37 National Portrait Gallery, *Annual Report of Trustees 1964–65*, 7.

38 National Portrait Gallery, *Annual Report of Trustees 1964–65*, 6.

39 There was also an aborted project at this time to re-display the seventeenth-century collection working with the theatre designer Timothy O'Brien. National Portrait Gallery Archive, gallery records, Building, rooms 12–15.

40 Strong acknowledges in his *Diaries* that 'Piper gave me my head, allowing me to begin rear-ranging the public galleries', Strong, *Diaries*, 7.

41 Strong, *Diaries*, 29.

42 *Guardian*, 29 November 1968, National Portrait Gallery Archive, gallery records, press cuttings.

43 *Time & Tide*, 5 December 1968, 13, National Portrait Gallery Archive, gallery records, press cuttings.

44 Strong, *Diaries*, 4.

45 *Time & Tide*, 5 December 1968, 13, National Portrait Gallery Archive, gallery records, press cuttings.

46 *Sunday Mirror*, 3 November 1968, National Portrait Gallery Archive, gallery records, press cuttings.

47 Similar feelings at the National Gallery are recorded by Michael Levey in Hollis, *Jennie Lee*, 273, though he did not think so, nor did Pope-Hennessy at the V&A: see John Pope-Hennessy, *Learning to Look, An Autobiography*, 163, in which he writes of sharing 'many of her social and educational convictions'.

48 Strong, *Diaries*, 23. That he became increasingly irritated by the old-style Left is revealed in an entry from 28 March 1973 and he was to become hostile to the proposed 'wealth tax' of the 1974 Wilson government.

49 *A Policy for the Arts, The First Steps*, London, 1965, 5.

50 *Museums Journal*, September 1966, 66:2, 96.

51 *A Policy for the Arts*, 14.

52 Levey cites an incident in the National Gallery when Lee chided a mother for hushing her child: 'Don't do that or she will associate the National Gallery with restrictions'; Hollis, *Jennie Lee*, 278.

53 *Museums Journal*, September 1966, 66:2, 97.

54 *A Policy for the Arts*, 5.

55 *A Policy for the Arts*, 13.

56 *A Policy for the Arts*, 20.

57 *Museums Journal*, December 1970, 70:3, 104.

58 *Queen*, 2 April 1969, 41, National Portrait Gallery Archive, gallery records, press cuttings.

59 *A Policy for the Arts*, 15–16.

60 Robert Hewison, *Too Much: Art and Society in the Sixties 1960–75*, London, 1986, xv, and see 57–8 on *A Policy for the Arts*.

61 See also Hugh Jenkins, *The Culture Gap: An Experience of Culture and the Arts*, London and Boston, 1979, 15.

62 Richard Hoggart, 'The Arts and State Support', in *Speaking to Each Other*, London, 1970, 241–2; and see Hollis, *Jennie Lee*, 294.

63 Peter Mandler, *History and National Life*, London, 2002, 131.

64 Mandler, *History*, 93.

65 Mandler, *History*, 100.

66 Peter Mandler, *The Fall and Rise of the Stately Home*, New Haven and London, 1997, 388.

67 This was the period of Peter Watkin's *Culloden* (1964), Kenneth Clark's *Civilisation* (1969) and *The Six Wives of Henry VIII* (1970).

68 Mandler, *History*, 94.

69 Raphael Samuel, *Theatres of Memory*, London and New York, 1994, 146.

70 *Queen*, 2 April 1969, 39.

71 Samuel, *Theatres*, 25.

72 For example, the long running series of contextualized biographies published by Thames & Hudson such as Tom Pocock, *Nelson and his World*, London, 1968. Mandler cites a gift pack of Trevelyan's *Illustrated Social History* as the 'top seller' of 1964; Mandler, *History*, 100.

73 Samuel, *Theatres of Memory*, 27.

74 Roy Strong, *And when did you last see your father? The Victorian Painter and British History*, London, 1978, 7.

75 Strong, *And when*, 11.

76 See Strong, *And when*, 45, where he makes this connection. For recent writings that help establish this as a context for the gallery's foundation see Rosemary Mitchell, *Picturing the Past, English History in Text and Image 1830–1870*, Oxford, 2000, esp. chaps 4 and 5; Mandler, *Fall and Rise*, chaps 1 and 2; Mandler, '"In the Olden Time": Romantic History and English National Identity, 1820–1850', in Laurence Brockliss and David Eastwood, eds, *A Union of Multiple Identities*, Manchester, 1997.

10

NARRATIVES OF DISPLAY AT THE NATIONAL GALLERY, LONDON

CHARLES SAUMAREZ SMITH

When I was Director of the National Gallery, I was, for obvious reasons, interested in issues relating to the display of the collection: how the collection had been displayed in the past, what was the rationale for the display in the present and what should be the method of display in the future.[1]

Described thus baldly, identifying the methods of display at the National Gallery might seem a relatively straightforward, intellectual project, based on the description as to how the galleries looked in the past, how they look now, and how they might be made to look in the future. But, the task was not easy.

The principal reason is that those involved in organizing displays in the past have often not bothered to describe why they have hung pictures in a particular way: they have presumed that the public and their fellow practitioners (in other words, those in the art world and curators) will recognize how and why pictures have been hung the way they have, without it needing to be explained. There are period orthodoxies in which there is an established consensus as to how galleries should look and on the relationship between the art and the display, which has militated against a clear description of aims and intentions. Methods of display are often loaded with a great deal of supplementary baggage about the power relations within the institution, who is permitted to undertake the display, and what their attitude is towards the public and to the relationship between the experience of art and the need for additional contextual information. But this intellectual freight is seldom discussed, except in private behind closed doors. It touches on sensitivities about how organizations are managed and who holds power within them. It is quite tricky to describe precisely because it has not been thought worth discussing in the past.

So, what I aim to do in this chapter is to provide a straightforward description of the history of display at the National Gallery since the early 1930s, while trying to draw out and describe the changing attitudes and ethos which lie behind it.[2]

HANGING BY EYE

In 1934 the young Kenneth Clark (plate 10.1), later to be internationally well known as a popularizing art historian, became Director of the National Gallery, fresh from a spell working for Bernard Berenson at I Tatti in Florence and as Keeper at the Ashmolean Museum, Oxford. He was full of zeal for shaking the dust

10.1 Howard Coster, *Kenneth Clark, Baron Clark*, 1937. © National Portrait Gallery, London, www.npg.org.uk.

off the institution and the potted palms out of the entrance staircase. He inherited an institution which was old-fashioned and where the pictures had traditionally been displayed densely, crowded on the walls like postage stamps in the late nineteenth century and still hung very tightly in a single line just above the skirting during the 1920s.[3]

Wanting to make his mark, Clark did so by re-hanging the collection in such a way as to earn the esteem of his Bloomsbury friends, moving Van Dyck's *Charles I on Horseback* because it apparently overwhelmed the British display in Room xxv (now Room 9) and including a much stronger representation of work by Manet and Cézanne, still regarded as dangerously modern.[4] As Helen Anrep wrote to him on 20 March 1935:

> At last I got a happy free afternoon to go to the National Gallery. I knew I would be glad to be there and looking at pictures again but I had no notion how exquisite and exciting it would be with your hanging – It isn't that you have improved things, that this or that picture looks better. It's a completely new Gallery – You have so changed the tenor and mood that one sees an old picture from such a different angle with such new associations that it is, if not a new picture, or new aspect of that artist – The whole place seems full of a new gaiety and fragrance and the individuality of minor men [has] acquired such a clear tone.[5]

Perhaps most importantly, she was able to report that Roger (i.e. Roger Fry) would have been thrilled.

It is clear from his autobiography, *Another Part of the Wood*, that Kenneth Clark had complete confidence in his ability to hang according to the judgement of his eye – an ability which he felt he had been born with and was conferred by his aesthetic judgement, which he always regarded as at least as important to the understanding and appreciation of works of art as a knowledge of their history. As he writes:

> From childhood onwards hanging pictures has been my favourite occupation. It has been a substitute for being a painter and a concrete illustration of my feelings as a critic. It is a curious art. One never knows what pictures are going to say to one another till they meet. Like two placid babies passing each other in their prams, they may either stretch out their arms in longing or scream with rage. People who hang galleries 'on paper', with measured squares representing the pictures, have never heard those cries of love or hate.[6]

In other words, his approach to the hanging of paintings was intuitive, based on the visual relationship between works of art and their formal values, rather than on a more strictly logical or historical sequence. His pleasure was akin to that of treating it as a semi-private collection and the comment about people who hang galleries 'on paper' was an implied criticism of the methods of his successor, Philip Hendy, who was known to have organized his hang by working with little, scaled-down reproductions of the paintings on graph paper. The surviving visual evidence of galleries during the 1930s, photographed after the installation of electric lighting, suggests that Clark hung quite sparsely on figured wallpaper with the occasional *cassone* to mitigate the institutional feel of the galleries.

In a lecture which Clark delivered in the last year of the 1939–45 war, subsequently published in the *Museums Journal*, he extolled the virtues of smaller

museums and galleries, rather than the large municipal museums, describing how:

> These are galleries [he was referring to Dulwich and Bruges] for the contemplative person and the professed lover of art. How far such people should be indulged at the expense of a wider scheme of education is a question which I will turn to later on, but I would say that these small, quiet, perfect galleries with only a few masterpieces are something very important to the life of the State and the understanding of art. They are the real thing, whereas the busy, educational, go-getting sort of picture gallery very often, becomes, as it were, journalism compared with literature.[7]

This passage is indicative of the essential elitism of his approach. John Amis, the music critic, remembers him saying how he knew that his staff felt that he lacked the common touch, a slightly ironic assessment given that he was later to become one of the most populist exponents of art history through the medium of television. He wanted small rooms and side-lighting and was sensitive to the benefits of seeing pictures under natural daylight. He ended with a plea against popularization:

> During the last few years we really have done our best at the National Gallery to make it accessible, but I feel that there is a limit to popularisation beyond which one cannot go without cheapening works of art. We must not try to persuade people that art is a ripe plum ready to drop into their mouths, but that it offers such rewards as to justify strenuous individual efforts.[8]

ISOLATING MASTERPIECES

Immediately after the 1939–45 war Philip Hendy, the newly appointed Director, who had come south from being Director of Leeds City Art Gallery, explained the logic of his hang (plate 10.2). He starts with the arrangement of the rooms:

> In its present form, truncated but more symmetrical than before, the Gallery has its centre no longer in Room I but in the Dome. In fact the Dome has come to dominate the building. The size and importance of the Italian altarpieces there have been increased; but I think I have made a mistake in following tradition and putting the finest of the large early Renaissance pictures in Room I, and not in the four rooms which radiate from the Dome. There they would support the altarpieces and make a still stronger centre, as well as filling the height of the rooms better.[9]

Here one sees an incoming Director grappling with the issues of the architecture of the building and what looks best where, as opposed to inherited traditions and public expectations which determined that Italian altarpieces should hang in Room I. Like Clark, Hendy believed that the look of the collection was at least as important as its intellectual logic. He went on to describe how:

> The traditional grouping by schools has been largely maintained; but a good many exceptions have been made, partly for the sake of a more harmonious and stimulating ensemble and partly for the sake of historical truth, to show that the spirit of the time is usually more important than national boundaries, and that ideas can transcend both.

10.2 Sir Philip Hendy re-hanging paintings in the Duveen Room, National Gallery, London, 1956. Photo: A. Whittingdon © John Bull.

The wording of this statement indicates the duality of his concern: for the look of the paintings on the one hand, influenced by his modernist aesthetic; and, on the other hand, for the intellectual logic of following the *Zeitgeist* rather than a layout dominated by national schools.

Hendy was not only interested in the look of the collection, but also in its environmental conditions, being a passionate believer in the benefits of an understanding of science to the display of the collection. He was responsible for the installation of air conditioning, following the experience of monitoring the stable, atmospheric conditions of the quarries in which the pictures had been stored during the 1939–45 war. This, in turn, made it possible to take the glass off the pictures in order to allow for a more immediate and more intimate experience of their surface. In 1947 damask was introduced as a background to the pictures, not because of its aesthetic qualities, but because it was believed to be a first step towards the control of relative humidity. Apparently 'by taking the

moisture from humid air and giving it out when the air is dry, [damask] does much to keep the atmosphere stable. It has other practical virtues, of which the greatest, in view of the undesirability of frequently changing Rooms for redecoration, is its relative permanence.'[10]

Hendy is remembered as being authoritarian in the way he hung pictures, reluctant, at least in his early years as Director, to delegate the responsibility to his Keeper and Assistant Keepers.[11] Perhaps surprisingly, his attitude to the hanging of the collection was the subject of debate in the House of Lords where, in 1954, Lord Strabolgi deplored the fact that 'There is a tendency at the National Gallery to concentrate too much on what I may call "window-dressing" for the benefit mainly of the ordinary visitor', and Lord Methuen, a former Trustee and owner of Corsham Court, agreed, regarding it as a betrayal of the old and well-tried policy of getting and keeping together a collection of pictures 'to illustrate the history of Western art as fully as possible'.[12]

Hendy may have been influenced by his time as a curator at the Museum of Fine Arts in Boston in the early 1930s, preferring the American tendency to show isolated masterpieces without regard for their setting. If so, it was not a tendency which was much appreciated by his staff, because his Keeper, W.P. Gibson (who was also his brother-in-law) wrote to Lord Crawford, a Trustee, in 1958, commenting on the fact that the annual report for that year implied that 'the Director's earlier inclination towards the Louvre's policy of hanging at large intervals a few masterpieces, by his taste, is now abandoned – one Bellini per wall, a Giorgione on a noble scale per room, or every mutation of Caracciolo, Strozzi, Preti, and Crespi to be set out in infinitude of boredom.'[13]

THE ART-HISTORICAL CANON

In so far as there was a shift in the approach to the hanging of the collection during the 1960s, it was probably characterized by a return to the desirability of providing an appropriately clear narrative, based on the belief that the National Gallery provides an exemplary canon of works of art, which can, and should, be arranged as far as possible teleologically, in order to show the development of the various national schools of painting.

Certainly, when it came to the writing of a guidebook to the collection in 1964, Michael Levey was able to provide an extremely lucid view of the sequence of the collection, beginning with Room I up the stairs to the left of the main entrance which was devoted to 'Italian Gothic' (plate 10.3). He began his account with an obvious sense of narrative confidence:

> The visitor should try to ignore the restricted and forbidding entrance hall of the Gallery and go up the staircase to the first landing, where stands a plan of the exhibition floor ... Turning left through the West Vestibule, one can pass through Room II, turning left within it, to find:
>
> ROOM I
>
> ITALIAN GOTHIC
>
> Western painting begins in Italy and this Room gives some idea of its very earliest years.[14]

This guide helps to reconstruct the layout of the National Gallery as it was in the late 1960s. Visitors came up through the portico of Wilkins's façade, through the front entrance, turned up the left-hand staircase in the staircase hall and

found themselves in a gallery devoted to the display of fourteenth-century Italian painting. They then toured through the building, reading it as a circuit, through the High Renaissance, through the seventeenth century, through the eighteenth century (but the eighteenth century has always been displayed slightly apologetically), until they came to the display of the French impressionists back by the front entrance, at which point they could leave to feed the pigeons in Trafalgar Square.

10.3 Room I, National Gallery, *c.* 1970. © The National Gallery, London.

AESTHETIC MINIMALISM

One can pick up the narrative of the hanging of the National Gallery in the annual report for January 1967–December 1968, which includes a section on 'The Arrangement of the Collection', written by Martin Davies, who was appointed in 1967 to succeed Hendy:[15]

> The ideal of hanging – for the National Gallery – is that all the pictures look their best, and nobody notices anything but them. The impossibility of ever attaining this ideal has some advantages. Respectful as one may feel to visitors who remember where their favourite pictures were and like to go direct and find again as before, static hanging cannot be much defended, at any rate lasting over many years, even in collections where acquisitions are not made. There would be something ridiculous in thinking that there is one place for each good picture in the National Gallery. There is something of life in changes of arrangement; to a degree, one even gets thereby new pictures without purchasing.[16]

This is an admirably clear philosophy as to how to hang pictures. But one realizes how culturally specific the ideas are as to what is the appropriate environment for

the viewing of pictures when one reads shortly afterwards the equally laconic paragraph:

> Museum fatigue is partly the fault of visitors treading too many Rooms too long; yet flooring, comfortable and in other respects satisfactory, is well worthy of the administration's attention. A nylon felt is being tried out in the National Gallery. It is easy on the feet; it is apparently hard-wearing; unobtrusive colours can be offered. One may hope that, in time, comfort in the Gallery will be greater.[17]

The idea that the pictures could speak independently of their surroundings was based on a belief that the surroundings should be treated as being as mute and nondescript as possible, abolishing all evidence of the original Victorian decoration and covering the wooden floors with felt.

The Trustees' *Annual Report* for the period January 1969–December 1970 continues the narrative of attitudes towards an appropriate style of display:

> A seemingly attractive option is that the National Gallery need not seek to excel in display techniques; the pictures of the Collection are competent to have their say. Yet permitting that is a display technique: of not scrambling the message.

This seems straightforward, but, again, it is clear how culturally specific it is and hostile to the original, when it goes on to say:

> Variety of wall-coverings is considered desirable. Changes may be noticed by visitors in the choice for certain Rooms of material that is not damask, and is without a pattern conspicuously woven in ... Much work to reduce adverse effects from the heavy architecture is needed.[18]

This passage helps to confirm that the orthodoxy of the time was minimal information – 'allowing the pictures to have their say' – although there was some recognition, at least on the part of Michael Levey when he was Keeper, that there was public demand for more information about the collection because he arranged for so-called 'room bats' to be available, as they were in historic churches. There was a general determination to get away from the characteristics of an historic hang by abolishing damask and disguising the Victorian architecture, which was then regarded as heavy, distracting and over-ornate.

CULTURAL CONTEXTUALISM

An uninterrupted circuit round the galleries, which provided a coherent narrative for visitors, was made impossible by the opening on 9 June 1975 by Queen Elizabeth of the new north galleries, which were designed in a style of postwar brutalism. The *Annual Report* for the period 1973 to 1975 shows the building in all its newly opened glory, with a grand, polygonal structure on the pavement on Orange Street advertising the Gallery and celebrating its various amenities, including a newly opened smoking room. In 1976 the basic guide was re-written by Homan Potterton to accommodate the change to the plan of the gallery effected by the opening of the new north wing galleries, which he described as 'a model of discretion and reticence in comparison to the grandeur of the Victorian interiors'.[19] The essential narrative was maintained, although requiring a

10.4 Room 32, National Gallery, 1976. © The National Gallery, London.

distinctive and slightly unsatisfactory loop through a series of 1970s galleries, which were built in the style of the time, rather brutal from outside, neutral within to the point of being off-putting. Their design reflected not so much the taste of the various architects employed by the government's Property Services Agency, but more the determination of Garry Thomson, the then Keeper of the Scientific Department, to provide a controlled environment with light only falling on the walls and not in the centre of the rooms.

Michael Levey's taste as Director was, likewise, of his time – hostile to the Victorian architecture of the main floor galleries as being distracting to the experience of the paintings and wanting the environment of the gallery to be as neutral as possible in order to allow the pictures to be seen to best effect (plate 10.4). Moreover, he was profoundly democratic by temperament and, having experienced the autocracy of Hendy as an Assistant Keeper, chose to delegate responsibility for the hang of individual galleries to his staff.

THE HERITAGE HANG

By the early 1980s, there was the beginning of articulate opposition to the diversity of styles of display in the National Gallery. The young Neil MacGregor, not yet editor of the *Burlington Magazine*, wrote in its December 1980 issue:

> The Underground long ago overtook the weather as a source of London grousing. Both must soon be in danger of being outstripped by the National Gallery. The newly reopened French and Spanish rooms live sadly up to one's expectations.

> What are those expectations? The early Italian room was some time ago rehung without being redecorated, so that the previous hanging can still be read in dust-marks on the wall, a palimpsest of past taste. The Pieros and Botticellis have for years had to fight for attention between turquoise cornice and tangerine carpet. The seventeenth-century Italian room contrives to look like a muddled country-house saloon, where a work of the quality of Annibale's *Pietà* jostles with the third-rate.[20]

This brief paragraph represents one of those seismic shifts in public taste away from the neutral style of gallery display, which had been very much the orthodoxy in the postwar period, towards an interest in displaying pictures as they would have been seen in the country-house galleries of the nineteenth century – a style of display first pioneered in Britain by Michael Jaffé at the Fitzwilliam Museum in Cambridge in the mid-1970s, then by Timothy Clifford in his refurbishment of the Manchester City Art Gallery in the late 1970s, and subsequently in the National Galleries of Scotland in Edinburgh. It was part of a much wider movement towards historic revivalism, a rejection of the modernism which had been such a dominant philosophy in the arts.

Not long afterwards, an article appeared in *Private Eye*, presumably written by Gavin Stamp, an architectural historian who wrote articles for *Private Eye* under the pseudonym 'Piloti':

> Whatever qualifications the directors of Britain may have, a visual sense would not seem to be one of them. Compared with museums on the Continent or in the United States, our buildings are badly treated: the original architecture is not respected, nor are the alternatives of a quality to justify the spoiling of what is usually an historic and beautiful structure in its own right. All too typical is the National Gallery ... which at considerable expense – to the taxpayer – is being continually altered and where the entrance hall greets the visitor like a Trust House hotel: lowered ceilings, stalls, desks, notice boards and hessian all conceal Wilkins' fine architecture.[21]

By 1986, following the arrival of Jacob Rothschild as Chairman of Trustees, there was a change of tune. Rothschild had an active interest in issues of gallery design, was sympathetic to the changes which Timothy Clifford was introducing at the National Galleries of Scotland, and was a close friend of David Mlinaric, the interior decorator who had been responsible for the refurbishment of Beningbrough Hall in Yorkshire in a style of stylish, un-archaeological historicism. This was the period of *The Treasure Houses of Britain* exhibition at the National Gallery of Art in Washington, when the country house was regarded as the *fons et origo* of British culture and its style of display the most appropriate environment for hanging pictures.[22]

In November 1986 – interestingly just at the point that Neil MacGregor was appointed as Director – Gavin Stamp wrote in the *Daily Telegraph*:

> Despite the lessons about the treatment of historical interiors and the hanging of old paintings provided by galleries throughout the world, our academic experts have tried to treat works of art in isolation. Their ideal has been but one painting hung on a bare, colourless wall, ignoring the complementary power of fine architecture and rich colour. The result has been that so

many of our museum interiors have been neutralised with dropped ceilings, hessian walls, incongruous display stands and gallons and gallons of white paint.[23]

Later on in the same article, he says how:

It has been the National Gallery which has triumphantly exemplified the worst aspects of the architectural blindness of our modern museum culture. With its neglected and colourless galleries, tawdry innovations and general impression of visual squalour and clutter, the treatment of this potentially fine building has made what should be our premier gallery into a national scandal. Now, at long last, with Jacob Rothschild as Chairman of the Trustees and with financial help from J. Paul Getty junior, changes are being made – if only to take the wind out of the sails of tiresome Mr. Clifford.

This article provides the thinking behind the current orthodoxy, known in curatorial circles as 'the heritage hang' and described by Timothy Clifford in an article published in the *Journal of Museum Management and Curatorship*.[24]

But there remained differences of opinion as to how rigorously this orthodoxy should be pursued and there were divisions behind the scenes in the late 1980s between the aesthetes, represented by Jacob Rothschild as Chairman of Trustees and Colin Amery as his *quondam* architectural adviser, who wanted a style of intense visual opulence, and those, including Neil MacGregor as Director, who had a slightly more didactic and democratic attitude to issues of display, who objected to David Mlinaric selecting smart, silk fabrics, not least on grounds of cost, and who regarded the style of the National Galleries of Scotland as too redolent of the elitism of the traditional picture-owning classes. They preferred the advice on issues of interior refurbishment of Purcell Miller Tritton, a well-established firm of conservation architects based in Norwich, who were employed as house architects and were responsible for working on the refurbishment of most of the galleries in the Wilkins Building over the past fifteen years, including the complete reconfiguring of the north galleries, converting them from 1970s brutalism to a style which aimed to reproduce the nineteenth-century mood of the Wilkins galleries. The characteristics of the hang during this period were that it should be as consistent as possible, lacking the modifications which might indicate the taste or interests or sensibility of an individual curator and ensuring a sense of intellectual clarity and coherence to the institution as a whole.

THE ECCLESIASTICAL LOOK

While work began on the refurbishment of the Victorian galleries in the Wilkins Building, plans were being made for the interiors of the Sainsbury Wing, motivated by the fact that a number of the trustees felt that it was inappropriate for the early Italian collection to be hung in nineteenth-century galleries. They wanted the new building to be built in a style which, as far as possible, replicated the viewing conditions of churches in Italy. If the interiors of the Wilkins Building were intended to look, as far as possible, like a *palazzo*, then the style chosen for the Sainsbury Wing was that of a basilica, with painted walls, rather than damask, and a certain Italianate austerity in the interiors, which was regarded, with good reason, as appropriate for the display of the early part of the collection.

10.5 Sainsbury Wing Galleries. © The National Gallery, London.

Robert Venturi was chosen as the architect because he had determined and well-considered views as to the appropriate environment for the hanging of pictures, based on his time as a scholar at the American Academy in Rome and his admiration for the interiors of Sir John Soane's Dulwich Picture Gallery. He recognized that the requirements of the project were very different from those of most American museums, which required flexibility, whereas the Sainsbury Wing was designed for a collection which was not expected to change very much, if at all. As a result, he was happy to design in the style which the trustees themselves favoured: rather reticent, concentrating on the quality of the interior spaces and of the daylight, rather than on making an emphatic architectural statement.[25]

However, there was one issue where Venturi held clear views which were distinct from those of the trustees. He had been much influenced by the experience of looking at works of art in the domestic interiors of houses in Philadelphia, preferring them to be displayed slightly more casually than they would be in the more highly articulated ordering required by a public museum. This meant that he was keen to have a clear sense of the relationship between the inside and the outside and favoured side lighting, as in the windows out on to the Sainsbury Wing staircase, as well as top-lighting from the clerestory windows, which were modelled on those of Dulwich. He described this approach in an article published after the opening of the Sainsbury Wing:

> The client wanted something that paralleled the original setting the painters might have anticipated for their art. The sense of place was important. Also it is thrilling to see art in the

real world, rather than in a museum: if you go to someone's house and they have a great painting in their living room, there is something *more* wonderful about it than if you see it in a museum – it's in the real world. At the same time you have to acknowledge the museum as an institution for accommodating high security and great crowds, so what we did was to place occasional windows in the galleries. A window indicates that you are part of the living world. Also you can look through it – and the magic you've been experiencing looking at great paintings becomes more magical after it is interrupted by the real world; it's like intermissions between acts at the theatre.[26]

Not everyone admired the top-floor galleries of the Sainsbury Wing when they were opened, some regarding them as slightly disneyfied, but they have provided a calm and effective setting for the display of the collection, which has worn well over the past fifteen years (plate 10.5).

The opening of the Sainsbury Wing compelled a considerable re-think of the way the pictures were displayed (plate 10.6). The change of philosophy was announced by Andrew Graham-Dixon in an article in the *Independent* on 7 July 1990:

It might be described as the first Euro-hang of modern times. A few days ago Neil Macgregor, director of the National Gallery, announced what have been billed as the most sweeping changes to his museum in its 150-year history: the existing hang, in which paintings are grouped by nationality, is to be replaced by a mixed hang governed by chronology. Passport controls, so to speak, are to be lifted, the boundaries between the art of different European nations to be defined less rigidly. The timing seems peculiarly appropriate: the revised and rehung National Gallery is scheduled for completion in 1992.

10.6 Curators at Work. © The National Gallery, London.

The changes have been under discussion, according to Neil MacGregor, for more than a year. 'The first thing the curators and I had to decide was how we would hang the collection once the Sainsbury Wing had opened. The obvious question was whether we should hang just the early Italians there or whether we should hang the early Italians *and* the early Netherlandish. The next question was whether they should be hung separately, as they always have been in this gallery – where they are currently to be seen as separate traditions in separate parts of the building – or whether we should try to present them as intermeshing traditions that actually illuminate each other.'[27]

This article provides most of the philosophical basis on which the National Gallery has been hung over the past decade and a half: that it should be hung according to chronology and not according to national school; that its ethos should be broadly art-historical; that the display should be, as far as possible, fixed, in order to allow for consistency and continuity in the experience of the collection; and that the style of the fabrics chosen should be rich, but not too evidently representing a decorator's taste.

THE BENEFITS OF VARIETY

In recent years there have been few changes in the method of display and those that there have been are mostly undetectable to the ordinary visitor. But, in so far as they suggest a modest difference in approach, they are towards a recognition that visitors often appreciate some degree of variety in the method of display, rather than a rigid uniformity. The eye of the visitor is extremely alert to modest changes in the hang of pictures and to the difference between pictures which have been hanging for a long time in the same position, which tends to produce a dull visual effect, and pictures which have been hung recently and purposefully, which keeps the mind, as well as the eye, alert. Visitors may not recognize this approach to the hang as being a small element of postmodernism in display methodology, but, in reality, what is now permitted is a degree of authorial freedom in order to introduce modest variations in the mood and feeling of different galleries.

The most visible change has been to introduce small and fairly discrete, floor-level display boards which explain to visitors the theme and content of each of the galleries. This is the least visitors should expect: some explanation as to how pictures have been selected and grouped, even if visitors do not necessarily pay attention to it. The display boards act as a visual index to the galleries, indicating that there is a consistent purpose to their layout.

Another change has been to permit slightly more variety in the display of individual galleries, which is partly a necessity owing to the immense amount of re-hanging required by the Gallery's programme of international loans. But experience has suggested that, for example, the re-hanging of Room 29 (plate 10.7), to allow for the display of Rubens's *Massacre of the Innocents*, and the re-hanging of Rooms 24 and 25, to celebrate the 400th anniversary of Rembrandt's birth, creates a slightly different and more systematically purposeful mood to a gallery, providing an opportunity for more active interpretation – treating a gallery more like an exhibition. Most intriguingly, the redisplay downstairs in the Sainsbury Wing exhibition galleries of the nineteenth-century collection in September 2006 led to a very different experience for visitors to this part of the

10.7 Room 29, National Gallery, 2006. © The National Gallery, London.

collection. The convention in permanent galleries is for visitors to graze through the rooms. The same pictures redisplayed in exhibition galleries led to much more systematic and purposeful viewing.

The third change is unlikely to happen. In autumn 2005 the architectural practice Caruso St John was commissioned to provide a systematic analysis of the current method of display in the so-called cruciform galleries in the basement (following the opening of the east door on to Trafalgar Square more evidently on the true ground floor). They provided a cogent analysis of the benefits of different styles of display according to the characteristics of the different periods of the collection: that it was correct that the early paintings should be displayed in surroundings which approximated to those of a church, while the later collection should be in those of a *palazzo*; but that it ought to be possible to display the nineteenth-century collection in more modern and perhaps slightly more domestic surroundings, equivalent to those of early twentieth-century museums and galleries in Europe, such as the H. Lange House in Krefeld, designed by Mies van der Rohe for private clients in 1930, or H.P. Berlage's Gemeente Museum in the Hague, which opened in 1935. By displaying this part of the collection on the ground floor, it would be possible to have a slightly more informal and accessible experience of works of art, closer to the street and without having to walk up to the portico, introducing a third display style to the gallery as a whole.

Caruso St John's designs were a reminder that the traditions of display in European museums are very different from those in Britain and the United States: more concerned with qualities of natural daylight, less theatrical and less reliant on spotlighting to provide a sometimes false drama to individual works of art.

What they also demonstrated is the extent to which the orthodoxies of the 1980s – the idea of hanging old master paintings in historical surroundings – remain deeply entrenched in public expectations as to how traditional museums and galleries such as the National Gallery should look; indeed, just as entrenched as the white box convention for modern art.

CONCLUSION

It is worth reflecting by way of conclusion on the differences between the traditional approach to museum studies, which has been dominated by an outsider view of museum practice and by the ideas of Pierre Bourdieu and Michel Foucault and, on the other hand, the possibility of a new approach, which might be regarded as more anthropological in style, more attentive to the nuances of museum practice and how they are regarded within organizations as well as from outside.

Within galleries, there is an under-articulated language to museum display. It is a language based on modest differences of curatorial approach, on how pictures are hung, on the use of fabric and wall surface, and the relationship of pictures to one another. These are issues of sensibility and aesthetics, as much as of politics and culture.

Notes

In preparing this chapter, I am indebted for a great deal of help to those who have provided information about the *modus operandi* of the National Gallery in the past or about the history of gallery display. They include John Amis, Fram Dinshaw, Ivan Gaskell, Grizelda Grimond, Elizabeth McKellar and John Steer. I am particularly grateful for conversations with two of the architectural practices involved, Robert Venturi and Denise Scott Brown and Adam Caruso and Peter St John, to Jonathan Conlin for detailed comments and much information, to all those who attended the conference at the University of Nottingham on Display and Spectacle, 4–5 January 2007, and to Sir Michael Levey and Michael Wilson, who read the final text and saved me from a number of errors. Every effort has been made to contact the copyright holders of plate 10.2.

1 This essay originates in a paper given at a conference organized by Professor Pat Rubin at the Courtauld Institute on *Museums as Delight and Teaching: Artists, Collections, Publics*, 19–21 June 2003. My ideas were subsequently developed at a colloquium organized by Ivan Gaskell and Michael Conforti at the Clark Institute under the title 'After Critique: Museums in the World', 14–15 October 2004. There is now a substantial literature on issues of display, including, most recently, Victoria Newhouse, *Art and the Power of Placement*, New York, 2005, and, more philosophically, David Carrier, *Museum Skepticism: A History of the Display of Art in Public Galleries*, Durham NC and London, 2006.

2 The displays in the galleries of the National Gallery in London have been subject to a great deal of systematic analysis, beginning with a chapter in Carol Duncan, *Civilising Rituals: Inside Public Art Museums*, London and New York, 1995, 21–47, and including a critique by Ivan Gaskell in *Vermeer's Wager: Speculations on Art History, Theory and Museums*, London, 2000, 174–96, and a longer account, intended for students, by Emma Barker and Annabel Thomas, 'The Sainsbury Wing and beyond: the National Gallery today', in Emma Barker, ed., *Contemporary Cultures of Display*, New Haven and London, 1999, 73–101. More recently, Jonathan Conlin has published *The Nation's Mantelpiece: A History of the National Gallery*, London, 2006, which provides a great deal of evidence that makes it possible to contextualize approaches and attitudes to display in the past.

3 Conlin, *Nation's Mantelpiece*, 123, suggests that Charles Holmes hung in a nineteenth-century way from floor to ceiling, but Michael Wilson has

observed that the evidence of photographs suggests that he had adopted a single hang.

4 For information about Kenneth Clark's time at the National Gallery, see Meryle Secrest, *Kenneth Clark: A Biography*, London, 1984, 90–100, and David Cannadine, *Kenneth Clark: From National Gallery to National Icon*, London, 2002.

5 Helen Anrep to Kenneth Clark, Tate Gallery Archive 8812/1/3/131. Fram Dinshaw alerted me to this reference and Sue Breakwell located the full text.

6 Kenneth Clark, *Another Part of the Wood: A Self-portrait*, London, 1974, 199.

7 Sir Kenneth Clark, 'Ideal Picture Galleries', *Museums Journal*, November 1945, 129.

8 Clark, 'Ideal Picture Galleries', 134.

9 Minutes of the National Gallery Board Meeting, 10 October 1946. I am grateful to Jonathan Conlin for alerting me to this and subsequent references to Hendy.

10 *The National Gallery: January 1960–May 1962*, 19–20.

11 I owe this comment to John Steer, reporting conversations with Michael Levey on hanging policies at the National Gallery.

12 8 April 1954, *Hansard*, 5th series, 186, c.1154–5.

13 W.P. Gibson to Lord Crawford, 14 November 1958, National Library Scotland, ACC 9769, 101/18 (1).

14 Michael Levey, *A Room-to-Room Guide to the National Gallery*, London, 1964, 3.

15 I am grateful to Sir Michael Levey for confirmation of the authorship.

16 *The National Gallery: January 1967–December 1968*, 21.

17 *National Gallery 1967–1968*, 35.

18 *The National Gallery: January 1969–December 1970*, London, 1971, 24–5.

19 Homan Potterton, *Concise Room by Room Guide to the National Gallery*, London, 1976, 14.

20 Neil MacGregor, *Burlington Magazine*, 122, December 1980, 855.

21 *Private Eye*, 23 October 1981, 7.

22 For the Washington exhibition, see Gervase Jackson-Stops, ed., *The Treasure Houses of Britain: Five Hundred Years of Private Patronage and Collecting*, New Haven and London, 1985. David Cannadine published a critique of the exhibition in the *New York Review of Books*, 19 December 1985, reprinted in *The Pleasures of the Past*, London, 1989, 256–71.

23 Gavin Stamp, 'The artless treatment of our national galleries', *Daily Telegraph*, 3 November 1986.

24 Timothy Clifford, 'The Historical Approach to the Display of Paintings', *International Journal of Museum Management and Curatorship*, 1:2, June 1982, 93–106.

25 In describing Robert Venturi's approach to the design of the Sainsbury Wing, I have been much influenced by conversations *in situ* with him and Denise Scott Brown and by reports of the design process by those involved, including Caryl Hubbard and Grizelda Grimond. He has himself written about these issues in an unpublished lecture 'The Art Museum as a Setting for Art as well as a Setting as Art', delivered at the 'Museums in Evolution' Colloquium at the Fondation Singer-Polignac in Paris, 18 November 1999, and subsequently revised for a symposium on 'Museum Architecture: New Buildings and Additions' held at New York University, 8 June 2001.

26 'National Gallery – Sainsbury Wing. Robert Venturi, David Vaughan and Charles Jencks. An interview', in *Post-Modern Triumphs in London*, London, 1991, 55.

27 Andrew Graham-Dixon, 'Hanging in the balance', *Independent*, 10 July 1990. See also John Russell Taylor, 'Hanging Matters', *Independent*, 6 July 1990.

11

'OUR GODS, THEIR MUSEUMS':[1] THE CONTRARY CAREERS OF INDIA'S ART OBJECTS

TAPATI GUHA-THAKURTA

ON INDIA'S 'GODS' AND THE MUSEUMS OF THE WEST

In the beginning of his book *Museum Skepticism*, David Carrier works with the central idea of 'metamorphosis' to show how a physical artefact in a museum acquires the 'envelope' that will make of it a 'work of art', and how art writers and museum curators work closely together in creating 'the envelopes in which art arrives'. Crucial to this process is the distinction that he invokes between 'the work of visual art and a physical object in which it is embodied', to underline the way the two entities remain categorically separate and separable, even as their identities come to be integrally tied to the same material artefact.[2] The case of a sculpted object from India, transplanted from an Indian temple to an American art museum, provides Carrier with one of the most obvious instances of the cultural osmosis of the religious idol into a work of art, whereby the same physical object sheds one 'envelope' and acquires a new one as it moves from an ambience of worship to one of an art display. We are returned here to Benjamin's classic formulations about the replacement of the 'cult value' by a new form of 'exhibition value' in a modern age of replicable and moving images.[3] All along, the assumptions are that the art museum as a modern 'ritual site' for the collection and display of art stands entrenched in a history and a cognitive cultural frame that is quintessentially Western.[4] And that this institutional space of the museum has a profoundly transformative impact on every object, including Indian religious images, that comes into its folds.

This essay will be complicating some of these assumptions by throwing open the ways in which the Western art museum today functions as a complex site for the production of new orders of 'religious' value around Indian sculpted objects. One of its main points is to foreground the ambivalence and instability of identities – the unresolved tensions between sacred and aesthetic tropes – that surround the contemporary lives of India's art objects, both within and outside the precincts of museums. Over the late nineteenth and early twentieth centuries, India offers her own internal history of the growth of the institution of the museum, alongside the disciplines of archaeology and art history, and the

11.1 *The Sculpture of India* exhibition at the National Gallery of Art, Washington DC. A giant torso of a Buddha figure (sandstone, third century CE, from the Archaeological Museum, Nagarajunakonda), leading on to a gallery of sculptures from the first to sixth centuries CE. Photo: reproduced with the kind permission of the Gallery Archives, National Gallery of Art, Washington DC.

unfolding of a long tradition of scholarship and connoisseurship around such collected and conserved objects.[5] Yet these historical and artistic consecrations, it will be shown, are neither stable nor sealed, and remain continuously prone to contestations. This essay explores the positioning of sculpture as the reigning Indian art object in American museum spaces, while also tracking some of the clashing custodial claims, especially some of the recent modes of religious re-inscription of these objects, that threaten to dislodge their parallel lives as 'works of art'. Central to the story will be the theme of the travels abroad of Indian sculpture, and the drama of their returns and repatriations.

Let me begin by asking: when, in what ways, and for whom does Indian sculpture present itself as 'gods' in museum spaces? Going by the question that set my title, we could turn to a contemporary group of South Asian viewers who confront Indian religious imagery in American museums and exhibition galleries with a strong sense of unease and indignation. Their disconcert comes from a conviction that the 'true' life of these sculptures (certainly in the past, but even in the present) are as worshipped gods, and that their very place in a museum is an offence to their ritual existence. One could dismiss this point of view as coming out of a cultural illiteracy about the long modern history through which these objects came into the institutional care of museums in India, passing from structures of colonial custodianship to those of national authority. One could even conflate this illiteracy with the 'ignorance' of the masses who still form the bulk of museum visitors in countries like India, who (as we are frequently told) cannot distinguish between 'gods' and 'museum treasures' and remain impervious to the aesthetic and art-historical worth of these sculptures.[6] At the same time, it is also important that we locate this position within the current ambit of immigrant South Asian identity politics in Britain and the USA, particularly within the growing wave of religious and cultural fundamentalism among expatriate Hindu communities that often expresses itself in the desire to reclaim for worship objects that the Western museums have been profiling as 'art'. The pressure of religious reclaim presents itself around specimens of ancient and medieval Indian sculpture usually in the form of a newly configured monolithic 'Hindu' faith, which tends nonchalantly to subsume Buddhist and Jain iconographies within its appropriative folds.[7] These claims can also be seen to surface primarily (and most vociferously) when the avowedly 'sacred' objects move outside the nation space to find a home in Western art museums. To date, there are hardly any instances of objects being reclaimed for worship by religious communities or temple authorities from within museums in India. One could argue, then, that it is in the perceived foreign and desacralized space of Western collections that matters of religious rights over divine statuary become closely entangled with the larger issue of national cultural patrimony over expropriated objects.

Let me now turn to a second closely related development that spins off such demands and anxieties around Indian religious imagery in Western museums. The recent past has witnessed the spurt of a new trend of multicultural museum practices in the West, especially in the United States, where both authorities and viewers are increasingly sensitive to the epistemic violence that non-Western sacred objects have suffered in Western museum spaces by being categorized as 'art', 'craft', or 'folk art'. Having conferred the designation of 'art' on its exhibits, Western museums today are at the centre of reversing this process by trying to

11.2 The new Tibetan Buddhist altar at the Newark Museum, consecrated and inaugurated by the Dalai Lama in September 1990.

recover the original, authentic and traditional context from which objects came 'before they became art'. There is thus a rising emphasis within current museum practice on the reproduction of tradition, authenticity and ritual symbolisms of non-Western objects within its precincts. In a freshly anthropologizing turn, much of Indian art, like all of African or Oceanic art or Himalayan Buddhist imagery, is being powerfully re-inscribed within museums as religious icons, with elaborate attempts made by curators to recreate around these objects the performative practices of worship of priests and local communities.

There are a large number of examples that can be cited here. One of the earliest cases is provided by the spectacular recreation of a Tibetan Buddhist altar at the Newark Museum in 1990 for the display of a variety of Tibetan sacred objects (such as *tankha* scrolls and gilded and painted statuary) which the

157

museum had been acquiring since the early twentieth century (plate 11.2). While the museum had in place an earlier altar, designed as far back as 1935, the crucial point of difference about the new altar was that it was conceived not merely as a display setting but as 'a true religious structure'; that it was built by a Tibetan monk trained at the Rumtek monastery at Sikkim; that it evolved out of the close involvement of the exiled Tibetan community and its religious and scholarly authorities; and that it was consecrated by the Dalai Lama himself.[8] A powerful endorsement of such trends comes from the scholar Ivan Gaskell, who uses this new Tibetan Buddhist altar to illustrate the way that museums can effectively integrate the aesthetic and sacred character of their exhibits and reconstitute living spaces of devotion.[9] Gaskell goes on to cite other more politically conten-tious renegotiations of the religious identities of museum objects, such as the famous Virgin of Vladimir icon at the State Tretyakov Gallery in Moscow, which became a target for repossession by the Russian Orthodox church in the post-Soviet years, opening up a huge debate as to whether the icon had earlier been royal or ecclesiastical property.[10] In what Gaskell describes as an 'extraordinary solution' to the debate, the icon was relocated in the space of a restored, unused church near the Tretyakov Gallery, where it could be accessed only through a corridor from within the museum during its opening hours and, at other times, from a separate street entrance, and where it stood in its curious double identity as both a state art treasure and a liturgical object.

Where Indian sculpture is concerned, a striking instance of such new exhib-ition practices can be seen in the ritual clothing of Chola bronzes as processional icons and the laying out of the elaborate paraphernalia of worship around them. While the more anthropological tenor of the displays mounted in museums like the Smithsonian Institution in Washington DC allowed for the physical clothing of the bronzes and the staging of *puja* rituals in front of them, a space like the Sackler Gallery in the same museum complex on the Washington Mall saw the option of a different display mode: a display of photographs of the clothed bronze statuary within the temples of Tamil Nadu (plate 11.3) in an exhibition entitled *The Sensuous and the Sacred*, curated in 2002 by Vidya Dehejia. Video footage of the ceremony of their public procession served as a crucial introduc-tion to the 'sacred' world of these images, before attention turned to their different stylistic, sensual and aesthetic qualities, and to the evolution of this sculptural genre across periods and iconographies.[11] These bronzes – largely attributed to the period of Chola dynastic rule in South India (approximately tenth to thirteenth centuries CE), which also marked the construction of some of the most spectacular Shaivite temples in which these bronzes would have been housed – have, for many years now, come to stand as some of the most canonized specimens of Indian sculpture. This innovation in exhibition method, conceived by a premier Indian art historian, tried to integrate the opposing practices of 'art' and 'ethnographic' displays, revealing the alternative ritual lives of these icons without detracting from the supreme artistic value of what was on view.

In recent years, the Durga clay idols of Bengal have presented themselves as another body of choice objects in the showcasing of India's ritual art in Western museums. In a repeating trend, set by the Peabody Essex Museum at Salem in 1995 and followed up in subsequent years by the National Museums of Scotland and Wales, the Honolulu Academy of Arts in Hawaii, the British Museum in

11.3 A clothed Nataraja (*c.* 1010 CE) at the Brihadeshwar temple, Thanjavur, which featured within the photographic installation on worshipped images at *The Sensuous and the Sacred*, Sackler Gallery, Washington DC in 2002.

London and the Museum of New South Wales in Sydney, the Crafts Council of West Bengal has been invited to carry a team of idol-makers, artisans and drummers to stage a month-long project, constructing the Durga images within museum premises. What has been of highest premium in these projects is the performance of all the rituals of the making of the image, from the preparation of the alluvial Ganges clay and the mounting of inner straw and bamboo frames to the crafting of the goddess' clothes, ornaments and decorations and her bringing to life by the final painting of her eyes (plates 11.4 and 11.5). What has been equally imperative for all involved is the adherence to what is projected as the uncorrupted, traditional iconographic form of the goddess and her entourage, with no concessions to the many current artistic innovations that mark the varieties of Durga images in the city of Calcutta. Finally, an integral component of each of these 'Creating a Durga' ventures has been the simulation of select practices of worship and the elaborate consecration of the completed image, which has thereafter been retained as an exhibit in the respective museum.[12] In the recent Durga image-making workshop that was conducted in grand public

11.4 Accessory clay pottery and figures being prepared to accompany the central image of the goddess. *Creating A Durga*, Honolulu Academy of Arts, Hawaii, September 2004. Photo: courtesy Ruby Pal Chowdhury, Crafts Council of West Bengal.

11.5 The idol-maker Nemai Pal (also doubling here as a priest in a ritual outfit), performing the ceremony of painting the eyes of Durga, prior to the clothing and ornamentation of the figures. *Creating A Durga*, Honolulu Academy of Arts, Hawaii, September 2004. Photo: courtesy Ruby Pal Chowdhury, Crafts Council of West Bengal.

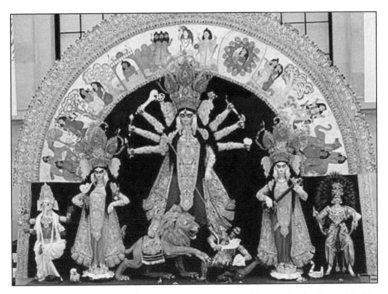

11.6 The completed Durga image, height 5.5m, made on site by Nemai Pal in the Great Court of the British Museum, London, September 2006. Photo: courtesy Jayani Bonnerjee.

view at the Great Court of the British Museum, the completed and consecrated image (plate 11.6) was taken in a ceremonial procession from the museum to Camden Town, where it was worshipped by the Bengali community during the five days of the autumnal festival and even accorded its ritual immersion in the Thames. If the clothing of the Chola bronzes presents a vivid case of the ritual re-profiling of objects that have long had an entrenched status as 'works of art', the Durga images offer a counter case of the transient craft object and religious idol being transmuted into museum exhibits for a Western viewership. Between them, they can be seen to represent two opposite ends of the spectrum in the production and valorization of the religiosity of Indian objects in Western museum spaces, with Western museum curators working in close collaboration with their Indian counterparts in foregrounding the primary religious identity of the Indian images that they place on display.

There is a stake here on the 'religious' as the all-important marker of tradition, authenticity and of the 'original' cultural lives of all such expropriated Indian objects. And the implications of such designations, we know, do not remain confined to the world of museums and displays alone but take on a sharper potency within the contemporary, combative identity politics of non-Western cultures in Western countries. As such new display and exhibitions practices have proliferated in the past two decades; they have closely converged with new modes of Orientalism, promulgated not just by Western museums and media but equally by the different cultural agencies of the Indian nation-state. What a smaller body like the Crafts Council of West Bengal has been involved in, with the international presentation of the religious art of Bengal's Durga Puja, has had many powerful precedents in the recent past. The trend had been set in motion by the grand Festivals of India that were held in Europe, Britain and the

USA in the 1980s, when the Indian government and art specialists worked in tandem with museum and exhibition authorities in the West to reinforce and recycle (as never before) a heightened sense of the cultural 'otherness' of India. While the display of India's visual and performative arts for a Western audience would thrive on a series of cultural essentialisms, the Western media found in these its most ready-to-hand cognitive tropes and multicultural safeguards. The extremes of such a celebration of alterity can be seen in the following review in the *New York Times Magazine* of the most important art exhibition of the Festival of India in the USA: *The Sculpture of India* show, mounted at the National Gallery of Art in Washington, DC.

> Indians [we were told] do not view their divinities any more than they view the art in their museums, with the kind of detachment that is regarded as good form in the West ... Indian visitors identify with Indian works with an intensity that is almost unknown in the West. To them, they are not *works of art at all, in our sense*, but *objects of worship* that happen to be in a museum and not in a temple. To see them lay gifts and offerings at the feet of the figure of a dancing Siva is an experience that has nothing to do with 'art-appreciation' or the nice distinctions in artistic quality and form that we in the West like to find between one Crucifixion and another ...[13]

In a sweeping gesture, the very entities of 'art' and 'museum' are rendered as constitutively alien to India, not just to the India of the past but equally to the country of the present. All of Indian sculpture is pushed away from the world of art museums, which it seems so inappropriately to inhabit, and repositioned within an alternative indigenous system of viewing and worship. And the one-and-a half century-old institution of the museum in India, which has always been regarded by both Western and Indian cognoscenti as a travestied form of what it was meant to be, is shown to occupy a nebulous position somewhere between a temple and a viewing gallery.

THE SCULPTURE OF INDIA AT THE NATIONAL GALLERY OF ART, WASHINGTON

I would like, in this section, to turn away from such a mode of imaging India and her sculptural art to remind ourselves of the long history of art collecting, museum practices and art-historical scholarship in India – and to present, as an exemplary product of this history, the landmark exhibition of the 'masterworks' of Indian sculpture that was placed on view in the National Gallery of Art, Washington DC in May 1985, as the inaugural event of the Festival of India in the USA. Like the prior two festivals held in England and France during 1982–83, the year-long Festival of India in the USA was a characteristically mega-event, jointly sponsored by the specially appointed festival committees of the two governments, generating over a hundred shows and performances, large and small, in museums across different North American cities.[14] The focus of such an event, as was to be expected, was on scale and magnitude, also on a comprehensive coverage of all aspects of Indian art and culture, ranging from the country's ancient to her contemporary arts, featuring the 'classical' and the 'folk', the 'higher arts' of sculpture and painting alongside book illustration, calligraphy, textiles, crafts,

11.7 Entrance gallery of *The Sculpture of India* exhibition at the National Gallery of Art, Washington DC: enlarged photograph of the Sanchi *stupa* and two of the earliest sculptures from the second to first centuries BCE – the 'Dwarf Yaksha' from the Pithalkora caves of Western India on the left and the 'Didarganj Yakshi' from the Patna Museum on the right. Photo: reproduced with the kind permission of the Gallery Archives, National Gallery of Art, Washington DC.

music, dance, photography and film. To use the Festival's own cliché, the idea was to offer the sights, sounds, smells and the very feel of India around a congregation of human and material exhibits. Such a promise was best fulfilled by a parallel exhibition of Indian crafts, craftspeople, folk musicians and performers, called *Aditi: A Celebration of Life*, which was organized by the Smithsonian Institution and spread out on the Washington Mall, in the manner of the many 'folk-life festivals' it hosts.[15] It was in such an exotic Orientalist setting, such a mixed mélange of shows and performances, that the *Sculpture of India* exhibition at the National Gallery of Art assumed its distinctive status, not merely as the inaugural but also as the key aesthetic event of the Festival. The art-historical specificity of genres like Indian sculpture was to be promoted through a few exhibitions such as this, and some even more specialized shows, such as one on Kushana sculptures at the Cleveland Museum and another on terracotta statuary at the Brooklyn Museum.[16]

The exhibition offered a privileged art-historical view of nearly five thousand years of the development of sculpture as the choicest form of traditional Indian art. There were 104 works in stone, terracotta, bronze and ivory, dated from 3,000 BCE to 1,300 CE – with the large majority of these travelling for the first time from museums all over India – laid out on the Upper Level and West Bridge of the East

163

Building, over 10,000 square feet of exhibition space. Ancient stone railings and pillars, animal figures, fertility and guardian deities, mother goddesses and a range of semi-divine beings took their place side by side with the more familiar meditating Buddhas, dancing Natarajas, portly Ganeshas, sensuous Krishnas, Parvatis or Lakshmis. Between them, they took American visitors on a novel tour across the length and breadth of India, into the intricate history of her many religions and iconographies, and the rich traditions of her religious architecture and sculpture (see plates 11.1 and 11.7–11.9). The exhibition bore in every detail the mark of the art-historical expertise of the scholar who had been invited to

11.8 *The Sculpture of India* exhibition at the National Gallery of Art, Washington DC. A gallery with some of the prime specimens of statuary from Mathura and Sarnath of the Kushana and Gupta era (*c.* second to sixth centuries CE), featuring the two 'great ages' of Indian sculpture. Photo: reproduced with the kind permission of the Gallery Archives, National Gallery of Art, Washington DC.

curate the show – Pramod Chandra, then Professor of Indian Art at Harvard University – who, in his training and background in India and later academic career in the USA, stood to best represent both the national and international stature of Indian art.

Much of the prestige of the exhibition had revolved around its select venue, featuring Indian art for the first and only time within the capital's National Gallery. In the strikingly modernist venue of the East Building, designed by I.M. Pei and housing twentieth-century European, British and American art, ancient and medieval Indian sculpture stood out in all its 'otherness', struggling to wrest for itself the same stature of 'art' that seemed to reside so naturally in all the other exhibits in the same precincts. That designation of 'art', the presentation of

a different, autonomous and far more ancient art tradition than that of the West, was a factor of utmost importance for the curator and the team of design professionals with which he was working. The battle for Indian art, the battle to free it of the calumny of Eurocentric prejudices and wrest for it the status of a 'fine arts' tradition, had long ago been fought and won.[17] If, in such exhibitions, scholars still needed to advertise the 'Indian-ness' of Indian art, they also wished to assert its rightful place within a universal 'family of art'. In choosing to focus on sculpture, Pramod Chandra's main intention had been to pick out a 'master-genre' of Indian art that could rival the traditions of European classical sculpture

11.9 *The Sculpture of India* exhibition at the National Gallery of Art, Washington DC. The early medieval period gallery, featuring in the foreground a South Indian sculpture of a large kneeling Nandi bull (the escort of Shiva), with the recreation of the darkened atmosphere of an idol within a temple sanctum. Photograph reproduced with the kind permission of the Gallery Archives, National Gallery of Art, Washington DC.

and 'convey a sense of the contribution of Indian sculpture to the common artistic heritage of mankind.'[18]

The selection of pieces for the show had been determined both by aesthetic criteria and the desire to offer a proper historical representation of all the main schools and trends of Indian sculpture. The exhibition carried distinct signs of the changing classificatory structures and the expanding object-domain of the evolving discipline of Indian art history. Avoiding religious classifications (like 'Buddhist', 'Hindu' or 'Jain') or dynastic labels (like 'Maurya', 'Sunga', 'Kushana' or 'Gupta'), the exhibition opted for the provenances only of 'time and place',[19] dividing its objects into chronological phases – such as the Proto-historic period

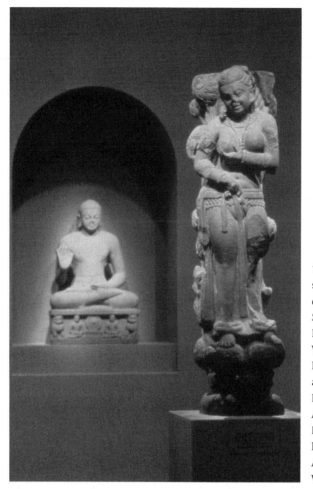

11.10 Photograph of 'Lakshmi showering milk from her breast'. *c.* second century CE *in situ* at *The Sculpture of India*, Washington: National Gallery of Art, Washington DC. Red sandstone, Mathura. The sculpture is set off against an image of a meditating Buddha (red sandstone, Ahichchhatra, second century CE). Photograph reproduced with the kind permission of the Gallery Archives, National Gallery of Art, Washington DC.

(*c.* 3,000–1,500 BCE), the Third Century BCE, the Second through First century BCE, the First through Third century CE, the Fourth through the Sixth Century CE, and the Seventh Century Onwards. Even as 'Indian sculpture' was presented as a national stylistic and conceptual unit, it was shown to feed off a rich diversity of regional idioms, and combinations and contrasts – 'works of grand conception and majestic power' alongside 'those cast in more intimate modes, both lyrical and delicate', 'images of absorbing spirituality' next to those of 'innocent sensuousness' (plate 11.10). The exhibition also made it a point to go beyond the known 'masterpieces' to search out several 'hidden treasures chosen from a vast corpus of works scattered in site museums throughout India'.[20] India's art history became a mirror of both the nation's history and its geography, with the exhibition space encapsulating the actual territorial space of the country it embodied.

In its choices and priorities, the *Sculpture of India* show stands within an ongoing history of the formation of major museum collections and the staging of exhibitions of Indian sculpture in Britain and the USA. Placed within this history, the exhibition offered itself both as a culmination and as a turning point. It brought to a crescendo a longstanding focus on sculpture, in both its earliest and

later medieval genres, as the prime category of India's 'great art' heritage. In keeping with earlier exhibition practices, it also laid a huge premium on the transportation of a large corpus of objects (including some rare and monumental pieces) from their home museums in India, and attached special importance to seeking out little-known items from several small site museums. In both these trends, the Pramod Chandra show at the National Gallery saw itself as following the trail of the pioneering exhibition on the 'master achievements of Indian sculpture' that was held at the Royal Academy of Arts in London during 1947–48, to commemorate the Transfer of Power and the arrival of India's Independence.[21] This show directly presaged the follow-up exhibition in the ceremonial precincts of Government House in New Delhi (soon to be renamed Rashtrapati Bhavan), which in turn led to the formation of the new National Museum of independent India. A key feature of the exhibition in London in 1947 had been the travels abroad, for the first time, of a large number of monumental and smaller pieces representing the finest specimens of Indian sculpture. It is this opportunity to encounter first hand the best of the nation's art that was seen finally to have dispelled the long-standing Western biases and misconceptions on the subject. While such an exhibition was a sign of the full-blown international stature of Indian art in the West, it also advertised the custodial authority and importance of the art establishment in India as the main support system for that stature.[22]

Much the same would be true for the exhibition curated by Pramod Chandra that followed almost four decades later. The strength and novelty of the National Gallery show, as he planned it, would lie in securing the rarest and the finest, and a host of relatively lesser-exposed items of sculpture that he, in his intimate knowledge, knew only to exist in museums and collections in India. From 1947 onwards the 'national' identity of Indian art abroad would be centrally premised on the strength and authority of the nation's own art establishment – on India's extensive network of central, provincial and site museums, without whose coop-eration no exhibition of scale and quality could be mounted in foreign museums. Thriving on a canon of reproducible images that circulated in catalogues, folios and postcards, much of the international aura of Indian art objects had also come to rest on the fact that the originals themselves could be made available in different exhibition venues across the world. It is this expectation that would be fulfilled, but also most bitterly contested, in the *Sculpture of India* exhibition of 1985. The event brought to a head a host of incipient tensions between the 'national' and 'international' custodians of Indian art, questioning the very legitimacy of the loan and travel of India's ancient museum resources. This is where the *Sculpture of India* exhibition would mark a sharp break with the past.

BUREAUCRATIC WRANGLINGS AND CLASHING CUSTODIAL CLAIMS

Let me now turn to the politics of the international transportation of Indian art objects, by taking the lid off some of the bureaucratic tussles and hindrances that not only preceded but spilled over into the time and space of the exhibition.[23] It is particularly instructive to look at these tensions in the light of the kinds of possessive national claims and the religious re-christening of Indian sculpture to which I have earlier referred, that can be seen to move between different popular, scholarly and institutional arenas. A series of lead players from different insti-tutions emerges in the unfolding drama – at the National Gallery, the Director,

J. Carter Brown, with Dodge Thompson and Anne Bigley of the Department of Exhibitions; Ted M.G. Tanen of the Indo-US Subcommission on Education and Culture, and Pupul Jayakar of the Festival of India Committee of the Indian government's Ministry of Culture, as the main representatives of the negotiating international bodies of either country; and, most importantly, Laxmi P. Sihare, Director of the National Museum, New Delhi, as the central mediating agent through whom the entire gamut of loans from Indian museums had to be negotiated. It is this last personality, Sihare, who emerges both as hero and villain in the fraught official exchanges of the period. Exercising his prerogative as the head of India's museums establishment, Sihare would repeatedly question the feasibility of loans, even when they had been approved by the smaller home museums, and would offer alternative items as replacements for originally chosen sculptures.[24] In the process, we see Sihare and the National Museum of New Delhi setting themselves up as an active front of resistance against the curatorial authority of Pramod Chandra and against the status of the Festival of India Committee as a promoter of the nation's art treasures. Indian and American media reports from the period sensationalized particularly the differences between Sihare and Pupul Jayakar. A formidable mix of scholarly and bureaucratic authority, Pupul Jayakar's powers over governmental policies and decisions would invite the rancour of many within the national administration, even as her driving initiatives in the international 'hard sell' of Indian art and culture would make her the continuous focus of media and public attention.[25] In the tensions that erupted over loans and damages, what increasingly surfaced were the dichotomous pulls that now set apart the 'national' from the 'international' custodians of Indian art.

The first of the controversies was triggered off by Pramod Chandra's request for a set of bronze statuary of the Chola period from a series of temples in Tamil Nadu. In the full list of requested 'India loans', these bronzes from the Tamil Nadu temples remained marked as 'pending' well into the advancing time of the exhibition, even as other desired loans, like the Rampurva Bull Capital from the Rashtrapati Bhavan collection, were cancelled.[26] While both Pupul Jayakar and Pramod Chandra readily conceded the risks involved in the travel abroad of this monumental Mauryan sculptural object (housed in the exclusive venue of the Rashtrapati Bhavan), they held firm on to their claims on the temple bronzes. They argued that these were some of the most unusual and lesser-known varieties in this sculptural genre, and that similar temple bronzes (though not these very ones) had travelled for the Festival of India exhibitions in London in 1982. This time, however, months before the exhibition, the propriety of allowing these bronzes to travel for the exhibition was taken up by the Tamil Nadu state legislature and blocked by a writ petition in the Madras High Court, on the grounds that these were 'religious objects housed in temples', and that their travel abroad would 'offend the sentiments of worshippers'.[27]

There is a crucial caveat to be mentioned here. While the art-historical literature on Indian sculpture had constantly upheld its identity as a 'sacred art', notions of the 'sacred', like those of the 'spiritual', had come to serve as a profoundly 'secular' designation, infusing the old religious object with the new ritual status of 'art'. Ever since its inception at the turn of the twentieth century, the field of Indian art history has stood deeply ensconced in these tropes of a

'spiritual' and 'transcendental' aesthetic that was singled out as the unique attribute of Indian art.[28] In the history of the discipline, we are often privy to the way that the continued location of sculpted objects within temple spaces was not a deterrent to their appraisal as 'art' by a new community of scholars and connoisseurs. Where the Chola bronzes are concerned, there is a wonderful irony in the way that one of the first Indian scholars and collectors of the genre, O.C. Gangoly, referred to his encounter with these figures in 'the sculpture galleries' he discovered 'in every corridor of all the important temples in the South'.[29] For the discerning scholar, a temple space could well double up as an art gallery, as it clearly did for Pramod Chandra, as he scoured the temples of Tamil Nadu in search of the finest specimens of these bronzes.

Yet, in the political climate of Tamil Nadu in the mid-1980s, all such configurations flew in the face of the counter-position of the legislature and the court which contended that the continued worship of objects and their positioning within temples de-legitimized their travel abroad as 'art'. The same genre of bronzes – such as this pair of Shiva as Vrishavavahana and his consort Parvati (plates 11.11a and b) – could more easily qualify for loan when they came from the Thanjavur Art Gallery. The location of some of these sculptures in museum galleries and of others in temples resulted from highly contingent and accidental developments. As these bronzes were being unearthed and disinterred in abandoned or used temple grounds during the twentieth century, it remained up to local villagers and temple authorities to hand these over to district collectors, according to the requirement of the Indian Treasure Trove Act of 1878, and thereafter up to the collector to decide as to whether these objects were to be rebronzed and rehoused in temples or made available for museum collection and display. That this disinterred bronze pair of Shiva and Parvati happened to have been handed over to the collector in 1952 and acquired by him for the newly founded Thanjavur Art Gallery in the district town now became decisive to their prospective career as travelling art objects.[30] The final judgment of the Madras High Court, delivered in May 1985 after the opening of the exhibition, is ridden with a host of paradoxes. It cleared for travel to the exhibition not just the Thanjavur sculptures, but also a selection of the requested temple sculptures, with the statement that these bronzes were *utsavamurtis* (those that were taken out in ritual processions) and therefore 'secondary deities' and 'not the main ones being worshipped'. It was also emphasized that 'every precaution would be taken for 'the safety of them while abroad' and that their loan for the exhibition 'would greatly enhance India's international prestige.'[31]

The claims of the 'religious', it seems, were never too far away, lurking around many of these sculpted objects even after they were placed on view in the richly aestheticized ambience of the exhibition. The mode of reference to all these sculptures as 'idols', in both Indian and American journalistic parlance, showed a continuous conflation of their 'sacred' and 'artistic' identities. And this line of divide between sculptures and divinities would be further blurred in the acoustic guided tours and popular hand-outs of the exhibitions, which presented the show as a tableau of the different 'Gods and Goddesses of India', invoking India as 'home to one of the oldest continuous civilizations' whose 'religion expresses the deepest and the most ancient truths of human thought . . .'[32] In pointed contrast to the art-historical provenance on each exhibit provided by the catalogue, the

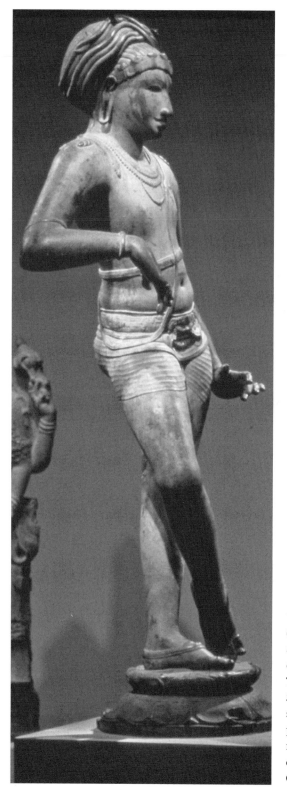

11.11a (left) Shiva as Vrishavavahana (meaning one with a bull as his escort) and 11.11b (facing) Parvati (Shiva's consort). Both bronze, *c.* 1011–1012 CE, Tiruvengadu. On display here at *The Sculpture of India* exhibition. Shiva stands leaning his elbow on a disappeared figure of the bull. Photographs reproduced with the kind permission of the Gallery Archives, National Gallery of Art, Washington DC.

acoustic tours told viewers only about the different attributes and powers of India's innumerable divinities. Often, such conflations between sculptures and gods were deliberately solicited by the Festival of India authorities. An inaugural ceremony of a *puja* was performed in front of an eleventh-century Ganesha image from Bhuvaneswar in the gallery, with offerings made to the 'god who removes all obstacles at the beginnings of a new endeavour', with some traditional dances, devotional songs and story-telling also thrown in (plates 11.12 and 11.13). The event was widely attended, with welcome addresses by the Indian ambassador, Shankar Vajpayi, Pupul Jayakar and Carter Brown. Pramod Chandra conspicuously stayed away.

The curator, it appears, had other continuing battles to fight. Cleared by the court, the loan of the promised bronzes from the Tamil Nadu temples and the Thanjavur Gallery would continue to be blocked by Sihare, this time on grounds of their 'uniqueness and rarity', with the offer of substitute specimens of the same genre of bronzes from the National Museum's reserve stock. 'Religious' objections gave way to equally urgent 'aesthetic' reservations: the National Gallery of Art's design personnel refused to accept Sihare's substitute offers on the grounds that they were inferior in artistic quality to the ones that had been selected by Pramod Chandra.[33] This caused the unprecedented embarrassment of featuring in the catalogue nine Chola bronzes which failed to arrive in time for the show, including the splendid Shiva–Parvati pair (plates 11.11a and b) that had its pride of place on the catalogue cover. The climax of this drama came with the final arrival of these two much-

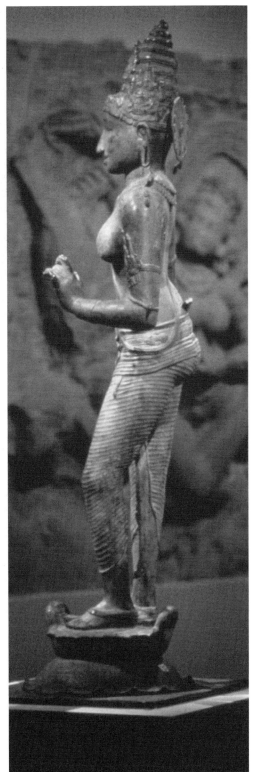

11.12 The sculpture of Ganesha, *c.* eleventh century CE, Bhuvaneshwar. Black schist. The inaugural ceremony of the *puja* was performed at *The Sculpture of India* exhibition in front of this sculpture. Photograph reproduced with the kind permission of the Gallery Archives, National Gallery of Art, Washington DC.

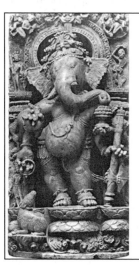

You are cordially invited
to attend a Puja,
a ceremony of blessing
before the opening of

**THE SCULPTURE OF INDIA
3000 B.C. - 1300 A.D.**

Saturday, May 4, 1985

NATIONAL GALLERY OF ART
East Building
Upper Level
Northwest Galleries

11.13 The invitation card for the *puja* to inaugurate *The Sculpture of India* exhibition on 4 May 1985, featuring the image of Ganesha. Photo: reproduced with the kind permission of the Gallery Archives, National Gallery of Art, Washington DC.

11.14 The late arrivals, the Shiva–Parvati pair from the Thanjavur Art Gallery, finally installed in the last gallery of *The Sculpture of India* exhibition, alongside other medieval temple sculptures in stone and bronze. Photo: reproduced with the kind permission of the Gallery Archives, National Gallery of Art, Washington DC.

coveted pieces, and their installation within the medieval sculpture gallery, more than a month after the opening of the show (plate 11.14). It was a diplomatic victory sealed through frantic negotiations on the eve of Prime Minster Rajiv Gandhi's visit to Washington and his scheduled tour of the exhibition. Similar considerations of antiquity and rarity also rendered uncertain, until a very late stage, the arrival of fragments of a newly excavated stone railing of the first century CE from the Kushana-period site of Sanghol in Punjab, with the pending status of the loan disallowing its inclusion in the exhibition catalogue.[34] The final arrival of these bronzes from the Thanjavur Gallery and of the Sanghol railing-pillar sculptures, along with India's Prime Minister, marked the highpoint of the *Sculpture of India* exhibition.

But the troubles were far from over. Another set of acrimonious disputes would erupt in the subsequent months over the alleged damage of some of the exhibition objects in the course of their travel abroad. At the centre of these allegations was the most ancient sculpted figure that travelled for the show, the 'Didarganj Yakshi' of the Mauryan period (plate 11.15). The Yakshi, as I have demonstrated elsewhere, had a long history of travels, relocations and artistic consecrations.[35] Unearthed on the banks of the Ganges in the outskirts of Patna in 1917, the statue had become an object of local worship before it was quickly wrested by archaeological authorities and placed in the newly established Patna

11.15 The 'Didarganj Yakshi'. Polished sandstone, *c.* third century BCE, from Didarganj near Patna, loaned from the Patna Museum to *The Sculpture of India* exhibition. Photo: reproduced with the permission of the American Institute of Indian Studies, New Delhi.

Museum. D.B. Spooner, Superintendent of the Eastern Circle of the Archaeological Survey of India, indicated how it was easy to convince the villagers that this woman with a fly whisk was 'clearly no member of the Hindu pantheon, nor entitled to worship of any kind by any community'.[36] Years later, Pramod Chandra, with his expertise on ancient sculptural iconography, established these fly whisks as common iconographic attributes of ancient tutelary guardian deities called Yakshas and Yakshis, noting with caustic relief that this thankfully remained unknown to the 'donors of Didarganj'. Wrested from popular devotion and disinvested of all sacred connotations, the Yakshi in the museum would thereafter be steadily reborn as the nation's most antique 'work of art', and 'as one of the earliest visual statements of the Indian ideal of feminine beauty'.[37] Over time, the sculpture moved from its first home in the Patna Museum to the exhibition at London's Royal Academy in 1947, from where it came to the Rash-trapati Bhavan show that opened in the new Indian capital of New Delhi in the winter of 1948. There it remained through the period of the setting up of the National Museum until it was reclaimed by the Patna Museum, from where again it was loaned in the 1980s for the Festival of India exhibitions in the UK, France and the USA.

At the end of the *Sculpture of India* exhibition, the Yakshi returned to India, allegedly with a fresh pockmark-sized chip on her left cheek, leading to a huge outcry in the Indian media about the ethics of the international travel of such rare art treasures. Archaeological and museum authorities in India listed no less than twenty-seven rare items that bore greater or lesser marks of wear and tear.[38] The Indian press made a great sensation about such 'damaging displays' and their 'damage of diplomacy'.[39] In official circles, much of this consternation would be expressed in the language of compensation and control. The most controversial of these battles for financial compensation surrounded the rarest of these objects, the 'Didarganj Yakshi' (plate 11.15), insured for 250 million rupees, of which the state government of Bihar demanded 62.5 million as compensation. The Festival of India projects had been propelled primarily by the demands of international capital. In the marketing of India as an exotic cultural entity, their main purpose had been to familiarize her for political and business relations, and to introduce her as a viable location for investment.[40] It was in keeping with the times and its demands that art objects came now to configure largely as items of economic value. With her historical and aesthetic significance established beyond debate, the preciousness of the Yakshi was now given its clear financial tag. Its status as a national 'art treasure' demanded that the sculpture be made scarce and inaccessible, available for viewing only in its original, national location.

Opinions remained divided over the extent of the damages sustained by these objects and their implications. Confronted by the hue and cry in the Indian media, the National Gallery in Washington hastened to absolve itself of the charges of mishandling, furnishing detailed condition reports on each of the objects in question on their arrival and departure from its premises, to prove that whatever damage had occurred had taken place, not during their time at the exhibition, but in the course of their unpacking and reinstallation at the National Museum in Delhi.[41] In India too, some felt that the issue was being blown out of proportion, while others emphasized that even a small rupture caused an

immense weakening of an ancient physical artefact. For most, what was centrally at stake was the loss of control of the national government over its museum resources. The chip on the Yakshi's cheek became the mark of a huge dent in national pride, outweighing all the other historical marks (such as the broken nose or the missing arm) of her physical mutilation. This damage was made the occasion by Indian art specialists and government officials for insisting that such rare and monumental artefacts could not stand the strain of foreign travel, and should never again leave India. The Festival organizers argued that everything they had done was for 'the greater glory of Indian art'. This glory, it was counter asserted, was best preserved in the sanctified territory of the country of origin.[42]

ON SMUGGLED ART TREASURES AND REPATRIATED IDOLS

I would like to present this story of damages, outrages and refused loans as part of a larger narrative of recovery and reclamation that takes us back deep into India's colonial pasts, into the background of archaeological and art-historical practices, through which figures like the Yakshi or the bronze pair of Shiva and Parvati were culled from other locations and uses, often from years of oblivion and disuse, and made available as 'art treasures'. I would also like to position these cases within a more recent politics of belonging that imbricates the newly nationalist and post-colonial histories of these objects. The Festival of India controversy rekindled, in a new context, many of the questions that have always beleaguered the subject of Indian art. There was, for instance, the central clash between contending claimants over the possession, protection and care of objects. The old colonial emphasis on the *in situ* preservation on India's antiquities was refurbished in the new language of possessiveness of India's state and national museums. At the same time, the old accusations of 'native' neglect and destruction of the country's antiquities also returns in the new debate around the apportioning of blame for the damage. The allegation (of course, hotly contested) that the National Museum of New Delhi was guilty of a lack of adequate care in the packaging and unpacking of objects once more posits the post-colonial Indian site as improperly equipped for the care of her art heritage.

Even more vital became the issue of reasserting the religious identities and ritual values of what could also qualify as the nation's 'art treasures'. One could argue here that objects like the 'Didarganj Yakshi' would never again be available for any other ritual practices other than those of 'art'. This unavailability had as much to do with the figure's iconographic complexity (its clear lack of fit with the standard pantheon of Hindu goddesses) as with the long, resonant history of its aesthetic and sexual canonization (as the most antique and exceptional specimen of stone sculpture and an emblem of the erotic feminine form in Indian art). As the controversy brewed around its damage, the sculpture remained once again in the National Museum in New Delhi, with the Patna Museum refusing to take her back without 'proper compensation'. The Yakshi eventually returned to Patna in 1989, to this place of her first museum location, now marked out as foremost among a special category of objects that should never travel again. Rendered into the most fetishized of art objects, this fetish is now left with a new curse of indifference and oblivion in the provincial confines of the Patna Museum. The most recognizable of the region's sculptures, copies and replicas of the Yakshi greet us everywhere around Patna: from roadside souvenir stalls and emporium

windows to the special commemorative gateways erected with Japanese funds at the refurbished Buddhist sites of Bodh Gaya and Nalanda. Alone and forgotten in the museum, the fossilized museum treasure seems to have lived out its life, leaving image and copy to proliferate freely.[43]

By contrast, the Chola bronzes have come to be inscribed with new kinds of sacral values, even as they have become some of the most widely circulating objects in the Western art market, especially in the illegal antiquities trade. In the process, they have also become the prime targets, both of religious and ritual reclamation by aggrieved temple authorities from whose custody they are purportedly stolen, and of national repatriation by state governments which have powerfully pushed the case for the return home of these 'gods'. The dispute over the loan of these bronze sculptures to the *Sculpture of India* exhibition takes on a new angle when seen in the context of the cases of the repatriation of two Nataraja sculptures from Western collectors to the government and temples of Tamil Nadu, in the years immediately before and afterwards. In the last section of the chapter, let me briefly touch on this theme of the new controversial lives of such Chola-period Natarajas as 'smuggled' art treasures and repatriated temple icons.

In the one case, there was the Shivapuram Nataraja (plate 11.16), considered by connoisseurs to be among the finest pieces of tenth-century Chola bronzes, which changed hands between several dealers and collectors in India and the USA, before it was acquired in 1973 by the Norton Simon Museum at Pasadena.[44] A mounting allegation by Indian authorities about the 'stolen' status of the Nataraja fire-balled soon after its acquisition by Norton Simon, bringing on law suits by the Indian government both against the Norton Simon Foundation and the New York art dealer Ben Heller, who had first purchased the statue when it came out of India and had sold it to Norton Simon. Both suits were suspended in 1976, when the Norton Simon Musuem agreed, in an out-of-court settlement, to transfer the 'title' of the Nataraja to the 'nation of India', on the condition that this 'masterpiece' could remain on display in his museum for another ten years before its return to India, and that the Indian government would not pursue its claims on any other allegedly 'smuggled' art objects owned by the foundation.[45] The Western museum, one could argue, made optimum capital out of this controversy. It took on a new righteous role as saviour of India's 'stolen gods'/'art treasures', and the main facilitator of their return to their country of origin, while also inoculating the rest of the Indian sculptures in its holding against all such anticipated future claims. The year (1985) that saw the huge tussle over the loan of Chola bronzes from Tamil Nadu's museums and temples for Pramod Chandra's exhibition coincided, then, with the time when the Shivapuram Nataraja was on the final months of its American odyssey and was being prepared for its triumphant return home.

What becomes pertinent in this story is the new category of the 'stolen' or 'smuggled' art treasure and the many histories that unfold around it. It confronts us with the fine line of distinctions that is drawn by the Indian government and by art dealers between the status of 'stolen' and 'smuggled' objects and the different legal and ethical connotations that redound on their reclaim.[46] It exposes the full complicity of different bodies of Indians – from bronze restorers and dealers to the museum and customs agents – in the sale and export of these objects. Most important of all, it throws open a fresh line of divide between 'national' and

11.16 The Shivapuram Nataraja. Bronze, *c.* tenth century, Tamil Nadu. The sculpture was repatriated from the Norton Simon Museum, Pasadena to the state government of Tamil Nadu. Photo: reproduced with the permission of the French Institute, Pondicherry.

'international' custodial claims over these items circulating in the art market. Thus we see how a prior history of the possession of this 'stolen' Nataraja in the home of a Bombay art collector in the 1960s could be implicitly condoned by authorities in India; and how it was the surfacing of this object in the American collecting circuit which orchestrated national outrage and official concerns about the return to India of this illegally appropriated 'national art treasure'.

Deeply embedded in such stories are also several new twists that come to coil around the reclaimed ritual identities of such peripatetic objects. As shown by Richard Davis in his studies of the multi-faceted careers of Indian monuments and images, the case of the Shivapuram Nataraja was one of several such examples of ceremonially buried temple icons in southern India, which were later accidentally discovered by locals in the vicinities of used and defunct temples. At times, such finds were duly reported and handed over to the temple or district authorities, in keeping with the Indian Treasure Trove Act of 1878.[47] However, all too often, as knowledge grew about the ready demand for these images, these bronzes swiftly passed from the local villagers and bronze craftsmen (who were entrusted with the work of their restoration and reconsecration) into the illegal national and international art market. Such was the fate of the Nataraja unearthed in the 1950s from the temple grounds at Shivapuram: where the original piece went on its travels as a desacralized and highly coveted art commodity, while, ironically, for decades, a fake copy installed in the temple served quite effectively its functions as a reconsecrated devotional icon.[48] Such was also the story of another stolen and returned Nataraja sculpture from another temple site of Pathur in Tamil Nadu, one that Richard Davis unravels like a detective thriller in his book *Lives of Indian Images*.[49] In the same years (1975–76) that the law suit for the return of the Shivapuram Nataraja was framed by the Indian government, the Pathur Nataraja surreptitiously moved from its underground life as a buried temple icon into the international art market, passing from Bombay to London art dealers on to Robert Borden, an officer of the Bumper Development Corporation of Canada, and a major purchaser of Asian art for several Canadian museums. And it was from the Bumper Corporation that this Nataraja was eventually wrested in 1991, following a long legal battle by the Tamil Nadu government, the state archaeological department and the Pathur Temple Trust.

With both the Shivapuram and Pathur Natarajas, the main plaintiff in the court cases was neither the Indian government nor the particular temple trusts, but the divine personage of Lord Shiva, with the god himself taking on a modern juridical personality to repossess the physical object in which his divine presence is manifest. What must be emphasized here is the way the Indian government participated actively in this extraordinary mix of religious and legalistic discourses, where the concerns for the recovery of the nation's art treasures tantalizingly blurred and blended with the intricacies of theological arguments about the nature of divine embodiment in such sculpted imagery, and where the artistic identities of these figures rested side by side with the principle, 'once a religious object, always a religious object.' An image that 'certainly attained greater celebrity as a litigated commodity than it ever possessed as a consecrated temple image' returned to the state but not to its sacred home in Pathur.[50] It required the renovation of the disused temple to house the reinstalled icon. Pending that, it was deposited in a separate, specially constructed icon vault at Tiruvarur that the Tamil Nadu government had conceived of in the 1980s to

prevent a rash of thefts of idols from small temples.[51] Ironically, the Shivapuram Nataraja, returned by the Norton Simon Museum in a landmark case of repatriation, found its way into the oblivion of the same icon vault, with the village temple in Shivapuram considered too unsafe for this highly coveted sculpture. Secure in their new custody, these 'gods' have remained 'jailed' ever since in a place which is neither temple nor museum and fails to fulfil the purpose of either. The bronzes in the vault are available neither for worship nor for art-historical study, nor are they given the climate-controlled protection needed to resist metal fatigue.

Is there any easy return, then, from being an art object into a renewed life as a devotional icon? Ivan Gaskell answers in the affirmative, as he presents new instances of the reconstitution of the sacred object within the museum, and shows how certain objects may be invested by cultures and communities with an 'inalienable sacred status' while others may be more amenable to slipping in and out of that status.[52] The Chola bronzes can be seen as wonderful examples of that second category of objects which seem to be able to move strategically in and out of different concurrent identities, negotiating the demands of both their artistic and religious reinscriptions in the present. The point at issue is to think of the 'religious' and the 'artistic' less as fixed and stable values, and more as a shifting, transmuting ground for the positioning of these sculpted icons. Taking the case of the disputes that wracked the *Sculpture of India* exhibition, or the legal battles that led to the repatriation of the Chola bronzes, this essay highlights the constant blurring of boundaries between the 'secular' and 'sacred' denominations of such ancient objects, and the impossibility of keeping safely apart the seemingly polarized worlds of 'art' and 'religion'. All such travelling objects today have to negotiate the multiple demands of art, authenticity and popular devotion, as they stand to embody both international goodwill and a contentious religious and cultural politics of nationhood. The tide, it is said, clearly turned with the Festival of India exhibition of 1985, as it also did with the return of the Shivapuram and Pathur Natarajas. The scope for procuring sculpture from India would henceforth be severely constrained by the zealousness of the Indian museum bureaucracy and by the new politics of repatriation. In a paradoxical twist, in the subsequent American exhibition and collecting circuit, the increasing visibility and aesthetic stature of Indian art objects would go hand in hand with the stigmatization of India itself as an intractable problem entity.

Notes

This essay has grown out of a project I undertook to chart a select history of collecting and exhibiting of Indian sculpture in American museums during the 1960s, 1970s and 1980s, during a Visiting Fellowship at the Center for Advanced Study in the Visual Arts (CASVA) at the National Gallery of Art, Washington, DC, in the summers of 2003 and 2004. I am particularly grateful to the staff of the Gallery Archives at the National Gallery of Art for allowing me access to the institution's repository of official papers on the *Sculpture of India* exhibition. Earlier versions of this essay have been presented at seminars at Kala Bhavan, Santiniketan in February 2005, at the Departments of Art History of the University of California

Berkeley, and of the University of Minnesota in October 2005, and most recently, at the 'Display and Spectacle' conference at the Department of Art History of the University of Nottingham in January 2007. The final version has drawn on the many comments and suggestions that came out of these presentations.

1 My title is drawn from a question that was posed to me at a public conference organized around an exhibition of colonial Indian photographs on Indian architecture at a museum in Los Angeles in 2004: I was asked by an immigrant Indian couple of the area whether it did not upset me to see so many of 'our gods' in the museums of the West.

2 David Carrier, *Museum Skepticism: A History of the Display of Art in Public Galleries*, Durham and London, 2006, 4–6.

3 See Walter Benjamin, 'The Work of Art in the Age of Mechanical Reproduction', in *Illuminations: Essays and Reflections*, London, 1973.

4 Carol Duncan, in *Civilizing Rituals: Inside Public Art Museums*, London and New York, 1995, offers the best formulation for thinking about the Western art museum as 'ritual structures', which help to produce, preserve and present 'art' as one of the most powerful secular-ritual objects of the modern world.

5 For an extended study, see Tapati Guha-Thakurta, *Monuments, Objects, Histories: Institutions of Art in Colonial and Postcolonial India*, New York, 2004.

6 The absence of an informed and initiated public has long been the bane of museum authorities in India, from the colonial period into the present, to a point whereby this problem of an 'inappropriate public' became symptomatic of the failed pedagogic project and the 'backwardness' of the transplanted institution of the museum in the colony. See Guha-Thakurta, 'The Museum in the Colony', in *Monuments, Objects, Histories*, 79–82.

7 This is an important theme outside the scope of this chapter. Just as India remains a multi-religious nation (with Muslims and Christians forming the largest of the non-Hindu religious 'minorities'), the figures that came to form the canon of ancient and medieval Indian sculpture came out of a medley of religious sectarian practices of the past, featuring a diverse range of Buddhist, Jain, Shaivite and Vaishnavite iconographies, whose styles, forms and motifs have featured as the main subject of Indian art-historical scholarship. But the currently configured ideology of Hindu nationalism often posits a conflated category of 'Hindu gods and goddesses' to refer to this entire body of sculpture.

8 Valerie Reynolds, *Tibetan Buddhist Altar*, Newark, 1991; and *From the Sacred Realm: Treasures of Tibetan Art from the Newark Museum*, exhib. cat., Newark Museum, 1999–2000 Munich, London and New York, 1999. Plate 11.1 is reproduced from the latter.

9 Ivan Gaskell, 'Sacred to Profane and Back Again', in Andrew McClellan, ed., *Art and its Publics: Museum Studies at the Millennium*, Oxford, 2003, 151–4.

10 Gaskell, 'Sacred to Profane and Back Again', 154–7.

11 Vidya Dehejia, *The Sensuous and the Sacred: Chola Bronzes from South India*, exhib. cat., travelling exhibition that opened at the Sackler Gallery, Washington DC, 2002. Plate 11.2 is reproduced from this source.

12 My observations here are based primarily on the case of the *Creating a Durga* exhibition held at the Honolulu Academy of Arts, Hawaii, during September–October 2004. I am grateful to Mrs Ruby Pal Choudhury of the Crafts of West Bengal for giving me access to the files and photographs on the project.

13 *New York Times Magazine*, 2 June 1985.

14 *Festival of India in the United States*, New York, 1985.

15 Held from 4 June to 28 July 1985 at the Smithsonian Institution on the Washington Mall, this exhibition featured 40 traditional performers and artisans and over 1,500 artefacts, many of which were created on site.

16 *Kushana Sculpture: Images from Early India*, Cleveland Museum of Art, Ohio, 13 November 1985–6 January 1986. *From Indian Earth: 4000 Years of Terracotta Art*, mid-January–end March 1986, New York: Brooklyn Museum.

17 This is now a widely discussed theme in the historiography of Indian art, first set out in Partha Mitter, *Much Maligned Monsters: History of European Reactions to Indian Art*, Clarendon, 1977, 252–86, and Pramod Chandra, *On the Study of Indian Art*, Cambridge, MA, 1983, 2–3.

18 Pramod Chandra, *The Sculpture of India, 3000 BC–1300 AD*, National Gallery of Art, Washington DC, 1985, 18.

19 The exhibition should be placed side by side with Pramod Chandra's historiographical survey of the field of Indian art history of the same years and his refining of its classificatory units; see especially the chapter on 'Sculpture' in *On the Study of Indian Art*, 43–79.

20 Chandra, *The Sculpture of India*, 19–20.

21 Chandra, *The Sculpture of India*, 18.

22 Discussed at length in my essay, 'The Demands of Independence: From a National Exhibition to a National Museum', in *Monuments, Objects, Histories*, 175–9.

23 *Records of the Departments of Exhibitions and Loans, Sculpture of India, May–September 1985*, Gallery Archives, National Gallery of Art, Washington, DC, (subsequently RG).

24 RG 22, Box 108, Folder 13, contains extensive, heated correspondence between L.P. Sihare, J. Carter Brown, Anne Bigley, Pupul Jayakar and the Indian Ambassador in USA, Shankar Vajpayi,

on the subject of refused loans and substitute offers from the National Museum, New Delhi.

25 See, for instance, the reports, 'The Splendours of India: Pupul Jayakar – Celebrating her Nation's Treasures with a Festival', *Washington Post*, 12 March 1985; 'Conflict surrounds the Festival of India', *Inquirer*, Philadelphia, 14 June 1985; 'Personal Antics on Show: What Pupul Jayakar wants, Pupul Jayakar gets', *Week*, New Delhi, 19–25 May 1985 (RG 14, vol. 1.).

26 Full list of 'India Loans'; list of objects expected to arrive after the initial shipment from India, 19 March 1985; list of still-pending loans of objects from Indian museums, 5 June 1985 (RG 22, Box 110, Folder 26).

27 Among the vast body of media reports, fax and telex correspondence on this subject in the National Gallery Archives, the problem is best summed up in a despatch from the US embassy in New Delhi to the National Gallery of Art, 20 April 1985, with an annex on 'Lok Sabha Questions to Minister of Culture, K.P.Singh Deo on the question of sending Tamil Nadu temple bronzes to the Festival of India Exhibition in USA', RG 22, Box 110, Folder 24.

28 For a condensed discussion of this theme, see Guha-Thakurta, *Monuments, Objects, Histories*, 184–8.

29 O.C. Gangoly, *South Indian Bronzes: A Historical Survey of South Indian Sculpture with Iconographical Notes based on original sources*, Calcutta, 1915, preface, i.

30 As described by Richard Davis (*Lives of Indian Images*, Princeton, 1997, 15–16), many of these temple bronzes had come to be ritually buried, in order to be protected from marauders and looters once the temples fell into disuse, and were unearthed by local villagers much later in the twentieth century. A first set of bronzes discovered at the same temple site in 1925 was returned to the Swetaranyeshwara temple, where they are still in worship. This Shiva–Parvati pair, found by a farmer in 1952 and handed over to the District Collector, however, came to be obtained for the Thanjavur Art Gallery which had just then been set up in the district headquarters.

31 Copy of the judgement notice by Judge S. Natarajan of the Madras High Court, enclosed in the correspondence between J. Carter Brown and Indian government officials, 25 May 1985, RG 22, Box 109, Folder 13.

32 'Gods and Goddesses of India, A Children's Guide to *The Sculpture of India 3000 BC–1300 AD*', an illustrated guide and work-out sheet; Acoustic-guide script on *The Sculpture of India* show, Narrator, Lyn Farmer, Production # 1038, May 1985, Gallery Archives, National Gallery of Art, Washington.

33 Memorandum on the negotiations with Pramod Chandra, Pupul Jayakar and Indian government officials on whether the National Gallery of Art should accept the nine substitute bronzes being offered by Sihare or whether it should press ahead with the 'original nine' chosen by Pramod Chandra, 16 May 1985, RG 22, Box 108, Folder 13.

34 Reports on the 'epoch-making' archaeological finds from Sanghol in *Sunday Observer*, New Delhi, 26 May 1985, RG 22, Box 108, Folder 13. The site of Sanghol in the Ludhiana district of Punjab had then been recently excavated and had yielded a rare crop of sculptural fragments that would have been part of a Buddhist *stupa* and railing complex at the site. The sculptures were ascribed by experts as belonging to the 'Mathura school of art that flourished under the patronage of the Kushana emperors during the first to second centuries CE'.

35 Guha-Thakurta, '"For the Greater Glory of Indian Art": Travels and Travails of a Yakshi', in *Monuments, Objects, Histories*, 205–233.

36 D.B. Spooner, 'The Didarganj Image now in the Patna Museum', *Journal of the Bihar and Orissa Research Society*, 5:1, 1919, 108.

37 Chandra, *The Sculpture of India*, 49.

38 Among other allegedly damaged objects were the Chalukyan 'Flying Gandharvas' of the sixth century CE which had a deep gash below the left leg of the female figure; the fifth century Mankuwar Buddha, which had scratches on the lobes of its right year; or a sixteenth-century painting of the *Devi Mahatmya* series, which had a hole burnt through it.

39 Raj Chengappa, 'Damaging Display', *India Today*, New Delhi, 30 November 1986, 148–50; N.K. Singh, 'Damage of Diplomacy', *India Today*, New Delhi, 31 March 1989, 192–4.

40 On this theme, see Brian Wallis, 'Selling Nations: International Exhibitions and Cultural Diplomacy', in Daniel Sherman and Irit Rogoff, eds, *Museum Culture: Histories, Discourses, Spectacles*, London, 1994.

41 Full 'Condition Reports' on the objects sent from India for the *Sculpture of India* show, recorded on their arrival and departure from the National Gallery of Art, Washington, 2 December 1986, RG 22, Folder, titled 'Alleged Damage to Sculptures'.

42 Chengappa, 'Damaging Display', 150.

43 Guha-Thakurta, "For the Greater Glory of Indian Art", 232–3.

44 The modern life and travels of this sculpture has been recounted by Richard Davis in his paper, 'The Dancing Shiva of Shivapuram: Cult and Exhibition in the Life of an Indian Icon' – lecture delivered at the Five Faiths Colloquium in the USA in August 2003.

45 My main source on his case have been the following media reports: Saryu Doshi, 'Robbing our Temples and Museums', *Illustrated Weekly of India*, Bombay, 10 October, 1971; Pratapaditya Pal, 'The Strange Journey of the Sivapuram Nataraja', *Los Angeles Times*, 22 August 1976; Paul Kunkel, 'The Case of the Dancing Idol', *Los Angeles Magazine*, May 1985, 192–5, 293; Geraldine Normane, 'Why Grave-robbing is no longer ethically acceptable', *Independent*, London, 17 June, 1986. My thanks to the staff of the archives of the Norton Simon Museum in Pasadena, California, for allowing me to consult these reports and other records in their holding.

46 It appears that in official parlance the term 'stolen' refers to the illicit removal and sale of an object from the temple or museum premises where it was housed, while the term 'smuggled' is used to indicate the illegal export of an object out of India, in violation of the Indian Treasure Trove Act of 1878 and Indian Antiquities Acts of 1971.

47 Davis, *Lives of Indian Images*, 15–16.

48 Such bronze icons, especially when they have been lying in disuse over long periods of time, are routinely rebronzed and reconsecrated to enhance their devotional value for worshippers. So, while the value of the untampered original is of supreme importance in the art world, the copy or remake has its legitimate place within a temple.

49 Davis, *Lives of Indian Images*, 222–59.

50 Davis, *Lives of Indian Images*, 252, 256.

51 Davis, *Lives of Indian Images*, 248–59.

52 Gaskell, 'Sacred to Profane and Back Again', 150–1.

NOTES ON CONTRIBUTORS

John Bonehill teaches in the Department of the History of Art at the University of Leicester. His publications include (as co-editor with Geoff Quilley), *William Hodges 1747–1797: The Art of Exploration* (New Haven and London, 2004), and *Conflicting Visions: War and Visual Culture in Britain and France, c. 1700–1830* (Aldershot, 2005). He has recently completed (co-written with Matthew Craske) a book-length study entitled *War, the Visual Arts and the Formation of Public Culture in Hanoverian Britain c. 1713–1815: Theatres of Mars.*

Deborah Cherry is Professor of Modern and Contemporary Art at the University of Amsterdam and at the University of the Arts, London. Her publications include *Location* (Oxford, 2007; co-edited with Fintan Cullen); *About Stephan Bann* (Oxford, 2006), *Local/Global: Women Artists in the Nineteenth Century* (Aldershot, 2006); and *Art: History: Visual: Culture* (Oxford 2005).

Fintan Cullen is Professor of Art History at the University of Nottingham. His recent publications include *Location* (Oxford, 2007; co-edited with Deborah Cherry); *Conquering England. Ireland in Victorian London* (London, 2005; co-authored with Roy Foster); *A Shared Legacy: Essays on Irish and Scottish Art and Visual Culture* (Aldershot, 2005; co-edited with John Morrison); and *The Irish Face: Redefining the Irish Portrait* (London, 2004).

Neil Cummings and **Marysia Lewandowska** have been collaborating since 1995. Their projects often focus on the relationships between art institutions and the political, social and economic spheres. Solo exhibitions include: *Enthusiasm,* Whitechapel Art Gallery, London, Kunst Werke, Berlin and the Tapies Foundation, Barcelona (2005); *Free Trade,* Manchester Art Gallery (2002); and *Capital,* Tate Modern, London (2001).

Group exhibitions include: *Generosity,* part of *Protections,* at the Kunsthaus Graz, Austria (2006); *Social Cinema,* their contribution to the London Architectural Biennale (2006); *Industrial Town Futurism,* at the Wolfsburger Kunstverein, Germany (2005); and *The Commons,* Liverpool Biennial International (2004).

Sabrina Norlander Eliasson is Assistant Professor at the Department of Art History, Stockholm University. She has worked as an associate curator at the National Museum in Stockholm where she co-curated the Grand Tour exhibition *Dreaming of Italy. Travellers in the South 1750–1870* (2004). Her forthcoming book with

Manchester University Press is entitled *Portraiture and Social Identity in Eighteenth-century Rome*. Her current research deals with eighteenth-century female convent culture and cultural consumption in Rome.

Peter Funnell is Curator of Nineteenth-Century Portraits and Head of Research Programmes at the National Portrait Gallery. He studied at University College London and took a doctorate in the history of art at Oxford University. A year-long fellowship at Yale led to his working and living in the United States in the mid-1980s. Since joining the National Portrait Gallery in 1990, he has curated a number of exhibitions and led major projects ranging from the redevelopment of the Gallery's first-floor displays to directing the research of 10,000 portrait illustrations for the new *Oxford Dictionary of National Biography*, of which he is a consultant editor. He currently combines his curatorial responsibilities with coordinating and promoting research at the gallery.

Tapati Guha-Thakurta is a Professor in History at the Centre for Studies in Social Sciences, Calcutta. The author of *The Making of a New 'Indian' Art: Artists, Aesthetics and Nationalism in Bengal* (Cambridge University Press, 1992) and *Monuments, Objects, Histories: Institutions of Art in Colonial and Postcolonial India* (Columbia University Press, 2004), she is currently writing a book on the public visual culture of the Durga Puja festival in contemporary Calcutta.

Angus Lockyer is Lecturer in the History of Japan at the School of Oriental and African Studies in London. His current research examines the use of expos within and by Japan between the late nineteenth and the early twenty-first centuries. Forthcoming articles include 'Expo Fascism? Ideology, Representation, Economy' and 'National Museums and Other Cultures in Modern Japan'.

Andrew McClellan is Dean of Academic Affairs and Professor of Art History at Tufts University, Boston. He has been a member of the Museum Studies faculty at Tufts since 1991. His most recent book is *The Art Museum From Boullée to Bilbao* (Berkeley, CA, 2007).

Robert Nelson has, in recent years, been interested in the reception of Byzantine art (*Hagia Sophia, 1850–1950: Holy Wisdom, Modern Monument*, Chicago, 2004) and icons (*Holy Image, Hallowed Ground: Icons from Sinai*, Los Angeles, 2006) and in the responses of viewers (*Visuality Before and Beyond the Renaissance: Seeing as Others Saw*, Cambridge, 2000). His current project involves the reception of Byzantine art in the Renaissance.

Helen Rees Leahy is Senior Lecturer and Director of the Centre for Museology at the University of Manchester. Previously, she worked as a museum curator and

director for over twelve years. Her research interests focus on practices of collection, display and interpretation in museums of art and design, and also in museums of war and conscience. Her chapter in this volume forms part of a larger research project on the bodies of museum visitors and was completed as a part of the programme of the ESRC Centre for Research on Socio-Cultural Change (CRESC).

Charles Saumarez Smith is Secretary and Chief Executive of the Royal Academy of Arts, London. He was previously Head of Research at the Victoria and Albert Museum, London, from 1990 to 1994, Director of the National Portrait Gallery, London, from 1994 to 2002, and Director of the National Gallery, London from 2002 to 2007. While at the V&A, he contributed an essay to *The New Museology* (London, 1989) and, at the NPG, he was involved in the plans and development of the Ondaatje Wing. He was Slade Professor at the University of Oxford in 2001–2002.

Index

Note: page numbers in *italics* refer to illustrations.